Oriental

Painting Course

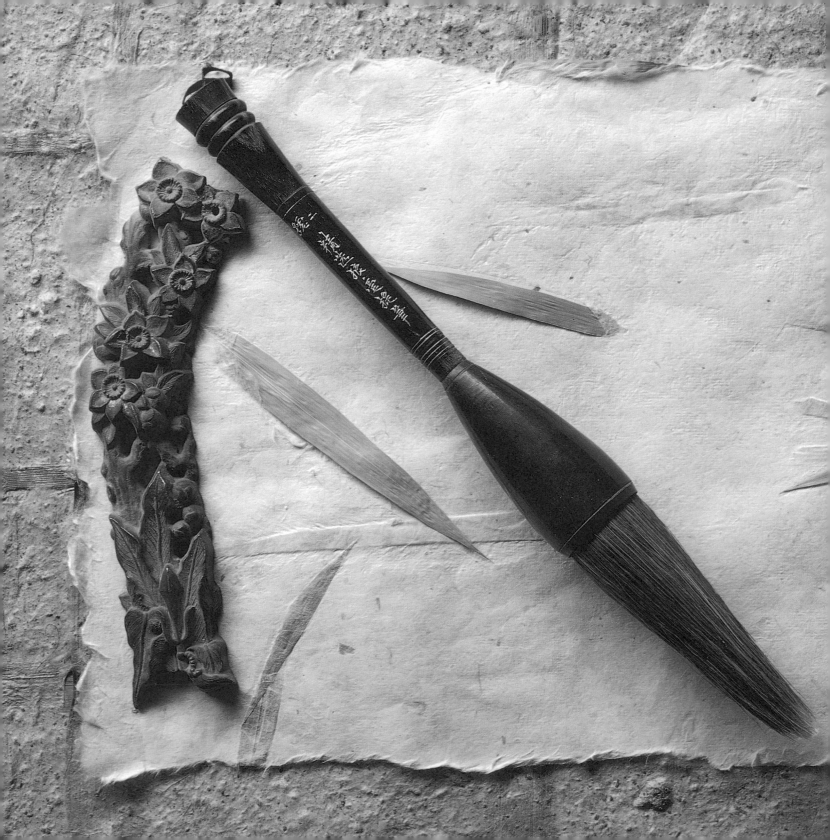

ORIENTAL
PAINTING COURSE

a structured, practical guide to the painting skills and
techniques of China and the Far East

by Wang Jia Nan, Cai Xiaoli

with Dawn Young

WATSON
GUPTILL

CONTENTS

A QUARTO BOOK

Copyright © 1997 Quarto Inc.

First published in 1997 in
New York by Watson-Guptill
Publications Inc., a division of BPI
Communications, Inc., 1515
Broadway, New York, NY10036.

Library of Congress Cataloging-in-
Publication Data
Wang, Jia Nan.
The complete oriental painting
course : a structured, practical guide
to painting skills and
techniques of China and the Far
East/Wang Jia Nan and Cai Xiaoli:
[edited by] Dawn Young.
p. cm.
Includes index.
"A Quarto book."
ISBN 0-8230-3389-9
1. Painting, Chinese—Technique.
2. Painting, Oriental—Technique.
I. Cai, Xiaoli. II. Young, Dawn.
III. Title.
ND1040.W338 1997
751'.0951—dc21 96–29557
 CIP
This book was designed and
produced by Quarto Publishing plc
The Old Brewery, 6 Blundell Street,
London, N7 9BH

Senior editor: Gerrie Purcell
Editor: Mary Senechal
Senior art editor: Elizabeth Healey
Designer: Ellen Moorcraft
Photography: Les Weis, Martin
Norris, Chas Wilder, Wang Jia Nan
Illustrator: Dave Kemp
Picture researchers: Giulia
Hetherington, Zoë Holtermann
Editorial director: Pippa Rubinstein
Art director: Moira Clinch
Assistant art director: Penny Cobb

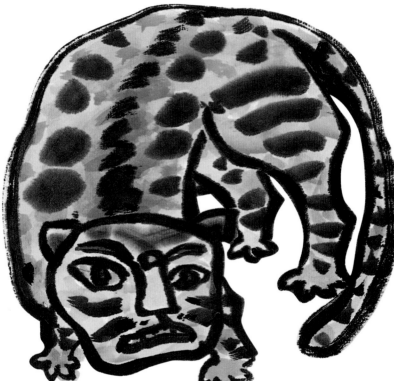

TIGER
by **Song Soo-Nam**

*Tigers have long been a favorite motif in Korean folk art, though seldom
resembling the animal in the wild in appearance or character. Often shown
sitting beneath a tree and scolded by magpies, they are usually far more
endearing than this one, whose circular form echoes the* yinyang *symbol.*

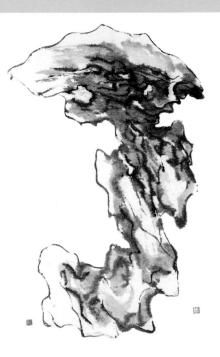

ROCK

by **Song Young-Bang**

Popular in China since the Tang and Song dynasties, this kind of ornamental garden rock, full of holes and delicately balanced so as to appear to soar upwards like a cloud, was regarded as a microcosm of the universe, balancing solid and void.

FOREWORD

To understand a nation's art, we should understand its history and the particular philosophy which lies behind it. In the case of China we are dealing with more than six thousand years of evolution during which techniques and procedural methods were developed in conjunction with a special way of looking at life itself. This has culminated in a treasure house of art works for all the peoples of the world to enjoy.

Of course, there are always barriers to understanding the art of another culture. Many eminent scholars have written on the subject, but this book is unique in several respects. Here we have, for the first time, a book which not only sets out the rudiments of Chinese painting for the would-be artist in a clear and concise way, but also gives a lively introduction to the appreciation and enjoyment of Chinese painting.

My fellow classmates from our days at the **Central Academy of Fine Arts** in Beijing, **Wang Jia Nan** and **Cai Xiaoli** are renowned as artists and teachers throughout the Western world. They have joined together with an English teacher and art historian, Dawn Young, to combine Western concepts with Chinese ones.

I take pleasure in supporting this worthy project and wish its authors every success.

YANG XIN
PRESIDENT OF THE PALACE MUSEUM
Forbidden City
Beijing
February 1997

INTRODUCTION

A copy of **Emperor Zhao Zhe's** *painting,*

THE FIRST LADY OF GUO STATE ON A SPRING EXCURSION

by **Cai Xiaoli**

This copy is a good example of how the Chinese admire excellent work from previous ages. The original is thought to be from the Tang dynasty, but the only extant versions are those done later by the **Emperor Hui Zong** (1101–26)**,** also known as **Zhao Zhe**. This painting is an example of *gongbi* (fine brush) painting. The grouping is complicated; some horses are trotting, others walking more slowly. The horses look ungainly by today's standards, but are in the fashion of the Tang dynasty. They are painted in a fine *ran* technique.

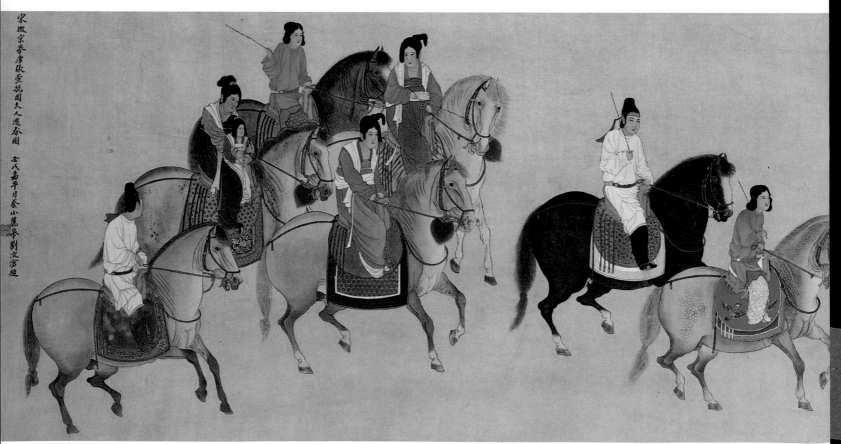

FLOWERS

by *Qi Bai Shi*

This painting is a good example of the exuberance and energy that can be captured using the *xieyi* (free brush) style.

This book contains the fundamental principles of a painting system that the Chinese culture passed on to many areas in the Far East. It is not the entire story of Oriental art but of that part based on traditional Chinese painting, which has been evolving for over two thousand years. The nucleus of the style is contained in this book, but you will see variants both in mainland China and in the many regions of the world where Chinese communities have settled, especially in Malaysia and Singapore. In other countries, such as Korea and Japan, the basic principles were assimilated well over a thousand years ago, and in some areas their paintings are close to the parent style. In other cases, the original style is barely recognizable, and Western ideas have been incorporated.

Traditional Chinese painting falls into two broad styles: *gongbi*, fine brush painting, and *xieyi*, free brush painting (see the examples left). *Gongbi* is primarily an outline drawing, with colors added where the artist thinks necessary. It is refined and decorative. *Xieyi* appears to be done with spontaneity, and even careless freedom. In fact, both styles depend on the total mastery of line. This is because Chinese painting developed out of and alongside calligraphy. The style taught in this book is mainly *xieyi*, and we continually emphasize the importance of thinking about it in a linear way.

Materials, techniques, and fundamental approach are different from those of the West. Most important is to realize that traditional Chinese painting does not depend on technique alone. It is part of a 3000-year-old culture in which painting is intimately linked with the arts of calligraphy, poetry, religion, and music. You need to know more about these to achieve success. This is why we have included information features alongside the lessons in this book. They give you the essential background about the materials, the methods, and their cultural significance that will help you understand and take full advantage of the lessons.

Before we began writing this book, we spent much time discussing the best ways of teaching and explaining traditional Chinese painting to Westerners. It concerned us that many people study the subject for a number of years without making significant progress. We developed new ideas during several years of organizing courses, exhibitions, and tours to China. Our aim was to produce a book in clear English, with well-chosen pictorial examples, that would use our knowledge of Western teaching methods without isolating the techniques from their indigenous culture. Our combined experience of teaching in China and in the West helped us evolve a way of presenting the subject in which the basic principles are plainly set out in the context of the historical and philosophical background. This approach is designed both for people who want to learn how to paint in the Chinese way and for those who just want to understand Chinese art.

The course is founded on the principles formulated by called "scholar-painters" who adopted a brush lifestyle and about life in general. We and about life in general. We for learning Chinese painting. We call this standard "modern

ABOUT THIS BOOK

We strongly advise that you work your way through the book, following the lessons and studying the information features in sequence.

Part 1 describes the materials and how to choose them. It gives you all the basic information you need about the techniques of brush-and-ink work, the relationship between calligraphy and painting, and introduces the vital concept of *qi* (spirit).

Part 2 is concerned with one of the main categories of traditional Chinese painting: Flower and Bird. Animals are also included here, because of the symbolism that links them, like birds, with particular plants in the expression of an overall meaning. It begins with ideas about choice of subject. Lessons four to eight build on the earlier techniques, and introduce simple composition. Lessons nine to twelve tackle more complicated subjects.

Part 3 explains the Chinese approach to Landscape painting and includes the depiction of figures. This is because figures are used not as subjects, but to reinforce the ideas in the picture. It is possible to move directly from **Part 1** to **Part 3** if you prefer, provided you study information feature five, on Ink and Color. Lessons thirteen to sixteen deal with fundamental techniques and compositional elements. Lessons seventeen to twenty give you ideas for adding character to your work, and Lessons twenty-one and twenty-two introduce figure painting.

Part 4 suggests ways of proceeding after you have completed the lessons in the book. It shows you some other styles of Chinese painting, and explains how to mount and frame your work.

The glossary contains definitions of Chinese painting terms, and the dates of the dynasties mentioned in the book.

WOODLAND SCENE

by Yukki Yaura

In this modern Japanese sketch the characters in the inscription form part of the design. Notice how the second column mirrors the shape of the escaping frog.

LOTUS

by Song Young-bang

This Korean artist has depicted blooms rising unsullied out of the muddy water: the image of the lotus was universally used in Buddhism as a symbol of purity.

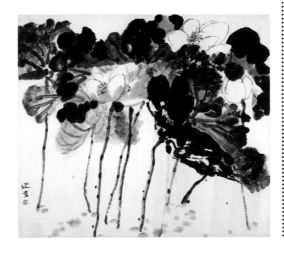

LESSON

Inspirational picture

Explanatory introduction text

Study or sketches text to help you learn and practice the subject of the lesson

Materials list

Examples or project to follow step-by-step

A synopsis of the aims of the lesson
• Further finished paintings are included to inspire you, and help you train your eye

INFORMATION FEATURE

Instructional exercise

Illustrated features used to expand on main text

Explanatory main text

Additional information, or tip boxes (this feature is also included in the lessons)

GLOSSARY

Illustrated techniques

pin yin transcription of original Chinese (Mandarin) terms

English translation of *pin yin* terms

Information box on dates for dynasties mentioned in the book

• • • •
EVERY TIME YOU PAINT, REMEMBER:

DO

● Find a good Chinese original painting to copy. Return several times to a composition that you like, to find the best way of rendering the brushwork.

● Decide on the size of paper you want to use, and cut it accurately before painting.

● Set out a large work surface with all the materials you need before starting to paint. Make sure the arrangement does not involve reaching across the paper, to avoid water or ink splashes on your painting.

● Make sure you are comfortable. Stand or sit up straight, or the *qi* will not go through your body to the paper.

● Prepare enough ink to complete the painting. Make sure the ink is dark enough from the outset.

● Use different brushes for color and pure inkwork.

● Load the brush with enough ink or color to complete the section you are working on.

● Dry your ink stick after use and store it in a dark place.

DON'T

● Eat too much before painting, or paint when you are agitated.

● Sit down to do a large painting, or stand to do fine work.

● Wash the brush too often, so losing valuable brushstroke quality and tone changes.

● Try to paint with a drawing brush, or vice versa, use small brushes for a large painting.

● Keep dipping your brush into the ink and water. Use what is on the brush before you reload.

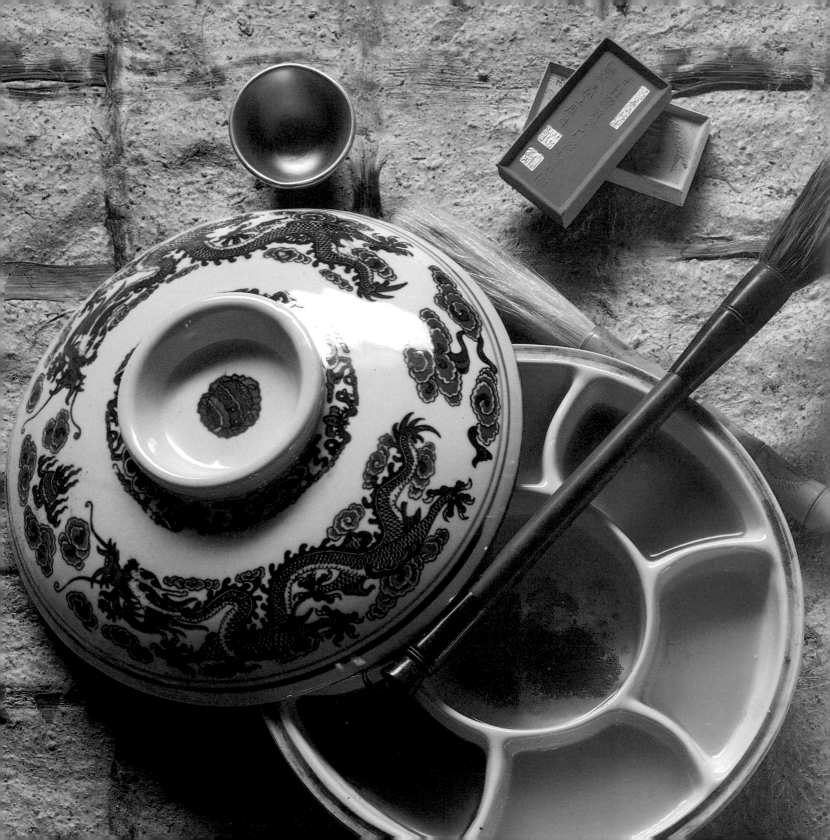

SECTION I

GETTING STARTED

This section introduces the essentials of traditional Chinese painting. The materials are few but special. As soon as you begin to manipulate the brush, you will find it a pleasurable activity. Practicing calligraphy strokes will help you become acquainted with inkwork and the concept of qi (spirit).

MATERIALS

An artist with many different pieces of equipment. The arrangement, on a large, flat surface, is important for ease of working.

The materials of Chinese painting are unique. A great deal of the charm of Chinese art relies on their singular properties, so try to use authentic materials from the start, following the guidelines given here and choose the best quality you can afford. Materials carried by stores that sell decorative items from China are often of inferior quality and therefore unsuitable. Try to buy from a reputable supplier. Be careful not to purchase Japanese brushes, which are often different. As with most things Chinese, the materials used for painting and calligraphy have a significance beyond their immediate practical purpose. The basic requirements are known as the "Four Treasures of Study:" paper (*zhi*), brushes (*bi*), ink sticks (*mo*), and ink stones (*yan*).

● ● ● ●

ADDITIONAL EQUIPMENT

In addition to the "Four Treasures" you will need the following:

● A large, flat, horizontal surface on which to paint.

● A clean blanket or thick felt to absorb the excess water that often seeps through the paper.

● Weights to hold down the paper; these could be pebbles or coins.

● Two large containers for water: one for washing brushes; the other for taking up clean water.

● Two large, plain ceramic plates with no ridges, for mixing the ink and colors.

● A rag for removing excess water, ink, and color from the brush.

THE FOUR TREASURES

Paper (*zhi*)

The most common paper for calligraphy and painting is *xuan*. This is commonly referred to as rice paper, but in fact is largely made from bamboo pulp. It is white and soft, and comes in various qualities and thicknesses. Some are sized with an alum and glue preparation, which makes the ink or color simpler to control. We advise that you begin by using grass paper, which is inexpensive and easy to work on. As soon as you have some experience of the properties of the brushes and ink, move on to an unsized *xuan*. The quicker you become familiar with it, the more authentic your painting will be. You should note that *xuan* was used for almost all example work in this book, even when paper type does not appear in a materials list.

● ● ● ●

PAPERS SUITABLE FOR PAINTING:

1	*pi zhi*	very thin rice
2	*te jing pi*	best-quality rice
3	*dan xuan*	single unsized *xuan*
4	*jian qian zhi*	semi-sized with gold leaf flakes
5	*jian qian zhi*	same as **4** but a different color
6	*yuan shu zhi*	grass paper

STICKS AND STONES

● These ink sticks, decorated with calligraphy and scenes in gold leaf, are works of art in themselves, and are valuable collector's items. A plain ink stick is satisfactory for practical purposes.

● Many ink stones are carved to resemble miniature landscapes, or embellished with images of gods and fantastical beasts. Some have a small well in which the prepared ink accumulates.
● Always dry your ink after use. If you leave it lying on the stone, it will form an immovable bond.

Brushes (*bi*)

The brush is the single most important tool of the Chinese painter, because all of the techniques depend on brushwork. Brushes are made from a wide variety of animal hairs. They fall into three basic categories: soft, such as goat- or sheep-hair, used for coloring and washes; hard, such as wolf-hair, used for drawing; and a mixture of the two, with a hard core and a softer outside. There are at least 200 different kinds. The selection of brushes is largely a matter of personal preference. Some professional artists use one brush for all purposes; some use a variety. If you look after your Chinese brushes, they will last a long time. Artists often exploit the irregularities of a well-worn brush in free brush painting, but for fine brush work, they prefer to use a new brush to perfect the details.

Ink sticks (*mo*)

Ink sticks are made of soots from materials such as burned pine wood or lampblack. These are pounded together with glue and camphor and placed in molds to form a solid block. The stick is rubbed on a special stone, with a little water, to make the ink. There are many types of ink stick. When you hold the best ones up to the light they will reflect a bluish sheen. If they appear red or gray in tone, they are of poor quality. A good ink stick will last a long time, and improve with keeping. Bottled ink is also available, and is suitable for practice, but rubbing your own ink is essential for the serious painter.

Ink stones (*yan*)

The *duan* stones from Mount Fuke in the Guangdong province of southern China are the most famous. Two other good stones are called *Sho* and *Tao*. The stone must be hard, non-porous, and have a fine grain, without being too smooth. Choose a round one, about 5 in (12 cm) in diameter. It must have a cover to keep the ink in good condition while in use.

SEALS AND SEAL PASTE

After you have been painting in the Chinese way for a short while, you will want to own some seals. These are used to sign your name or add a poetic idea or dedication to enhance the meaning of the image.
● Seals are made in a wide variety of hard materials that can support fine carving techniques. They are imprinted with a bright red paste derived from the mineral known as cinnabar.
● Artists' seals are different from those you can buy on every street corner in China. Painting seals have to be specially carved by an expert. See lesson two for suggestions about suitable messages.

1

2

3

1 Cock's tail
2 Sheep-hair (washing)
3 Special Large Sheep (calligraphy)
4 Extra hard mixed hairs (e.g. badger and wolf)
5 XXL Sheep
6 XL Sheep
7 L Sheep
8 Long mixed hair (sheep and wolf)
9 Medium Sheep (washing)
10 Medium Sheep (washing)
11 Sheep (drawing)
12 "White Cloud" mixed-hair (washing)
13 "Dragon's Beard" (very hard mixed hair)
14 Mountain Cat
15 "Jade Bamboo" (hard mixed hair)
16 Large Badger (hard)
17 Medium Badger
18 Small Badger
19 "Orchid and Bamboo" (wolf)
20 "Plum Blossom" (wolf–drawing)
21 Small Wolf (drawing)
22 Small Wolf (painting)
23 Small Wolf (calligraphy)
24 Fine Wolf (drawing)
● The five brushes in **bold** type are most suitable for the beginner.

When you buy the brushes, the hairs will be hard, due to the glue with which they are stiffened for shipment. Soften them ready for use by soaking them in cold water for about 25 minutes. Do not replace the brush in its plastic cap after softening or you will damage the bristle. Always dry your brushes horizontally before putting them away. They are often kept in a rolled-up mat for protection. Never store them in an unventilated container.

CHOOSING A GOOD BRUSH

A good brush should be:
● Strong yet flexible, with a feeling of springiness.
● The hairs near the shaft should be well-rounded but come to a fine point.
● They must be firmly anchored in the shaft, which is usually made of bamboo.
● All good brushes have their names inscribed on the shaft.

THE TRADITIONAL COLORS

You need:
indigo; earth brown; three or four reds, in varying tones from cold to warm; a green, made from copper crystals; a blue, made from cobalt crystals; white; and rattan yellow. The yellow is used in little chunks of resin. CAUTION: IT IS EXTREMELY POISONOUS!
● You will also need deer's horn glue.

24 23 22 21 20 19 18 17 16 15

4

5

6

7

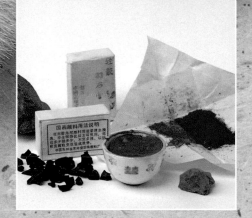

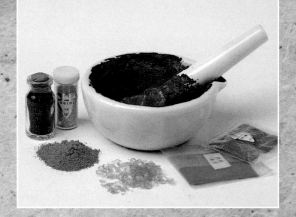

The three forms of color – tubes, chips, and powder – are made from the same basic ingredients. It is the pigments that give traditional painting its character; they come from vegetable or mineral sources.

Chips are small shavings of pigment combined with glue. They need to be mixed with warm water and last well if stored in a lidded container. Professional artists favor powdered pigments, but these require complicated mixing with the correct amount of glue.

14

13

12

11

10

9

8

THE INFLUENCE OF CALLIGRAPHY

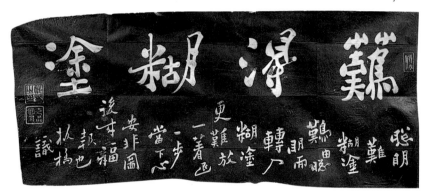

Many Chinese artists are also well-known calligraphers. This calligraphy passage in li shu *style, by the famous Qing dynasty artist* **Zhong Ban Qiao,** *shows strength and artistic balance in the brushstrokes.*

MATERIALS FOR THE LESSON

BRUSHES
Orchid and Bamboo (19)

COLOR
Ink

WHY PRACTICE CALLIGRAPHY?

● Calligraphy and painting are both art forms and have similar objectives.

● When you concentrate on calligraphy, your mind is concerned only with the execution of the brushstroke, and not with extraneous matters, such as color and composition.

● You will need to write simple characters on your paintings to make them complete.

If you have been enchanted by the magic of traditional Chinese painting, you probably want to begin producing your own pictures as soon as possible. However, there are certain fundamental techniques to master first. These are mainly based on the ability to use the special Chinese brush. The best way to learn this is to practice some Chinese calligraphy.

Traditional Chinese painting and calligraphy have their roots in the pictorial representations of objects that were first incised onto bone, shell, and bronze. As the need for increasingly complicated modes of expression developed, the symbols could no longer be related to objects, and purely abstract forms were introduced. The farther calligraphy evolved from the representational, the more artistic it became in its own right. However, the close connection between calligraphy and painting persists. The twin arts share the same basic materials of brush, paper, and ink, and the skillful use of the brush is the dominant force through which expression is obtained. A connection is also maintained through the calligraphic inscriptions that are an essential part of many paintings.

THE AIMS OF THE LESSON

How to hold and control the brush

Learning the basic brushstrokes of Chinese painting

STUDIES AND SKETCHES

The first and most important lesson is how to hold the brush (see right). This may feel difficult at first, but it is essential to practice until it is comfortable, because you cannot do Chinese painting without the correct finger positions.

Begin with your elbow resting lightly on the table. This will give you the greatest control in the early stages. When you can do this with ease, lift your elbow and use your entire lower arm. Finally, try to paint standing up. Note that fine brush painting and fine calligraphy are done with the elbow on the table. Cao shu and full free brush painting must be done standing.

Practice the basic painting strokes shown on the next page, and in the "fall" example, until you can do them accurately from memory.

HOLDING THE BRUSH

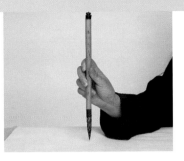

▲1

Hold the shaft of the brush between the thumb and the first and middle fingers. Tuck the fourth and fifth fingers neatly in behind. The palm of the hand should form a hollow in which you could hold an egg. Begin by sitting with the elbow resting on the table and the wrist cocked. Hold the brush halfway up the shaft and at right angles to the table.

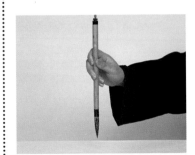

▲2

The hold is always the same, whatever the size of brush. What can be varied is the place where you hold the shaft, and the position of your arm. The artist is still sitting, but the fingers are slightly higher up the shaft and the arm is off the table.

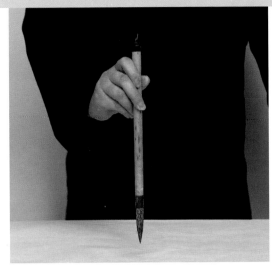

▲3

The maximum freedom is gained when you are standing up. Then you can use the entire arm from the shoulder and will be in the best position to execute wrist and elbow maneuvers (see lessons five and eight.) The brush is held near the end of the shaft.

• • • •

The character *niao* for "bird" shows the five main stages in the evolution of calligraphy from representational to increasingly complex and more artistic forms. In the *jia gu* (bone inscription), we can clearly see the body, wings, and feet, followed by a reduction to more simple lines in the *zhuan* (seal script). The *li shu* (official script) is one of the first to be written with a brush on paper. It was the form originally developed as an artistic medium by the great calligraphers. The *kai shu* (regular script) was a simplified form of *li shu*. It is the best one for learning Chinese writing. In the most artistic style, *cao shu*, the form of the bird is almost lost.

DEVELOPMENT OF A CHARACTER THROUGH THE DYNASTIES

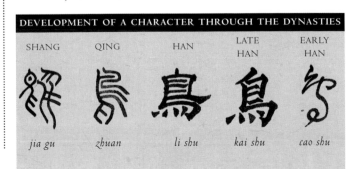

SHANG	QING	HAN	LATE HAN	EARLY HAN
jia gu	*zhuan*	*li shu*	*kai shu*	*cao shu*

BASIC STROKE PRINCIPLES

Three forms of calligraphy will help you practice your painting strokes. These examples all use the character an, meaning "peace." Practice them in the order shown, on newsprint or grass paper.

 1

Copy this *zhuan shu* character to learn the most common drawing stroke: the "center brush." Hold the shaft at right angles to the paper, and keep the tip in the center of the stroke. The stroke width should be constant throughout. The center brush is fundamental to calligraphy and painting. Performing it correctly will give you control of the brush.

 2

Chinese characters are based on a uniform structural size, however many strokes they contain. This gives them a balance, proportion, and elegance that is especially noticeable in the *kai shu* form. It is also done with a center brush, but involves changes of movement, thick and thin strokes, and careful structuring. This is the most useful style for learning the full range of basic strokes, and the "fall" example (right) gives you detailed instructions for it.

 3

The flexibility of the brush is most fully exploited in the exuberant *cao shu* style. This is based on a *zhuanbi* "turning brush" in which the angle and direction constantly change in a continuous flowing movement. When the angle of the brush to the paper is at its lowest extreme, it is known as *cefeng* "side brush," and *cao shu* needs both center and side brush techniques.

FALL (AUTUMN)

This project, in the *kai shu* style, is based on the character for fall. It will give you a good foundation for all future painting, because it incorporates all the main painting strokes, showing you brush movement, pressure, and control.

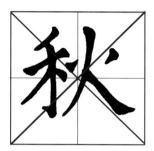

Cut a piece of grass paper or newsprint into a 4-in (10-cm) square. Trace the pattern shown here in red. The aim is to achieve a balanced structure with the parts equally disposed about horizontal and vertical axes.

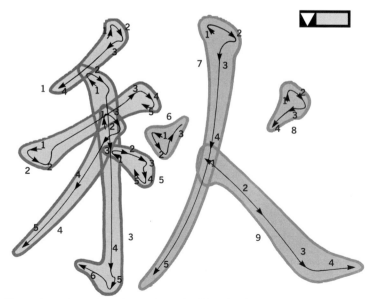

The red numbers show the stroke order. The classic way to write is from top to bottom, and from left to right. It is important to follow this order exactly. Inside each stroke outline, blue numbers and arrows indicate the direction of the stroke. This diagram should be read in conjunction with the step-by-step photographs that follow.

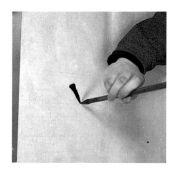

1

Begin at **1**, moving toward the top of the stroke. **2** Press down, coming back on the stroke. **3** Continue in a straight line. **4** Gently lift the brush off the paper.

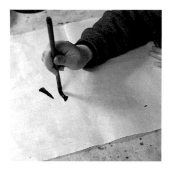

2

1 Tuck the end in. **2** Push hard down, then straighten the brush. **3** Gently release the pressure. **4** Push down gently and tuck the end in to finish.

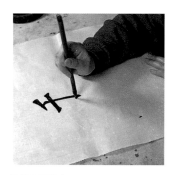

3

1 and **2** Tuck the end in. **3** Make a strong, straight stroke, pushing down hard at the end. **4**, **5**, and **6** Gently curve to the right, then go back on yourself, lifting up to the point of the brush at the end.

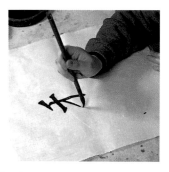

4

The stroke comes to a very fine point.

5&6

These two are dots. They are similar in execution, but follow a different direction of movement (see diagram.)

An important feature of many strokes in both calligraphy and painting is known as "tucking the end in." This involves starting the stroke by going a little way in the opposite direction to the one where you want the stroke to go. It gives a good solid shape to the stroke beginning. This may also be done at the end of a stroke.

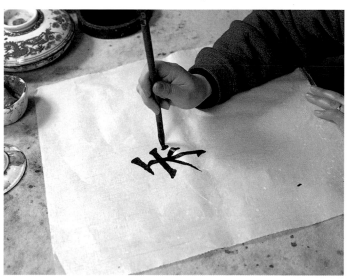

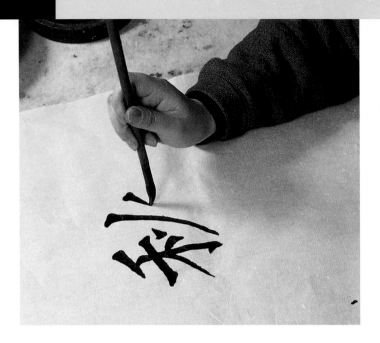

◀ **7&8**

Stroke 7: 1 and **2** Tuck the end in. **3, 4,** and **5** Make a strong controlled stroke lifting at the end.
Stroke 8 is a dot, starting from the same angle as stroke **7**.

FURTHER EXAMPLES

In China, calligraphy has always been highly esteemed for its own sake, as well as being a practical means of expression. Fine examples by old and contemporary masters are collected as enthusiastically as paintings. As you look at these additional examples, bear in mind that the structure of a character involves an interplay between its parts, and each character has a dynamic flow of energy underlying its direction that must not be interrupted. Similarly, in a passage of calligraphy, each character is related to the others.

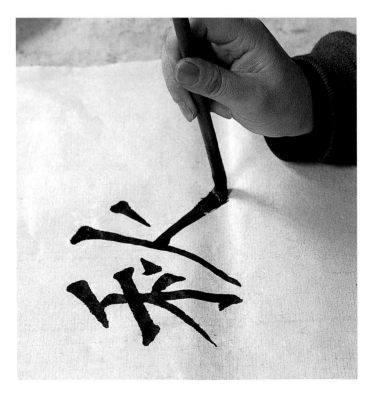

◀ **9**

The final stroke is one of the most difficult. **1** start by tucking in the end. **2** Press down firmly in the direction of the arrow. **3** Increase the pressure and change slightly to a side brush. **4** Lift gently.

Many ordinary people in China enjoy practicing calligraphy as a hobby. Stone rubbings like these, from ancient monuments and books of reproductions serve as examples.

Bringing News of Spring by another well-known painter, **Cheng Shi Fa**, is in a more personal style, based on *li shu*. In places, the brush became very dry and left the paper exposed. This is considered a most desirable effect, because the energy continues across the gap and suggests great vitality. It is known as *fei bai* (flashing white.)

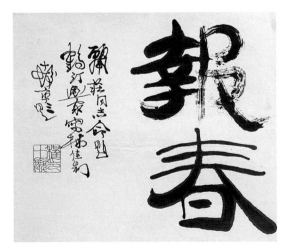

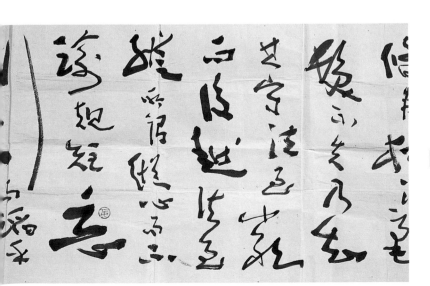

This fine *cao shu* work is by **Fei Xin Wo**. The *cao shu* style is sometimes called 'one brushstroke' calligraphy because the flow of energy (or *qi*) is continuous, even when the stroke temporarily leaves the page. The movement resembles those used in *Tai Ji* exercises (see p.34).

INSCRIPTIONS AND SEALS

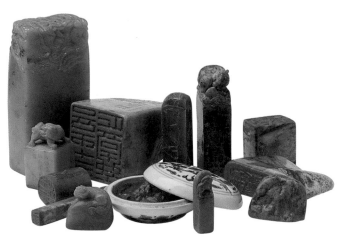

Practice impressing your seal on some spare rice paper before putting it on your painting. First check that your cinnabar paste is smooth and not oily. If it is, stir it with a spatula. Since the rice paper is very thin, you must put a wad of paper, or other soft material, under the place you want to imprint; the larger the seal, the thicker the wad should be. Make sure that the seal is the correct way up. Many a good painting has been ruined by applying the seal upside-down. Press the seal straight down into the paste, so that it covers the entire surface. Then press firmly down onto the paper, supporting the seal with the other hand. Lift the seal up and away from the paper. Do not rock the seal while it is on the paper as it will smudge the imprint.

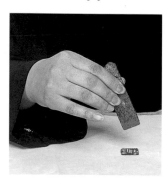

The inscriptions and seals on traditional Chinese painting are often necessary to complete the meaning and composition. You therefore need to learn enough calligraphy to be able to write your name in Chinese characters at least. Whether you need to know more depends on the circumstances. Any inscription must be appropriate; you might write that the painting was done in spring, or "when the leaves fall," for example. Throughout the book, you will find examples of Chinese characters that you can use on your paintings. The calligraphy should support the meaning, the composition, and also the style of the picture. As a general rule, you should use *cao shu* on a freestyle painting, while a more careful work will need *kai shu*. Another rule of thumb is: the less color in a painting, the more calligraphy.

You may lack the confidence to put inscriptions on your paintings at first, but seals are essential in free brush painting, to balance the composition. Seals are traditionally imprinted with red cinnabar paste, and must be used with discretion if the color is not to dominate. There are two styles: *yin*, where the characters are incised into the stone; and *yang*, where the characters stand out in relief.

STUDIES AND SKETCHES

Plan where you will put the calligraphy and seals before you begin painting. Study the suggestions in this lesson, and as you progress through the book, notice how artists use calligraphy and seals to support the image.

(BELOW) Examples of the use of inscriptions in composition:
1 The comparative fragility of the lotus stalks is supported by the strength of the calligraphy.
2 The inscription blocks off the corner, so that the movement does not escape.

In this way, the energy is redirected into the painting and a connection is made between the separate parts.
3 The calligraphy breaks up the empty space and balances the mass of rocks.
4 The inscription follows the movement of the mountains and improves the white space, which would be too long.
5 The two parts are linked by the calligraphy, which also forms a barrier through which the energy cannot escape.

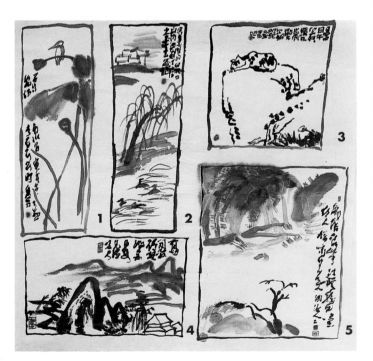

NAME SEALS

We suggest that you need a minimum of four seals for inclusion in your paintings: one free (see page 24) and three name seals (two medium and one small). The examples here will guide you. Beware of the eye-catching color of seals, and remember that *yin* characters imprint with more red than *yang*. Use seals like spices – to add piquancy and interest.

YIN AND YANG SEALS

These large seals show the difference between *yin* and *yang* cutting.
Their meanings are:
(LEFT) *Ba Da Shan Ren* (*yin*)
(RIGHT) House of *Tang Hua* (*yang*)

1 **2**

3 **4**

5

These are free *xian zhang* seals. Their meanings are:

1 The view on this side is better
2 Art comes from study
3 Yellow Mountain pine tree
4 New ideas are better
5 Fascinating landscape

Examples of where to place seals and calligraphy:

1 Greeting each other (name and free seals).
2 Value the empty space (two name seals, one free).
3 Signature away from seal to make it interesting.
4 Judicious placing to support the composition.
5 Seals greeting each other. (Do not put on same level.)
6 Greeting from top and bottom. (Do not put on same line, e.g. through the triangle formed by the man's shoulder.)
7 A subject such as bamboo needs more seals on one painting. The seals are like notes in music, with different emphases: large and small; loud and soft.
8 If there is only one seal, do not put it right at the bottom. Leave room for the composition to breathe.

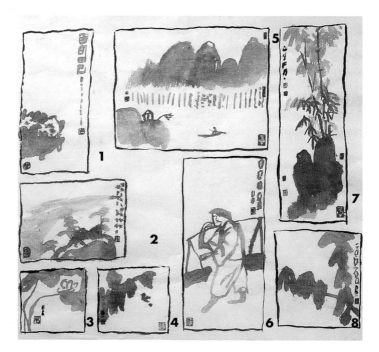

FURTHER EXAMPLES

Generally speaking, images and words are more integrated in Chinese thought than in the West, due to the symbolic basis of the written language. As far back as the Bronze Age, patterns and dedications were put onto artifacts and buildings. Later, similar inscriptions were added to paintings, and the patterns provided a model for the seals. Here are some more examples of the mutual enhancement achieved by the harmonious combination of image, inscription, and seal.

● ● ● ●

Seals fall into three basic categories. First are name seals, which can consist of a family name, given name, or *hao* (painting name). They are usually done in formal script on square or regularly shaped stones. Second are seals bearing phrases or sayings (see far left). These are known as *xian zhang*. They are done in a free style on irregularly shaped stones, and are usually placed in one or more corners of the painting. Third are the seals of collectors, which are usually small.

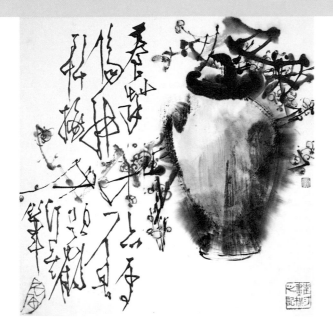

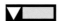

After the Rain by **Zhang Li Chen** is an exciting blend of calligraphy, seals, and painting. The calligraphic inkwork of the lotus, and the reiteration of the seals' redness by the flowerheads, show harmonious cooperation. The composition is balanced by the calligraphy coming from the top right. The two seals at bottom right, and the smaller ones dropping from the calligraphy, subtly indicate the division of the white space.

In **Plum Blossom in an Old Vase**, the painting is by **Cai He Ding** and the calligraphy by **Shi Lu**. It became a fashion for artist friends to show their appreciation of each other's work by doing joint paintings. This requires mutual understanding and a common intent. Here, calligraphy is integrated with the image of the painting; its structure helps support the flowers. Each benefits the other.

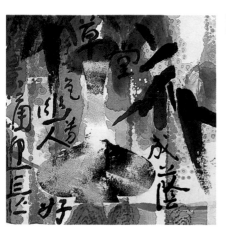

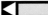

Ancient Vase by **Wang Jia Nan** uses calligraphy in the background as a contrast to the image. Hints of bamboo and ancient seals serve to evoke thoughts of times long gone.

THE IMPORTANCE OF INK

You might ask why the Chinese favor using black ink on white paper so much. The reason is that this combination provides the utmost contrast in the simplest possible way. It is thought unnecessary to crowd a page with colors when seeking to suggest the highest spiritual and harmonious ideals.

We already saw the importance of good, strong brushstrokes in calligraphy, and these depend absolutely on the correct use of ink. Brushstrokes and ink control are inextricably related, and we advise you to spend as much time as possible perfecting these two skills. You will then be ready to put the highest expression into your painting. The secret of using ink lies in knowing just how much water and ink to put on the brush. This will, of course, differ with the size of the brush and absorbency of the paper. It is something you can only learn with practice and with patience.

Ink in Chinese painting is therefore more than just black. It is complete in itself, and contains the property of suggesting every color, because it offers the possibility of so many amazing changes. It is not a negative black, but a concentration of all the colors and tones of the natural world. It is all the gradations between the palest gray and deepest black. For the Chinese, the successful transference of these tones onto paper is an inherently satisfying experience in

INK PEONY

by *Zhang Zi Xiang* (*Early Qing dynasty*)

Look at how many effects the artist obtained using only the brush and ink. All stages are found on the flowerhead, from the transparent delicacy of the outer petals, through the controlled flow of dark into light ink on the inner petals, to the deep intensity of the stamens. The beauty of the painting is such that you do not miss the use of color.

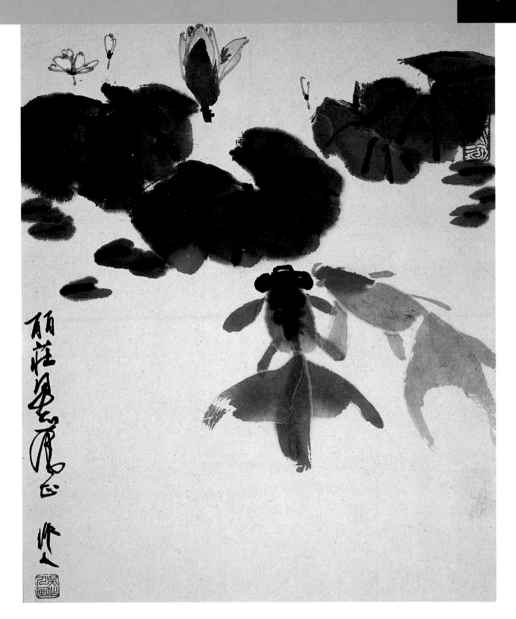

itself. It is important to keep this fundamental attitude toward inkwork in mind as you approach the many forms of painting that recur throughout the book.

Ink is the essence of the beauty of traditional Chinese painting. With ink alone, you can show the perfect brushstroke, the energy of movement, and the emotion within you. There is nothing finer than the rich effect of Chinese ink on white paper. It must be Chinese ink, because it is made in a special way; no other ink, or even black watercolor, will create the same effect. Learning to write with a brush enables the Chinese to absorb this feeling for the ink on rice paper from an early age. Practicing calligraphy, as explained in lesson one, will help you to do the same.

GOLDEN FISH

by *Wu Zhe Ren*

This picture shows the perfect use of varied brushstrokes allied to the complete control of ink flow. The flowerhead rises proudly from the density of the lotus leaves, like a beacon in the darkest part of the painting. The fish, in contrast, are almost translucent, and the different brushstrokes used to paint their fins give the impression of movement.

MIXING INKS AND WATER

Ink in Chinese painting ranges through every tone from palest gray to deepest black, depending on how much water and ink you put on the brush.

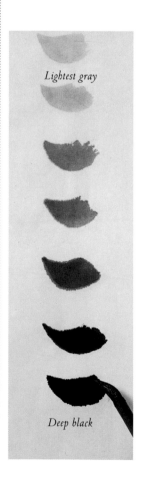

Lightest gray

Deep black

Another reason for choosing only black ink and white paper is that they symbolize purity. If you want to feel the *Dao* of Chinese painting, the first step is to learn how to use ink. For some paintings, you begin with light ink and gradually put in the darker elements. One advantage of this method is that you can add the darker ink while the lighter parts are still wet, causing it to flow and give interesting effects. This technique creates a warm, soft feeling. For other paintings, you might prefer to start with dark ink, but you will not be able to work on top of it. If you did, you would make the dark ink gray, and kill its spirit, or *qi* (see information feature three). As soon as you put the ink on the paper, most of the energy you are transferring to it becomes fixed there.

Generally speaking, building up from light to dark is more suitable for Landscape painting, whereas in Flower and Bird painting, where you want to focus on certain points, you begin with dark ink and introduce the lighter elements in relation to it. There are no hard and fast rules. It depends upon the subject. You should, however, try to differentiate your brushstrokes. Concentrate on creating balance and contrast between light and dark, wet and dry, hard and soft, and so on. Most important of all, before you start work, is to have in your mind and heart: use of ink, brushstrokes, and order of painting.

To summarize, the essence of a Chinese painting lies in the contrast between the deepest black of the ink and the brilliant whiteness of the rice paper. The other strokes will range in tone between these two extremes. Do not be tempted to overdo the blackest parts or they will lose importance. Your aim should be to convey the feeling of immediacy and freshness. If you do it well, the ink will retain the appearance of being wet even when it has dried. We call this impression "the spirit of the ink," or *qi.*

TONES

If you are doing a large painting, the brushstrokes are usually strong, short, and very black, since the effect needs to tell from a distance. For small and fine paintings, a lighter shade is more usual. The key to both methods is the skillful manipulation of the ink.

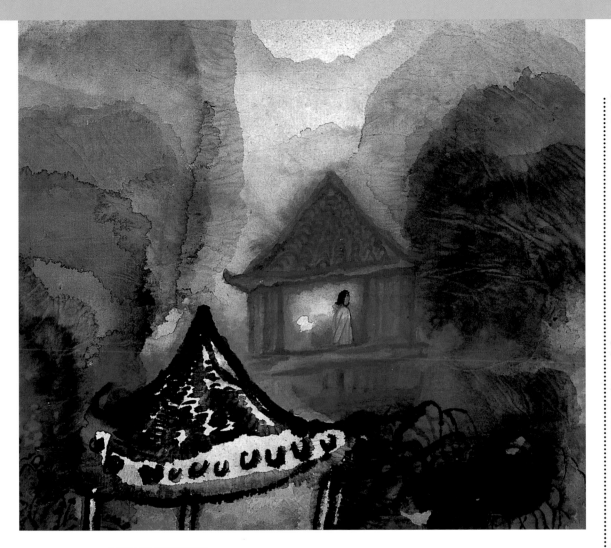

LOST IN THOUGHT

by Wang Jia Nan

The same brush and ink principles hold true in this
modern painting. It relies on the subtlety of the ink
tones to suggest a remote mountain region, where the
scholar may contemplate the beauties of nature without
interruption. The little color is subjugated to the inkwork
and serves to reinforce it. Notice that the pavilion in the
foreground is painted with the darkest tones.

GETTING USED TO INK

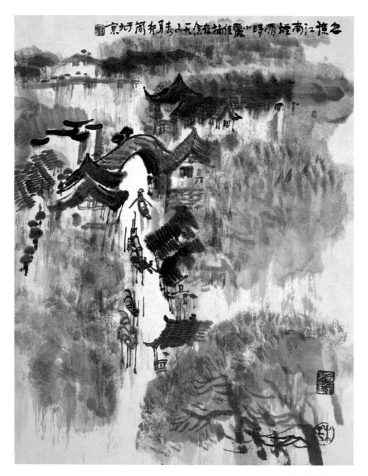

RIVER SCENE

by Li Xin Jian

Using various tones of ink and purposeful brushstrokes the artist has focused on what was exciting, and abstracting essential details to arouse the senses.

The main technical problem of Chinese painting is how to load the brush with ink. This may seem a simple matter, but the mastery of brush and ink combined lies at the heart of Chinese painting. So we cannot over-emphasize the importance of getting used to ink by thoroughly practicing the skills shown in this lesson before moving on. When we talk about ink, we include color, but you should practice with ink alone, because it enables you to see the tones, the pressure, and the stroke shapes more easily. If you can do it well in ink, you can do it well in color. The two are so closely integrated that since the 11th century, Chinese painting has been known as "ink painting," even when color was used.

INK TECHNIQUES: TONE, WATER, AND PRESSURE
We have already seen how ink painting means using all the tones from palest gray to intense black (see p.28). When loading your brush, you must also learn another spectrum: from very wet *po* to very dry *xi*. Finally, you have to feel how much pressure to apply for each stroke. This depends on how much ink and water is on the brush, how absorbent the paper is, and how much humidity there is in the atmosphere.

MORE BRUSH TECHNIQUES
In lesson one, you learned some basic brush techniques. The following are four more that constantly recur in Chinese painting. All four may be used

THE AIMS OF THE LESSON

How to rub good ink

How to transfer the drawing of a plant to an ink painting

Four new brush techniques

on one painting where necessary. As you work through the book you will become more aware of their usage.

GOU: drawing with a brush. The shape of the subject is defined by the line, which will vary from thin to thick and from dark to light through control of the brush and ink.

CUN: using a side brush stroke to add texture – to trees and rocks, for example.

DIAN: using dots. This technique is frequently applied to Flower and Bird, and Landscape painting, both to create effects and to highlight certain features.

RAN: painting with light ink or color, so that the brushstroke is barely discernible.

Ink techniques and the correct handling of brushstrokes are interdependent, and both must be practiced together.

STUDIES AND SKETCHES

The flexibility of the Chinese brush can give you a false sense of your ability to perform the strokes. Chinese painting is essentially based on line and not on form, even if this is not immediately obvious. Look carefully at the examples in this lesson to see what we mean.

Give yourself plenty of practice in getting the feel of the materials and the way in which they are used. Begin by copying the banana leaf examples (**Steps 1 and 2**). *Then adapt the principles to everything else you want to paint. Think of this maxim:*

**Look and draw;
remember and paint**

● ● ● ●

Ink sticks based on oil or lacquer soot have a warm (and therefore blacker) appearance on white rice paper that is preferable for Flower and Bird painting; those based on pine soot give a softer, colder effect more suitable for Landscape painting.

RUBBING INK

◄ 1

To make your own ink, rub the ink stick on the stone for about 20–25 minutes, always in the same circular direction. While you are rubbing, think about what you are going to paint, which brushstrokes you will use, and the overall composition. Then when the ink is ready, the energy will flow more easily from your heart to your brush. The rubbed ink should be of a thin, syrupy consistency.

▲ 2

As soon as you touch the paper, even with clean water, you will discover how absorbent it is. One of the secrets of Chinese painting is to know how much water to put on the brush. That is why plenty of practice is so important.

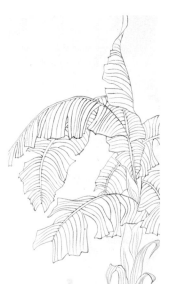

BANANA LEAF EXERCISE

◄ 1

Practice copying this brush drawing in ink of a banana leaf. Remember that although it is drawn from nature, you must use the rules of calligraphy (see lesson one) to delineate it, making a proper start and finish to each brushstroke, with turning techniques in-between.

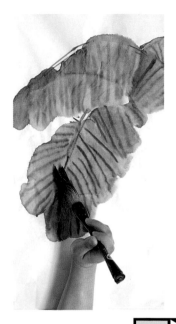

◀ 2

This picture shows how the drawing of the natural plant can be converted into an ink painting, using similar brushstrokes. Remember the line taken by the brush in **Step 1** and imitate the movement with a broader brush here.

▶

Little Chick Lost by **Cai Xiaoli** is an example of how well this method transfers to a finished painting, giving it the maximum liveliness with the minimum of strokes. But you can only do this if you have a detailed knowledge of the subject in your mind.

••••

It is important to make the right amount of ink each morning for the paintings you intend to do that day, because freshly made ink will appear more dynamic.

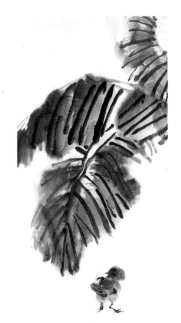

EXCITING

(cao shu)

The finished paintings on these pages illustrate some of the many different ways in which the ink and brush techniques described in this lesson can be applied. They show how the nuances of ink, sometimes with the subtlest touch of color, can conjure a whole gamut of expression in subjects ranging from banana leaves and birds to highly contrasting landscapes — from life and from memory.

••••

After perfecting brush manipulation, you must practice the different degrees of ink saturation, because without the various tones and effects, your painting will be lifeless. Retouching is, however, possible in certain circumstances which is explained in later lessons.

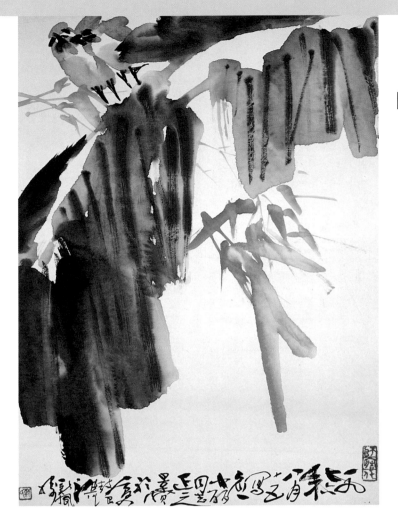

Birds in a Banana Tree by **Zhang Jing Xian** is a fine *xiao pin* painting (information feature four), with splendid control of ink, water, and brush. The placing of the calligraphy along the bottom suggests uneven ground. This may appear merely capricious, but it was deliberately positioned to balance the composition. Without the calligraphy and the seal, the image would be too heavy on the left-hand side.

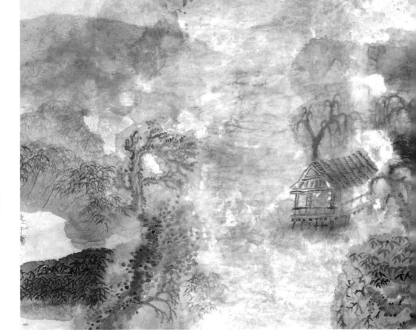

The Old Cottage by **Wang Jia Nan** is a rain picture, like the one on p.30 by **Li Xin Jian**, but with an entirely different, sad and lonely feeling. It is based not on an actual scene but on recollections of times past. Here, the greatest nuances of ink differentiation are augmented by the subtlest use of color. The artist exploited every variation of brushstroke, from the wettest *pe* to the driest *xi*, from the linear *cun* to the evanescent *ran*.

WHAT IS QI?

THE SPIRIT OF *QI*

The concept of *qi* is important in painting and in life. There are many ways of looking at it, and we shall concentrate on three: the *qi* in the human body, the *qi* in nature, and the *qi* in Chinese painting. The Chinese character for *qi* means "steam" or "air," which explains why you cannot see it or touch it. It is a sort of unseen, moving energy. We can only give a few examples here, which we hope will help you when looking at Chinese paintings and be the basis for continued reading in background books.

Many Chinese believe that *qi* enters your body when you take your first breath. The air you inhale nourishes your vital organs, along with the food you eat. This *qi* is considered to be a life-giving channel in the body, just as much as the arteries or blood vessels. The *qi* is concentrated in certain nodal parts of the body. In order to use this energy you must focus on them, and develop their potential. One way of doing this is through exercises that help to push the energy around your body and to clear channels that may have become blocked. In addition to physical health, this *qi* is thought to be linked to our mental and moral well-being. Once the *qi* energy is under control, it can be used to great physical effect.

The second *qi* is like the first, except that instead of being restricted to the human body, it permeates the whole of nature. People can identify with this greater energy force, because of their personal *qi*. Human behavior is closely linked to nature's appearance. So, when Chinese people go into the countryside to look at natural phenomena, they are not only admiring the scenery, but also hoping that they will absorb some of the strength of the mountain or the

Tai Ji Quan is a development of *Qigong* exercises that promote the circulation of *qi* around the body. If you practice it, you will get a good idea of how the movements of Chinese painting should be. In *Tai Ji* nothing is jerky; all is smooth. Every movement has a start, a development, a suspension, and a relaxation. It is like a Moebius strip: continuous, smooth, and yet always changing shape.

vitality of the waterfall. Traditional Chinese painting took on some of these ideas centuries ago. Paintings were a vehicle for conveying the metaphysics of nature through the images on the page. **Gu Kaizhi** (345–406), who was one of

the first to postulate theories about Chinese painting, said that "form exists in order to express spirit." If drawing with the brush is the skeleton, and ink and color work is the flesh, then the *qi* is the life force.

Good paintings always have this *qi*. It partly derives from the physical act of painting, but it is also transmitted through a mental image onto the painting, and thence to the viewer. We try to link the various parts of the painting by an unseen conduit of energy, which you can feel, but not precisely see. There are physical ways in which this can be made more explicit, such as using bridges over water, clouds between mountains, water courses from high peaks to low levels, and so on. Links can also be implied. For example, if there is a person in the picture looking at birds flying, the direction of the gaze must follow their line of flight or the *qi* will be broken. Chinese painters try to ensure that the energy is never static.

Another type of *qi* goes beyond the boundaries of the picture frame and back in again (see lesson five). This is why we often paint only part of a branch or tree. In such cases,

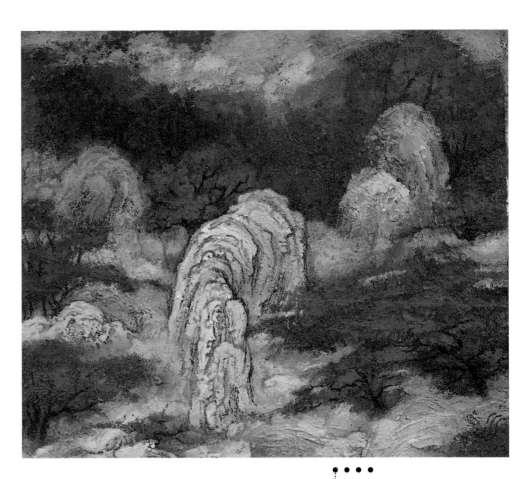

COLOR *QI* OF LANDSCAPE

by *Wang Jia Nan*

The moving energy of *qi* may be transmitted through the voids, through the solids, or even through the colors of a painting. If the line of energy is blocked, then the *qi* will be interrupted.

• • • •

There are many ways of thinking about the *qi* in a painting. An interesting concept is that the viewer is as much the recipient of it as the artist is the generator. One reason why so much emphasis is placed on looking at the works of old masters is the idea that you absorb the *qi* from them.

the energy goes out of the picture, linking the artist and viewer to the physical world beyond, and also attracts energy from that world into the painting. Just as in *Tai Ji* exercises people watching should be able to follow the patterns, see them begin, develop, reach a climax, and then subside into a resting position, before taking up a movement in another direction, so the viewer of a Chinese painting should be able to follow the movement, even when it goes out of the picture frame and returns; it is barely perceptible but undeniably there. It must be controlled and not dissipated.

We also use *qi* in combination with the idea of *yun* in Chinese painting. *Yun* means "charm" and "good taste and refinement in literary pursuits;" it refers to the style and atmosphere of a painting. In this case, the energy is charged up and bristling with a nervous excitement, which generates an atmosphere over and above what we see on the paper.

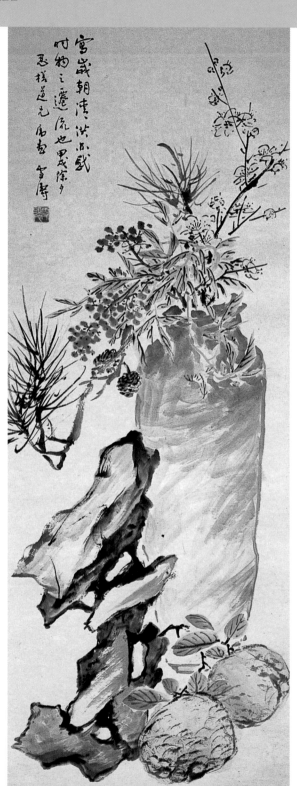

SCHOLAR QI

by *Wan Xue Tao* (1903–1984)

The union of *qi* and *yun* is often found in scholar paintings such as this. The combination of the pine, indicating longevity and solitude, with the plum blossom, standing for fortitude, plus berries and fruits – symbolic of the seasons to come – embody the most cherished ideals of the scholar.

How can the non-Chinese painter recognize and produce *qi*?

Divide your study time as follows: 40 percent reading background books; 30 percent practicing calligraphy, not only because this is the best way to train your brushstrokes, but also because you can feel the transference of energy as you make the strong and deliberate movements required; the remaining 30 percent should be devoted to the actual painting.

If you follow such a plan you will see an enormous improvement.

**FLYING
WATER**

THE SPIRIT OF PURITY

by *Wang Jia Nan* and *Cai Xiaoli*

Calligraphy is often a good starting point for gaining an understanding of the potential energy of *qi*, since the force rushes through the dynamic black lines, and crosses the divide between the flicks at the extremities of the strokes, like sparks across an arc gap.

SECTION 2

FLOWER AND BIRD PAINTING

Here we move from simple depictions of flowers and plants to compositions including rocks, birds, and animals. The philosophy behind the subjects is explained. By the end of this section, you will be able to produce your own Flower and Bird paintings.

SUBJECT MATTER

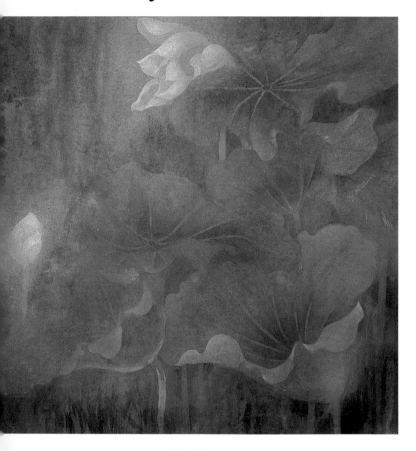

SUMMER LOTUS

by *Cai Xiaoli*

This fine brushwork painting shows the lotus in one season, but it is equally popular in its autumn, winter, and spring aspects. The lotus is admired for its purity and because it raises its beautiful flowerhead far above the murky waters in which it grows. It thus shows humble people how it is possible to succeed even when their beginnings are less than auspicious.

To reproduce the images of traditional Chinese painting, you need to know something of the ideas that lie behind them. A subject is always chosen for a reason, and the subject matter of Chinese art runs like a thread through all creative endeavors and into everyday life.

Traditional Chinese painting falls into two broad categories. The first comprises serious work for which the artist makes comprehensive preliminary drawings before composing a highly finished painting; it will probably have washes and details added after the main elements. The second category, which is known as *xiao pin* painting, is an important part of what you will learn in this book. *Xiao pin* literally means a "simple artistic creation." When applied to painting, it conjures up an image of the artist engaged in lighthearted ink play as the brush ceaselessly cavorts back and forth on the paper. That does not mean that it is a trivial exercise. Many of the greatest artists painted entirely in this manner, and *xiao pin* paintings are displayed in galleries just as much as "serious" paintings. But it does mean that you need to perfect the skills of handling the brush and ink before you begin, so that you can complete the painting with dexterity.

One of the main subject areas of traditional art is Flower and Bird painting. You may be surprised to find that animals are included under this heading. This is because every traditional subject has an inner meaning or extra connotation,

and birds and animals are often associated with particular plants to reinforce that idea.

This approach to painting was primarily developed by a small group of highly educated men who dominated artistic standards until the end of the 19th century. They were known as the "literati," but were renowned for their prowess in all of the arts. For the purposes of this book, we shall refer to them as the scholar-painters. The subjects they chose to paint are the foundation of traditional Chinese painting.

The most famous plants associated with the scholar-painters are the so-called "Four Gentlemen": Bamboo, Orchid, Chrysanthemum, and Plum Blossom. The title was given to the four plants because the

ORCHID LEAVES

by *Cai Xiaoli*

This highly wrought painting is a masterpiece of understatement. The orchid stands for perfection in womanhood, symbolizing humility and refinement. Here it is so self-effacing that only the leaves appear, but they are painted with such an interweaving and vitality against the silver background that you can hardly believe this is just a picture of leaves. The utter simplicity seems to make a statement of profound truth.

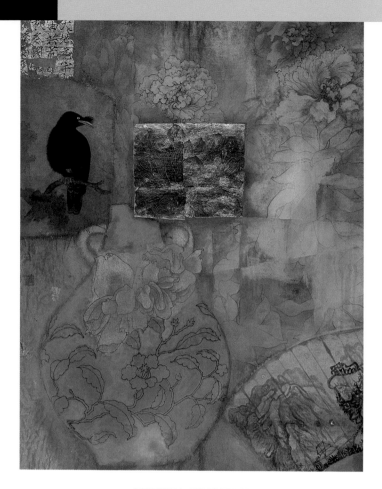

ORIENTAL ATMOSPHERE

by *Cai Xiaoli* and *Wang Jia Nan*

This picture juxtaposes subjects found in various kinds of Chinese painting. The black bird is in typical 12th-century court style. In the top left-hand corner, there is a poem; in the bottom right is a fan with a landscape of mountains and a temple. Most of the other symbols are of flowers: a lotus painted on the gold leaf, with a peony above, and a riot of other floral motifs.

scholar-painters found certain characteristics in their growth that they could identify with and respect.

When painting or looking at a Chinese painting, remember that all plants are symbolic. Such associations are frequently multilayered, especially when flowers and birds or animals are used in combination. These pages show just a few examples. Try to see the hidden meanings in other paintings throughout this book. And take note of those that interest you personally.

The Chinese empathy with nature goes beyond seeing living things as having certain human characteristics. There is a tendency toward personification of all natural objects, even inanimate ones, such as rocks. This is present in paintings on many levels. First it may simply be a matter of identifying with the attributes. The pine tree lives a long time and can endure the harshest of conditions. Therefore if you paint a pine tree, you may try to show it in a desolate location, using strong brushstrokes. Any colors will reinforce the impression of coldness.

Alternatively, birds and animals may be depicted with actual human characteristics, especially in humorous paintings. A bird, for example, may be painted as a thinking, sad, or angry man. The eyes and head are often painted oversize, which adds to the humanizing effect. This is one way in which artists can express their own feelings. Sometimes such paintings tell a story. A flock of birds playing on a rock or chasing each other through leaves are like children romping. Often the story will have a serious message: a large fish devouring small fish is symbolic of a rich man feeding on the poor.

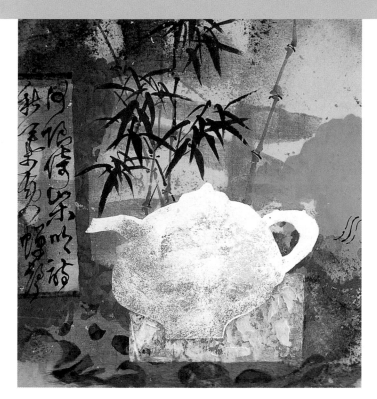

THE CHINESE TEAPOT

by *Wang Jia Nan*

This group brings together four objects associated with the scholar-painters: calligraphy, bamboo, rocks, and tea. We saw the importance of calligraphy in lesson one. Lessons four and nine will tell you more about bamboo and rocks. What place does tea have in this erudite lifestyle? Tea had long been associated with social rituals in China, but by the time the scholar-painters came to prominence it was regarded both as a connoisseur's hobby and as a suitable, mildly medicinal beverage for aesthetes.

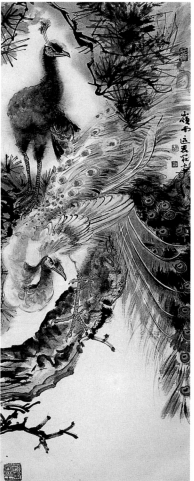

PEACOCKS IN A PINE TREE

by *Ou Li Zhuang*

The peacock is considered to bring good luck, and when coupled with a pine tree, which stands for a long life, it is especially fortunate. This is a typical example of a southern-style painting with a clever contrast of colors and patterns. The blue bird acts as a foil for its white companion, and the triangular shape formed by their soft tail feathers is echoed by the harder pine needles. Even the leafless branches seem to mirror the foot of the bird just above. The calligraphy is balanced by the seal in the bottom right corner.

• • • •

Many households and businesses have a painting of a tiger coming down a mountain to look for food, hoping that it will bring them luck (see the example **In the Moonlight** by **Feng Da Zhong** on p.100); if the tiger is shown going up the mountain, it indicates that the young people should get ready to fulfill their duties to society.

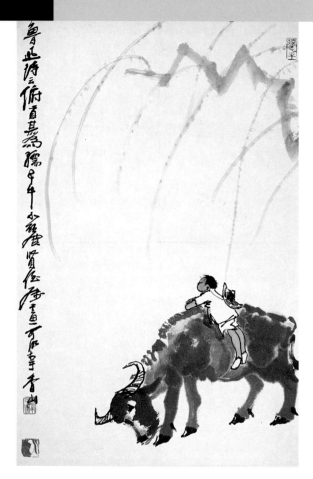

BOY WITH WATER BUFFALO

by *Li Keran* (1907–1989)

The water buffalo is so important as a working animal in rural communities that it is treated as a member of the family. In painting, it represents diligence and faithfulness. Artists often see themselves as hard-working buffalo. In this picture, by one of the most important 20th-century Chinese painters, it is paired with a willow tree, the Buddhist symbol of humility – an example of how animals have become associated with the general group of Flower and Bird painting.

MORNING GLORY

by *Qi Bai Shi* (1863–1957)

The basic principles of traditional Chinese painting have lasted into the 20th century, but in the hands of a master they are given a new vitality. This artist did not paint one of the scholar subjects but chose a flower associated with the ordinary people, especially in the countryside. The vine climbs a trellis which might be outside the humblest cottage but it is just as magnificent as any peony adorning a palace. The neat red trumpets stretching toward heaven are set off by the free brushwork of the leaves. The delicacy of the calligraphic vine is supported by the vine-like calligraphy tumbling down the right side of the paper. The ultimate touch is the dimunitive insect below.

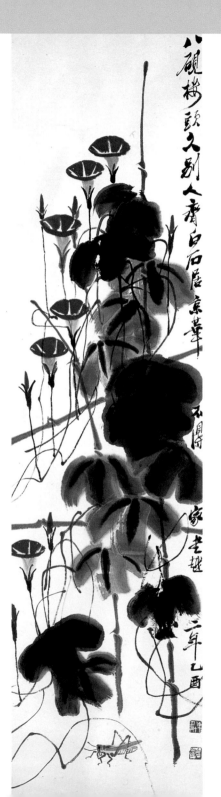

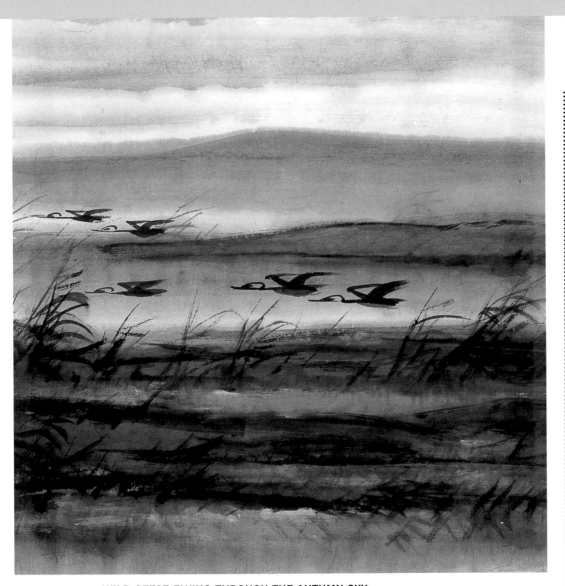

WILD GEESE FLYING THROUGH THE AUTUMN SKY

by *Lin Feng Mian*

The wild goose is often seen as representing a faraway loved-one, as in this painting by a leading 20th-century artist. To understand the sadness of the geese, look at how the artist depicted the bleak moonlit night and the watery marsh. It is not only the subject matter but the astringent strokes and restrained colors that bring out the intense urgency with which they fly toward their home. The speed of their flight is emphasized by the movement of the grass in front and the hills behind.

**WHEN THE WIND STOPS,
YOU SMELL THE FRAGRANCE
OF THE ORCHID**

BAMBOO

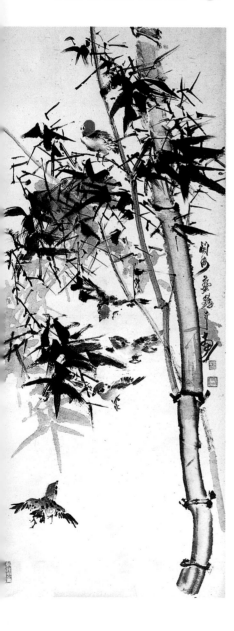

BAMBOO WITH BIRDS
*by Cai He Ding
(1909–76). This is a fine example of a bamboo painting. Notice how the artist set up contrasting movements between the birds and the branches. In particular, look at all the different angles and facets of the leaves.*

Bamboo has been a leading subject of Chinese painting for centuries, and it is also a good example of the way in which painting subjects are more than the representation of a visual or imaginary world. There are more than 280 different sorts of bamboo in China. It comes in a variety of colors, shapes, and sizes, and it flourishes in all types of soil. Its parts are used for building, utensils, papermaking, and eating. People also find its structure aesthetically and emotionally pleasing. Its growth habit is straight, strong, and vigorous, yet when it sways in the wind, it can seem yielding and compliant. It can withstand all weathers, from extreme heat to severe cold. It is easy to understand how ordinary people can identify with these qualities. The scholar-painters read even more in the bamboo. They saw that the Chinese character used for the joints of the bamboo, *jie*, was the same as that used for the principles of living a good life. In addition, the hollow branches reminded them that no matter how much you know, there is always room to absorb more.

From the East Han dynasty on, bamboo was depicted on all manner of surfaces, such as bronze, stone, and silk. But it was not until the invention of rice paper that its full potential as an expressive artistic subject was realized and "ink bamboo" became a favorite subject for artists.

For your first painting we have chosen a bamboo, because it uses all the techniques of brush-and-ink work that you have already learned.

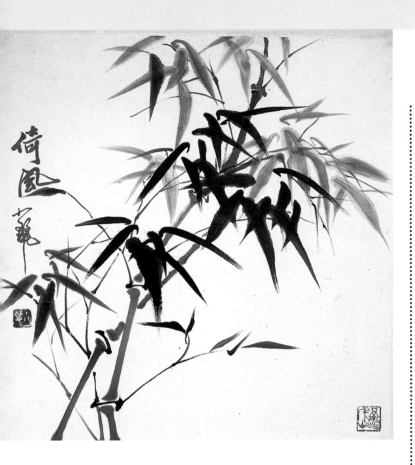

STUDIES AND SKETCHES

Before you begin the step-by-step you need to think about composition and so you must study the finished painting above first. The darkest elements must go at the front, and there must be plenty of differentiation in the inkwork. You must also set up the greatest contrast first: in this case the central group of leaves. Two other main points of composition to consider are movement and space. Look at the four corners of this painting and observe where the spaces are. The smallest space is at the bottom left corner, the largest at the top left. There is a small space at the top right, a larger space at the bottom right. This sets up an overall movement, flowing clockwise from left to right. The calligraphy reinforces this movement. The big seal in the bottom right corner balances the whole picture. It is also important to establish plenty of contrast between the canes and branches. Notice how they cross. There should be no parallels or equal spaces.

To paint the bamboo, refer back to the kai shu *calligraphy examples in lesson one. When you start each stroke, remember to tuck in the tip. As you continue the stroke, turn the brush and make a definite finish.*

This is an example of a different way of painting bamboo, using an XL Sheep-hair brush (6) for the cane. Because the cane dominates the composition, it was painted first.

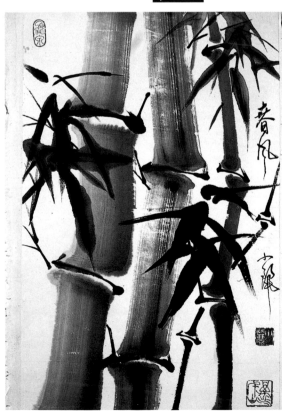

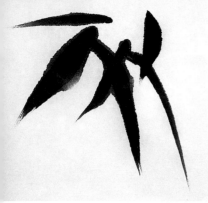

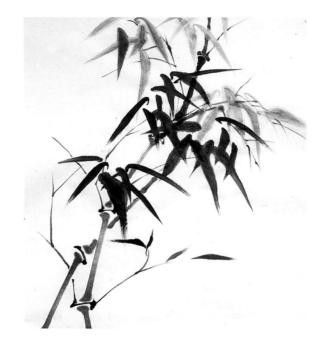

EVENING BREEZE

(slim golden)

 1

Load the Orchid and Bamboo brush (19) with clear water. Add light ink to the middle of the brush, then dip the tip in dark ink. Use up all this ink before reloading.
• Before applying your first stroke, look at **Step 2** to see where to place it. The positioning of these first leaves is very important.

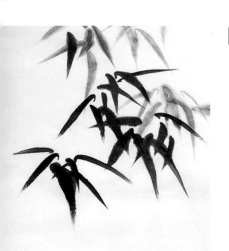

 2

Add a little water to the brush to paint the second and third groups of leaves behind.
• Set up a relationship between the three groups to ensure balance and diversity.

Put some water mixed with a little glue on your brush, and add some lighter leaf groups to the background before the first leaves are completely dry. Continue to balance the groups.

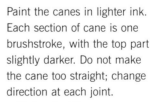 **3**

Paint the canes in lighter ink. Each section of cane is one brushstroke, with the top part slightly darker. Do not make the cane too straight; change direction at each joint.
• Notice that the new branches connecting to the leaves come from the joints. Using Orchid and Bamboo brush (19) make the joint stroke with very dark ink, using calligraphy techniques, when the canes are almost dry.
• You may need to add a few leaves to balance the composition.

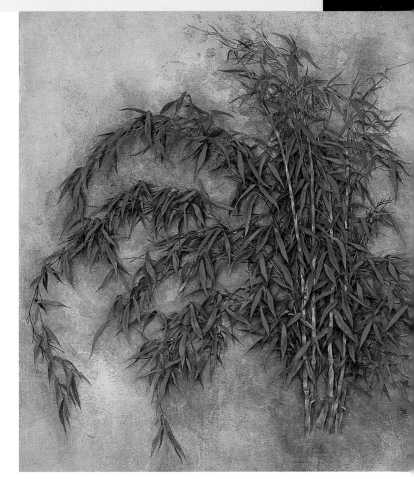

FURTHER EXAMPLES

Here are two examples of advanced bamboo painting. Both are serious exhibition pieces. Compare them to see how the artist managed to convey the contrasting atmospheres of spring and winter.

Snow Bamboo by **Cai Xiaoli**. This is a combination of "free brush" (*xieyi*) painting for the background and "fine brush" (*gongbi*) painting for the leaves. The two techniques are often used together in modern Chinese art. Notice how the black inkwork of the rock seems to repel the bamboo, which seeks shelter from the cold. Although the bamboo is weighed down by its covering of snow, the leaves peek out bravely, seeming to look for better times to come.

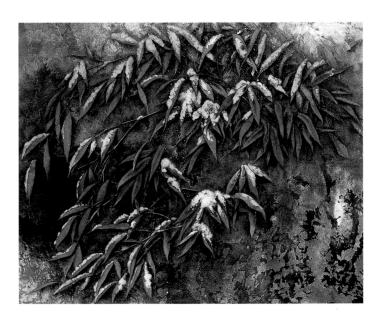

Spring Bamboo by **Cai Xiaoli**. This painting of Spring Bamboo is entirely in "fine brush" work, using copper crystal pigments. This requires the utmost control of the medium and detailed knowledge of the plant. Note how every leaf turns a different way, each one trifled with at the whimsy of the wind, conveying a lighthearted feeling of spring.

ORCHID

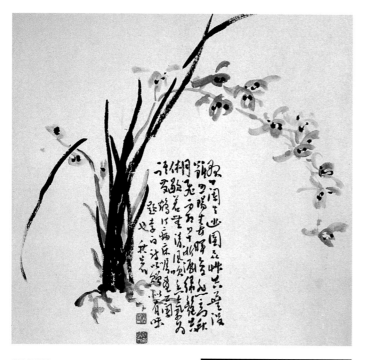

ORCHID

by Han Qiu Yen

This traditional painting has an asymmetrical composition. The calligraphy occupies a central position stabilizing the composition. The function of the falling flowerheads is to allow the movement to drift gracefully beyond the picture edge.

The orchid was originally a somewhat secretive plant found only in remote locations, hiding behind rocks or by the shores of lakes. In China today it has been cultivated into more than 100 varieties. Historically it was seen as the scholar's sweetheart, embodying the virtues of beauty, purity, and fragrance as it grew beside the water like a demure young girl washing her hair. The famous poet *Qu Yuan* (c. 343–278 BC) wrote a poem about the orchid in which he describes the delicacy and refinement of its flowers with the green leaves wafting in the breeze: *"Oh, how pure is the autumn orchid, blooming in a hall full of beauties."*

The first painter of orchids is considered by many to have been **Mi Fei** in the Song dynasty. Since that time artists have interpreted it in innumerable different ways. It is one of the most useful plants for imparting the skills of Chinese painting. Where bamboo has leaves but no flower, and plum blossom has flowers but no leaves, the orchid has both — and the painter must strive to capture their essential qualities, which require different techniques. The leaf of the orchid is one of the most difficult strokes to paint well. You need excellent coordination of hand and arm, with the movement flowing from the shoulder in one smooth sweep. In China it is said that "you need half a lifetime to learn how to paint bamboo but a whole lifetime for the orchid."

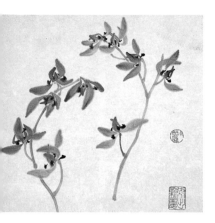

STUDIES AND SKETCHES

You should make sure you get to know your subject intimately by drawing it. The concentration on line will help you to make the correct strokes when you use the paintbrush.

When you are ready to paint, practice the stroke for the main leaf first (see right). After practising this important leaf you can set up the others in relation to it.

Last come the flowerheads. Above are some examples of flowerheads for you to copy. Notice how many different aspects there are. The stems should be painted with care. Do not make them too stiff. Where the stamens can be seen, they should indicate the direction of the flowerhead faces.

MAIN LEAF

Think of this as an elaborate *cao shu* stroke (see lesson one) using the entire arm. One brushstroke requires almost 270° of movement, changing direction to express the sinuous turning of the leaf. The pressure on the paper must be positive, yet reflect the thinness and suppleness of the leaf.

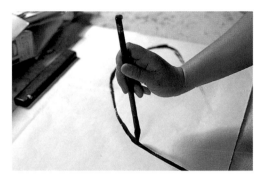

△1

Begin by holding the Orchid and Bamboo (19) brush in the *zhong feng* (center brush) position. As you start the stroke, hide the tip, as explained in lesson one.

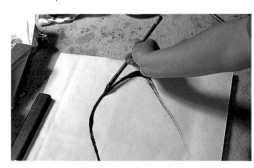

△2

Continue the stroke, changing to a *cefeng* (side brush). Still with a side brush, describe a quarter circle, as though from 1 to 3 o'clock.

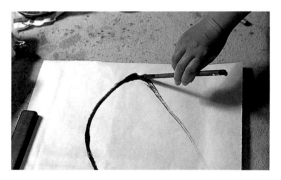

△3

The hand turns over, so that the palm is facing down. This is the start of the *tuobi* (dragging stroke). As you make this movement, the fingers are also rolling the brush, first counter-clockwise, then clockwise.

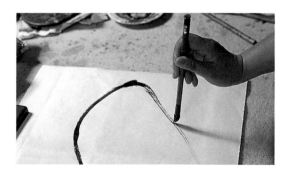

△4

The *tuobi* finishes, and the hand returns to its starting position.

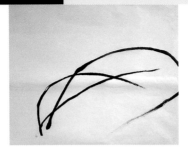

△5

The first few strokes are crucial to the whole composition. After the long turning stroke that you have practiced, paint two or three crossing it. These secondary strokes should complement and endorse the movement of the first stroke but not dominate it.

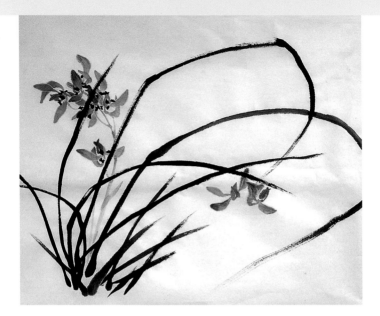

◄7

The flowerheads are composed of dots. Using the White Cloud brush (12), they are assembled in groups of five to suggest the flower. They should peep in and out of the leaves which appear to cradle them in an embrace.

△6

Now add the tertiary group of leaves. Some should turn away from the main group; some should intersect with them; all should be subordinate to the first group. The aim is to achieve interesting relationships between the leaves. Take care not to make them all spring from the same base.

8▶

The finished painting. There are three areas to bear in mind: technique, mood, and composition. The picture is composed of line and dot, *gou* and *dian* (see lesson three.) Every line is done in a special order, just like the calligraphy strokes. The mood can change according to the time of day or location, but always try to capture the orchid's refinement. The subject lends itself to asymmetrical compositions. Here, the first large stroke goes out of the picture and returns, giving a feeling of extension beyond the frame.

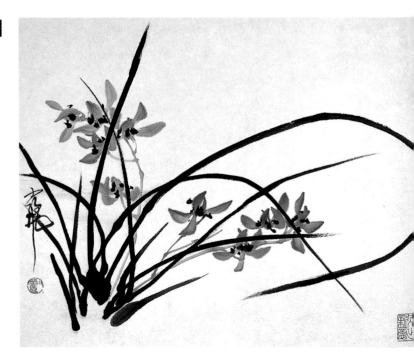

PERFECT ENDING

(cao shu)

In its natural habitat the orchid grows in clumps. The Chinese artist mentally selects one plant and from that the leaves and flowers that will best evoke the characteristics of the species. The strokes will follow convention, but the way they are expressed will be as individual as handwriting.

As you paint the orchid leaf, feel the qi rising within you and flowing out through arm and brush onto the paper. Your mood should be happy, dwelling on the characteristics of the plant.

*Once you have learned how to execute and group the three basic strokes on which the composition of the orchid depends, you can develop the painting in many different ways. You may want to paint a single plant or incorporate it into a larger picture, as **Cai Xiaoli** has done with **Yellow Orchids** (below).*

Yellow Orchids by **Cai Xiaoli**. This serious painting uses a singing yellow which brings out the traditional femininity of the plant. The movements of the leaves are different from those of the flowers, which creates an interesting composition. The "free brush" work of the background is an excellent foil for the glorious array of blossoms and leaves painted in "fine brush" style. The piece is in the 10th-century Royal Court manner.

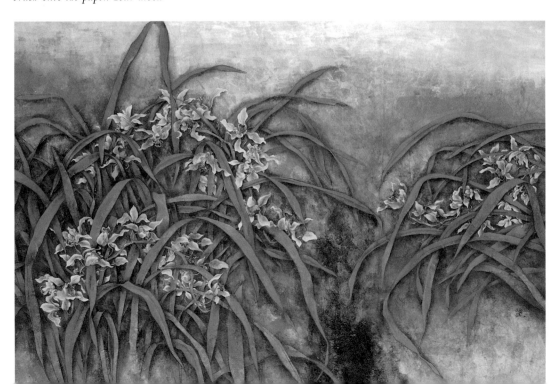

INK AND COLOR

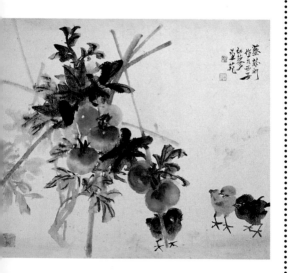

COUNTRY PLEASURES

by *Cai He Zhou* (1910–71)

This traditional painting illustrates the use of contrasting, host and guest colors. The leaf is painted with ink so that the color of the tomato appears even more vivid. The painting utilizes color to suggest a rustic style of living.

As we saw in information feature two, the tones of black ink are already seen as color. Any additional color is therefore regarded as an adjunct to ink and not an improvement on it. This is why the range of colors used in Chinese painting is relatively limited. In flower painting we do not attempt to reproduce the colors of nature exactly, but to express our emotional response to what we see. This response will be personal and different for each artist. One way of showing the personal response, in *xieyi* (free brush) painting, is by the use of contrasting colors in a host and guest relationship. When contemplating a flower subject, the mind's eye is impressed by one dominating color which sets the mood. This major color is probably the flower. The stems and leaves are not painted with greens, but in tones of black ink so that the flower appears brighter and fresher by contrast. Another way of painting the stems and leaves uses a little indigo mixed with ink. In this case they are in a subordinate role to the flower, and the whole painting is dedicated to one color mood.

The main concern in *gongbi* (fine brush) painting is how to combine colors. There are no definite rules. It is a question of personal taste, whether you prefer a rich or delicate palette. As with free brush, the technique relies on finding the relationship between the parts and making a subtle balance between them. Although ink does not take such a prominent part in fine brush painting, it is still the controlling factor; it provides the underlying structure and supports the colors.

Further to the questions about color on p.55, think about the following: remember that there should be a host and a guest color, which should be in a reciprocal relationship of major and minor, warm and cold, and giving and taking. Look at paintings by masters and try to understand how the dominating color, which determines the mood of the painting, was chosen. Above all, surrender yourself to the *qi* of the image.

COLOR TECHNIQUES

● The most important color technique is the use of water. Since most Chinese colors are water-based, we dilute them with water and not with the addition of white.

● Dark tones should not be applied in one go, but built up gradually to the required intensity. Use a *ran* technique in a series of layers, each of which adds texture to the final result, giving it depth and making it more interesting. Artists sometimes use as many as 20 layers.

● You can blend two colors on a plate, and they will make a third. More interestingly, you can load two colors onto a brush and, as you paint, they blend into a variety of colors and tones. This technique creates much fresher color.

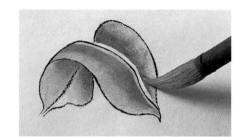

● To tone down the color of a leaf, for example, paint it first with brown and then, over the top, with indigo or Chinese blue or green. This gives a more subtle effect. We call this technique "covering."

● Another technique uses complementary colors, painted one on top of the other. For example, the under-stroke may be a deep rose red and the top one pink. If you paint the top stroke while the first is still wet, the two will blend and become indistinguishable.

● In the technique known as "backing," color is added to the back of paintings to change or enhance the colors on the front.

There is a lot of information in this feature. Do not expect to absorb it all immediately. Practice all the techniques on *xuan* paper until you learn how the materials behave in each case. The only way to learn is through trial and error.

WARM AND COLD COLORS AND INK

Ink has the almost magical property of generating warmth or cold, which is taken up by and from colors associated with it. The artist can use this to convey personal feelings about a subject. The hot colors are the reds, yellows, and browns; blues and greens are cold. Ink is a kind of "middle" color; when juxtaposed to a cold color, it gives the impression of warmth, and vice versa.

QUESTIONS TO ASK ABOUT COLOR

● How do I perceive the color of the subject?

● What is my personal response to what I see in nature?

● How can I change the actual colors of nature to suit my personal expression?

IRISES

by *Cai Xiaoli*

Here is one example of how to combine colors in a painting. Many different pigments were used, but the overall impression is of two major colors: purple and green.

● ● ● ●

The key words with reference to color are: CONTRAST – BALANCE – MOOD

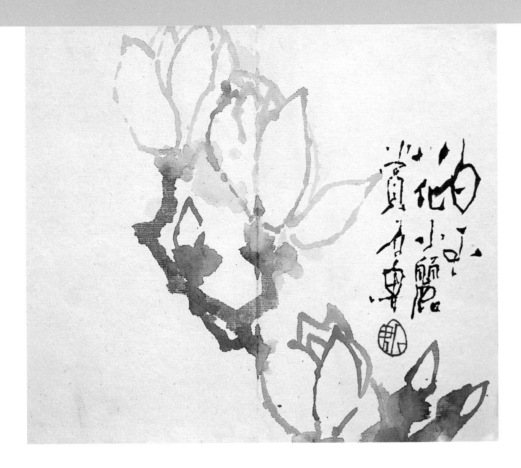

WHITE JADE FLOWER

by *Shi Lu* (1919–82)

In this painting by a famous 20th-century master, the major color is ink. The reciprocating color is a delicate light green, which gives the work a fresh, spring-like feeling. The flower that we know as magnolia has the picturesque Chinese name of "White Jade Flower."

PINK PEONY

by *Ou Li Zhuang*

There are regional variations in Chinese taste. Generally speaking, the northern school tends to favor the contrast approach, whereas the south inclines toward a wider color palette, as shown in this painting.

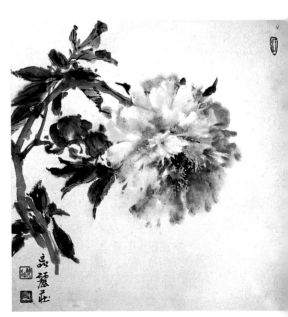

• • • •

A common mistake is to underestimate the strength of color when the painting is dry. Remember that all colors appear more intense when wet.

BRILLIANT AUTUMN

by *Yuang Yan Ping*

In this contemporary example, the ink contrasts strongly with the fall colors, giving them added potency. Without the ink as a foil, the painting would lose much of its spirit.

SIZE AND COLOR

The size of a painting influences the choice of color. A large painting, intended to be seen from a distance, should be painted in brighter colors; otherwise the details will be lost. A small painting may be done in the most delicate hues.

SUMMER PEONIES

by *Cai Xiaoli*

The summer mood of this painting is conjured up by the contrasting colors of the two flowers: the slightly colder blue behind, and the warmer pink in front. There is also contrast between the colors of the flowers and the background.

• • • •

HOW COLOR CONTRAST WORKS

In the Song dynasty, there was an emperor, who set a competition for artists. The purpose was to illustrate a poem:

Among ten thousand greens, there is but a speck of red. The color of spring does not invade the whole frame.

The winner painted a young girl in a blue skirt, standing in front of a green bamboo. The only red in the painting was on her lips. This shows that the major, or host, color need not occupy a large space in the picture.

BRUSH FLYING, INK DANCING

CHRYSANTHEMUM

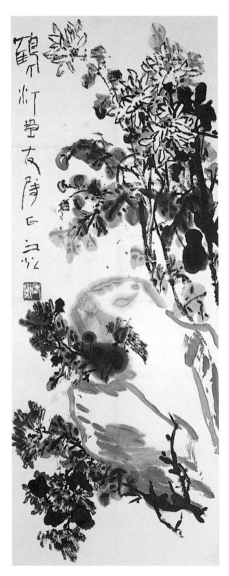

by Xie Zhe Guang

This example captures the essential characteristics of the flower, especially its vigor and wonderful display of color.

MATERIALS FOR THE LESSON

BRUSHES

Sheep drawing (11)
Orchid and
Bamboo (19)
White Cloud (12)
Medium Sheep (9)

COLOR

Ink, Indigo,
Rattan Yellow, Earth Brown,
Warm Red (hong),
Cold Red (rouge),
White
Glue

PAPER

Xuan

The chrysanthemum has always been popular in China because it continues to flower in the fall (autumn) long after all the blossoms of summer have faded. Furthermore it does not end the season on a subdued note but blazons its glory in a riot of color, as though defiantly facing up to the harsh winter ahead. For these reasons, the scholar-painters, in particular, identified with this flower. They had a strong sense of responsibility for society, yet felt themselves to be under pressure from the ruling classes. In modern times also, many Chinese like to bring this plant into their homes to remind themselves that it is possible to triumph in adversity, and to brighten their surroundings. A popular entertainment is to sit and drink wine while contemplating the virtues of chrysanthemums.

THE AIMS OF THE LESSON

Loading the brush with color

Breaking color with ink and breaking ink with color

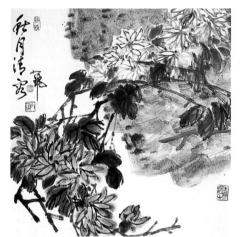

STUDIES AND SKETCHES

The brushstrokes used in painting this flower should be strong and free to reflect its character. The contrast between the relatively dark leaves and the brilliant flowers needs to be brought out. Practice in particular loading the brush with both wet and dry ink. For example, use a wet lower brush loaded with dark ink, and a drier tip loaded with light ink, on the same stroke. Start with the flower nearest you. Make the flowers behind it smaller, and turning in a different direction. A common mistake is to make the petals too sparse. They are

actually quite closely packed, and the whole flower gives the feeling of being a compact, almost solid ball.

The completed painting (left) shows how the elements of the step-by-step are combined. Notice the careful placing of the plant in relation to the edges of the paper, how the spaces are set up, and the contrasts in tone and color. Note also how the imagination used the images gained from nature to portray the essential characteristics of the chrysanthemum rather than a photographic representation. Compare it with the painting **Autumn by Xie Zhe Guang** *(opposite.)*

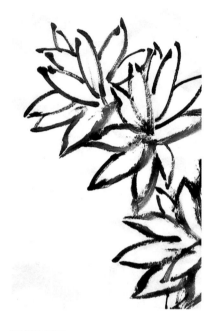

Before starting **Step 1**, *mix the color for* **Step 2**.
Using ink on an Orchid and Bamboo brush (19), draw the shapes of the petals with calligraphic brushstrokes. Vary the strokes by sometimes using the tip of the brush, sometimes the side; by alternating between light and dark ink; and by using a wetter or drier brush. The speed of the stroke will also add variety: slower for a dry brush; quicker for a wet brush.
• Build up each flower gradually, remembering to show profile petals as well as full shapes. All petals should come to the center of the flower.

See **Step 2**. This is the order for loading your brush with the colors you should have pre-prepared.

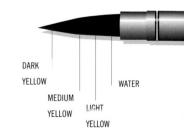

DARK
YELLOW
MEDIUM
YELLOW
LIGHT
YELLOW
WATER

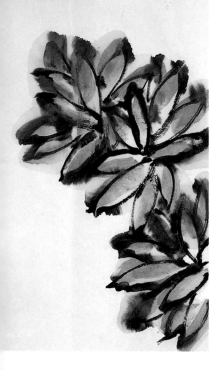

CHRYSANTHEMUM FLOWERHEADS

Another method, known as *mogu* (without bone) is to begin with color, using a White Cloud brush (12) and painting the petal shapes in a free brush style. Vary the intensity of color, making the entire flower darker toward the bottom.

• Leave space between the petals in this version, or your ink strokes will be too close together.

▼3

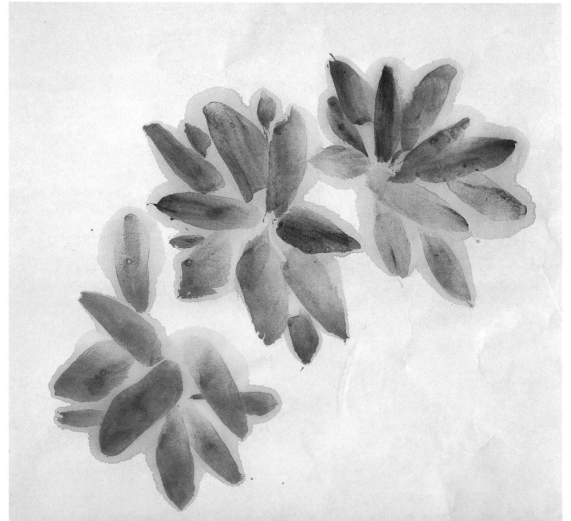

▲2

Fully load a medium Sheep-hair (9) or White Cloud brush (12) with light yellow paint. Add a medium yellow to the center part, then dip the tip in a small amount of dark yellow. Fill in the petal shapes but not too precisely. Vary between touching the ink line and going over it. Do this while the ink is still wet to gain the effect of shadow as the colors merge. At the top edges of the petals, you can leave a white gap between the line and the color. A little glue can be added to the color to make it more intense.

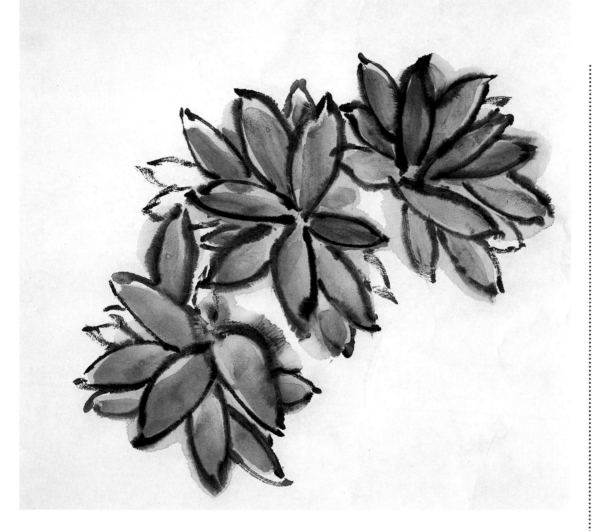

FROST
(li shu)

While the pigment is still wet, draw in the outlines, taking care not to follow the contour of the color too closely. Again, you can be inside or outside the color, and can leave an area of white between the line and the color.

To create the leaves for both painting methods (see picture bottom p.61), load a medium Sheep brush (9) with light ink, with a little indigo on the tip. Use different brushstrokes to show both full-face and side-view leaves, varying their tone and size. Before the color is dry, draw in a few veins with an Orchid and Bamboo brush (19). Use pure black sparingly so as to ensure its impact. Next draw the stalks, utilizing bold brushstrokes, and paint with a mixture of ink and a little brown. Join the leaves to the stalks with a fine brush and dark ink.

• The large stalks resemble *cao shu* calligraphy and the smaller *kai shu* (see lesson one).

PLUM BLOSSOM

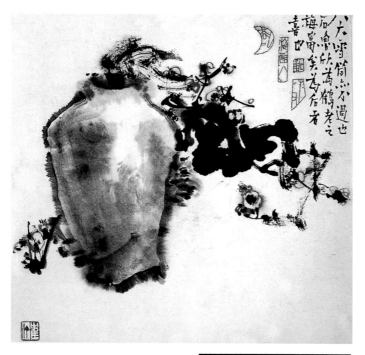

EARLY SPRING

by Cai He Ding

In this painting notice the contrast between the positive delineation of the branches and the varied movements of the flowers.

MATERIALS FOR THE LESSON

BRUSHES
Orchid and Bamboo (19), White Cloud (12), Plum Blossom (20), Small Wolf (21), Jade Bamboo (15)

COLOR
Ink, Indigo, Cold Red (rouge), Warm Red (hong)

Like bamboo, plum blossom occupies a very special place in the Chinese heart. Both were part of the cold weather triumvirate, pine, bamboo and plum, which were painted not only for technique but also for the mood and the spirit they could express. They were known as the "Three Friends," and were an established part of the painter's repertoire long before the Ming dynasty, when **Chen Ji Ru** chose another amalgamation of bamboo, orchid, chrysanthemum and plum. He considered that the scholar-painters should concentrate on these four to perfect their skills, and they later became known as the "Four Gentlemen".

The Chinese plum has two characters: it is a plant of the wilds, growing on remote hillsides where it might live for over a hundred years; the same plant was brought from its natural habitat to be cultivated in the gardens of connoisseurs, where it was nurtured to produce magnificent blooms that come before the leaves, defying the winter elements. The wild and cultivated aspects of the plum are both loved by the Chinese, and both are the subject of Chinese painting.

The contortions of the wild plum reminded onlookers of a ferocious dragon. When transplanted to gardens, it was judiciously trained to give a similar aspect. The old branches were pruned to represent the body, and the new growth was given space to

THE AIM OF THE LESSON

To differentiate between the brushstrokes of the old and new branches and the delicate flowers

develop straight and true, like an iron rod. Another admired characteristic is the constancy of the plum, returning each year to be the first flower to display its attractions, like a peacock parading before its mate. It therefore also symbolizes undying love.

• • • •
TIPS

• Do not attempt to make your painting exactly like the plant. You are aiming to capture its spirit.

• Keep the whole composition in mind while working. The brush needs to move quickly to convey the ruggedness of the old trunk, but space must be left for the positive direction of the new branches and the delicacy of the blossoms.

• Think about the space left between groups of blossoms and branches.

• The first few strokes are the most important, because they establish the spirit, or *qi*, of the whole painting.

STUDIES AND SKETCHES

Begin your studies by researching the characteristics of the plant. Make drawings so that you are familiar with all stages of its development. Remember that not all the blossoms face the same way, nor are they all the same size. Look at the finished paintings on pp.68–69, especially **Nature's Companions**, *that show details of different aspects of the flowerhead. Some blossoms are full-blown, some are still in bud. Those toward the bottom of the plant tend to open first. Contrast the blossom grouping: some should be clustered together, some should stand alone. They should also be in a reciprocal relationship, as though the fully opened "adult" flowers are in conversation with the younger ones, darting in and out among them.*

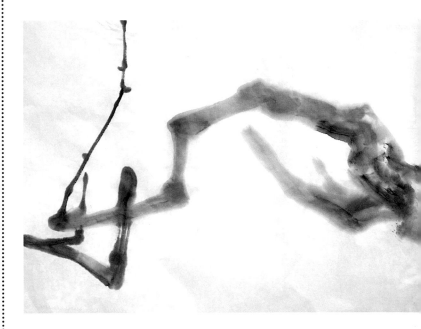

◤ 1

Begin by using an Orchid and Bamboo brush (19) loaded with light ink. Add dark ink to the tip. Lay in the main structure of the painting, pausing where the brush turns, then continue in a different direction using both center and side brush. Remember to leave enough space for the blossoms, which are added later.

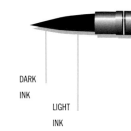

DARK INK

LIGHT INK

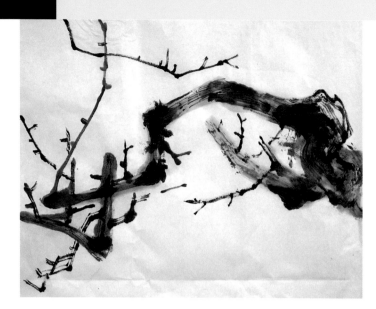

◀ 2

While the first ink is still wet, take a second wolf-hair brush, such as Jade Bamboo (15), load it, and then squeeze it with your fingers to get rid of the excess water and to spread out the tip. Paint the details of the trunk, using a center brush. If you want to leave "flashing white," you must move fast. Add the new branches, making them straight and strong.

3 ▶

Start painting very simple blossoms. Use a sheep-hair brush, such as White Cloud (12), and try to reproduce the essential shape and direction in one stroke. The basic color is a light pink, but vary the tones of individual petals by adding a little indigo to some brushstrokes, and a little red to others. Do not mix them too much on the plate – allow the colors to blend on the paper.

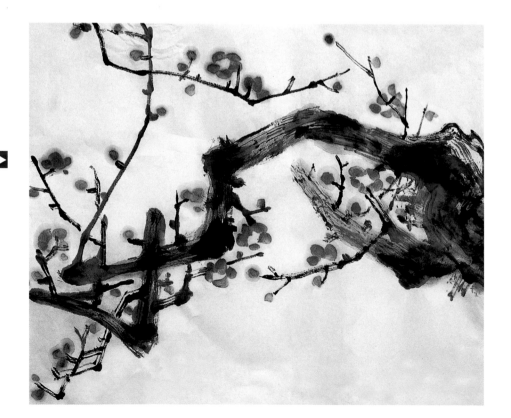

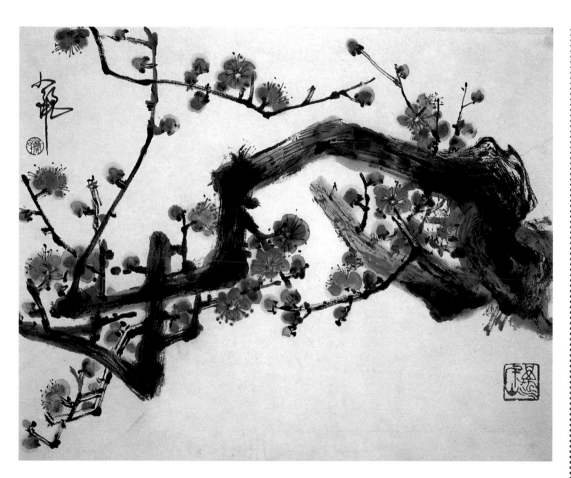

FLEETING FRAGRANCE

(*zhuan shu*)

▲4

The finishing details should be done while the paint is still wet. Using a small, dry wolf-hair brush (20 or 21), add the stamens with light, rapid strokes. These can also help to indicate the direction of the blossoms. Now is also the time to reconsider your composition: You can add dots to the trunk and branches to strengthen them at salient points.

*The examples in this lesson are by the leading 20th-century painter **Cai He Ding**, who specialized in painting plum blossom. The picture entitled **Early Spring**, on p.64, illustrates the "broken branch" technique. Look at the freedom of the strokes and the control of the brushes. The strokes were executed roughly, using a lot of ink. See how the details and shapes are carefully balanced to give the utmost liveliness to the composition, and how the whole is enhanced by the addition of the calligraphy and seals.*

Notice the different atmospheres conveyed by each of these further examples. Try to understand the meaning underlying the differences, and to emulate them.

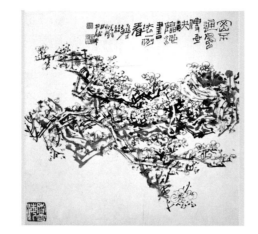

After the Rain. This delicate painting suggests clear weather after rain, with a sense of coming spring. Every branch is dancing with happiness. Here the artist painted the flowers faintly white, with a contrast of indigo and a little green. Notice also the interesting arrangement of the three seals, and the movement of the flowers.

▲

Wild Plum. This example shows the wild nature of the plant. It uses many tones of ink to give a silver effect, and the brushstrokes convey the flamboyant display of the blossom. The drawing is very complex, especially in the center, yet every movement is depicted with absolute clarity. The artist made clever use of untouched paper as the color of the flower, and positioned the subject in the middle of the space. The empty space is contrasted with an intense concentration of detail, and the shapes it makes are never repeated in exactly the same way.

▼

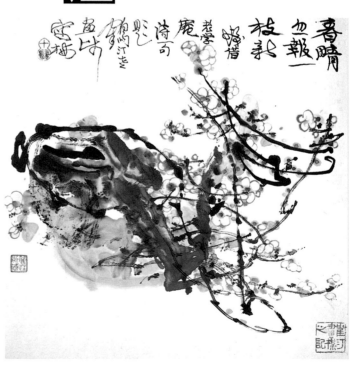

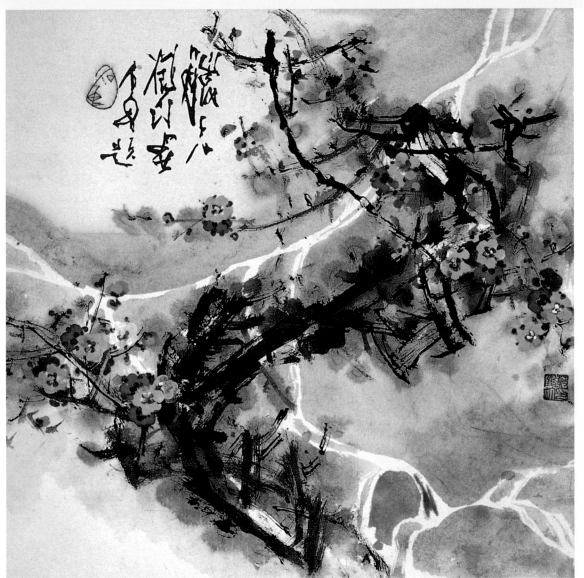

Nature's Companions.
This is also a wild
plum, but now we are
well into spring.
Exuberant flowers are
seen against a mountain
waterfall. The
brushstrokes of the
branches are descriptive
and calligraphic,
bridging the waterfall to
convey the feeling of a
link with the whole of
nature through the
mountain. This sense
is increased by the
way in which the
strokes go beyond the
picture space, and by
the dynamism of the
brush strokes.

WISTERIA

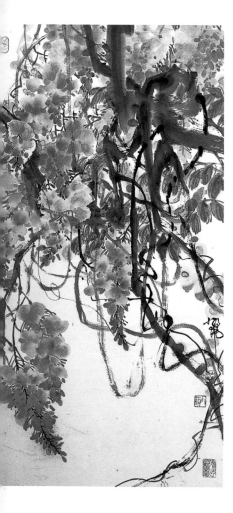

BRUSHES

2 or 3 White Cloud (12)
Sheep drawing (11)
Medium Sheep (9)
Medium Badger (17)
Orchid and Bamboo (19)
Mountain Cat (14)
Fine Wolf (24)

COLOR

Ink
Indigo
Rattan Yellow
Mineral Green
Mineral Blue
Cold Red (rouge)
Warm Red (hong)
Earth Brown
White

PAPER

Xuan

WISTERIA WATERFALL

by Cai Xiaoli

This painting captures the grace of the flower.

Wisteria is a popular plant in China and serves here as an example of climbing vines. For the Chinese it represents the stages of life in a poetic way.

Try to picture the characteristics of the wisteria before you start to paint. When the flowers first appear, they reach upward toward the sky. As the florets open, the clusters become heavier and fall, like a waterfall tumbling down a ravine. The vine itself is remarkably strong. In former times, where it grew wild in the mountains, people used it to make ropes for climbing and lines for fishing. When you are painting the vine, you must feel this strength with your brushstroke. In contrast, the old branches have endured endless hot summers, which have dried them up, revealing the scars and rigors of a long and arduous life. Different brushstrokes are needed to show these disparities.

Practice painting the vine first. This is the element that will give the painting its vitality and spirit. Do not worry if the paint line is not continuous. If you perform it with confidence, the energy will flow between the breaks and give it vitality.

In this lesson we continue to study the turning stroke *zhuan bi*, which we first met in the leaf strokes of the orchid (pp.50–53). We will start the actual picture with the flower clusters, which are going to be our focus. If you plan to do a large painting, you should begin with the branches and leave space for the flowers.

STUDIES AND SKETCHES

You should begin by copying other Chinese paintings of the subject, which will give you the necessary feeling for the difference between Western and Chinese paintings.

Only when you are familiar with how other Chinese paintings deal with a particular subject should you go into the field to study your subject at first hand.

Make detailed drawings, as shown above, and you will be equipped to do even better work in the studio.

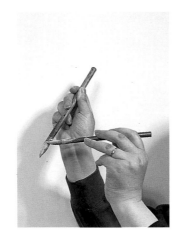

◄ 1

Begin by practicing the loading of the brush. Wet your brush, then load it in four stages as shown in the diagram: the quarter nearest the shaft is pure water; the next quarter is green, mixed with a little red to a medium tone; the next quarter is a little darker than the green and red medium tone; the tip is touched lightly into indigo and both reds.

Finally use one brush to add white to the base of the other brush (see photograph left). This is done so that you do not overload with white.

• Do not mix the colors too much on the plate. As the brush executes the strokes, the colors will mix naturally, giving you a variety of different tones.

WATER

INDIGO PLUS
BOTH REDS

DARKER
RED/GREEN

RED/GREEN

WHITE

◄ 2

Now you are ready to begin painting. Start from the bottom of the flower cluster, using a White Cloud brush (12). At the top of the cluster, the petals are almost pure water. Do not be tempted to reload the brush too often. As you paint more petals, the color on the brush becomes lighter, and this adds to the effect.

• Remember not to make your flower groupings too regular. If there are three clusters, put two together and one slightly apart.

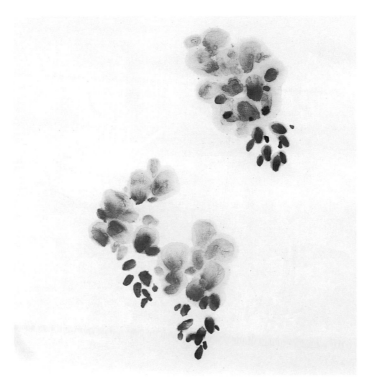

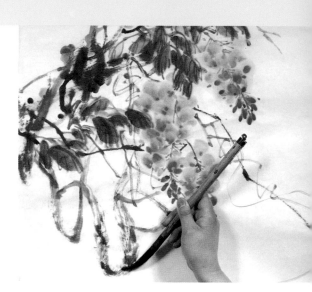

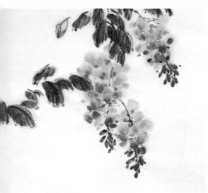

◀ 3

Add the leaf shapes with a Sheep brush (9 or 11). Show both old and new growth, differentiated by color loadings. The old leaves are done with a blend of ink, indigo, and yellow; the young ones with ink, indigo, and a little red. This contrast is important, not only pictorially but also for its wider connotations of balance and reflection of life's pattern. Remember to group the leaves naturally. While they are still wet, add the veins with a fine Wolf-hair brush (24).

▲ 5

Pay particular attention to the position of the hand as you paint the vine stroke. Imagine yourself as a skater describing figures on the ice as you go through 180°, and you will have some idea of the movement range involved: sometimes gliding; sometimes pausing before executing a reverse that almost doubles back on itself. Use both center and side brush strokes.

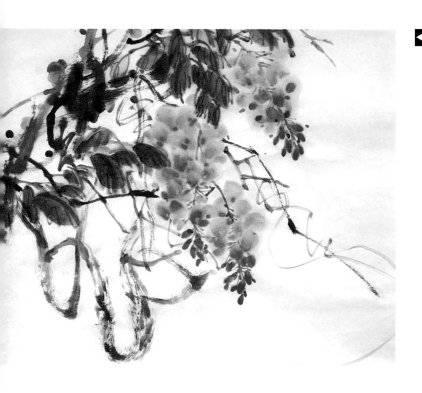

◀ 4

The main branches are the framework of the picture upon which all else depends. Using a Mountain Cat brush (14) paint them with slow, controlled brushwork, using light ink mixed with Earth Brown, sparsely loaded to give the effect of age. For the vine, with its more vigorous growth, use dark ink and more flowing strokes, using a Medium Badger brush (17).

Here the painting stroke relies on *kai shu* calligraphy (lesson one.) The tendrils are painted quickest of all, with sure, rhythmic strokes, reflecting the impetuosity of youth.

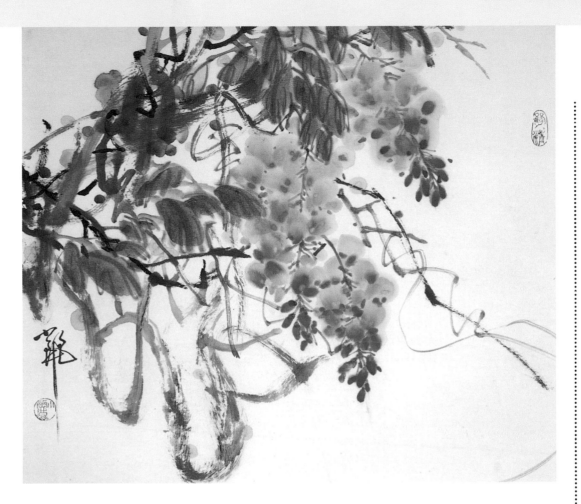

The finishing stages are relatively simple but vital to the success of the whole. Use a *dian* technique (see glossary) to emphasize certain points, to provide balance where needed, and to define the space. Dots can enhance the white and change the shape of the space, but do not cover the whole page. Remember to leave some areas unpainted to become significant and asymmetrical spaces.

VINE

(cao shu)

CREATING AN ENVIRONMENT

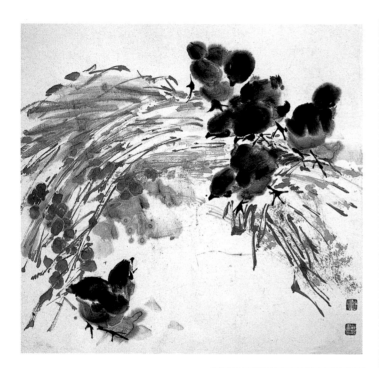

THE SCAVENGERS

by *Cai He Ding*

This picture of chicks is a typical example of a xiao pin painting (see information feature four). The single chick seems to be calling to the group of four. Two answer his call, one ignores him, and the fourth is more concerned with food. The picture is full of vitality brought about by this interaction.

One flower can be used alone as a subject of a Chinese painting. However, it can be difficult to control the composition in a picture based on just one plant. In this lesson, therefore, we combine the flower with a rock, which will give you a solid base and also provide a pleasing contrast with the motion of the blossoms and leaves.

Once again the scholar-painters are the originators of this idea. Many scholars were drawn to Lake Tai in the Jiangsu province of southeast China by the beautiful strangely shaped rocks that surrounded its shores. In line with the Chinese idea of endowing natural features with human characteristics, the scholars saw these stones as friends and they became known as "scholar rocks." The emperors took up this veneration of rocks, and after the capital was established in Beijing in the 14th century, they had many such stones transported to the gardens of their palaces, where they recreated a microcosmic south China landscape. The idea of suggesting a huge expanse of natural scenery on a small scale was also adopted by artists, as we shall see in the Landscape Painting section (pp. 102–195). Here we concentrate on the use of the "scholar rock" as an environmental feature in Flower and Bird painting.

THE AIM OF THE LESSON

How to paint scholar rocks as a complement to the flowers already studied.

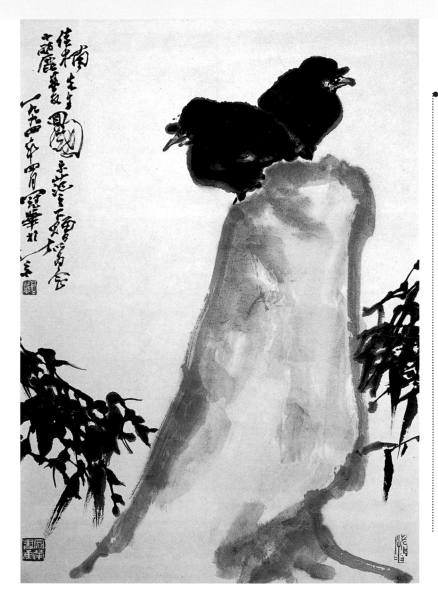

Birds on a Rock by **Gao Guan Hua** is a good example of how to put your subject in a suitable setting. There are three elements: birds, bamboo, and rock. The birds are the main subject, with the bamboo as a balancing feature. However, both of these occupy less picture space than the rock, which is seen as a host, accommodating the birds. The quality of the inkwork emphasizes the relative elements. The viewer's eye is drawn to the birds by the intense blackness. Although the bamboo is equally black, it is painted with a different brushstroke, less concentrated than for the bird. A dry *cun* brushstroke for the rock ensures that it does not detract from the prominence of the birds.

• • • •

TIP

An important tip for all traditional Chinese painting, is that no image should be too clear-cut. Therefore, when painting a rock that is basically square, we like to think of its having an underlying roundness. Conversely, a round rock would have an implicit element of angularity. Try to bear in mind this Daoist idea of painting the "round in the square" and the "square in the round" in order to avoid too great a uniformity.

"Scholar rocks" are painted with quick, fresh brushstrokes, and not in the detailed way you would describe them in landscape, where they are the main image (see lesson fifteen). "Scholar rocks" are notable for their strange conformations, with holes and irregularities. There are two ways of painting them: you can either draw the rock in outline and then introduce a little color, or you can make the shape using color on a large brush in the mogu style (see lesson six) and then indicate the contours with ink. This is like the two ways of dealing with chrysanthemums. Whichever method you use, take care to vary the brushstrokes. Keep the inkwork of the rock positive but underplayed. Remember that the function of the rock is to show the flower to greater advantage and not to overwhelm it.

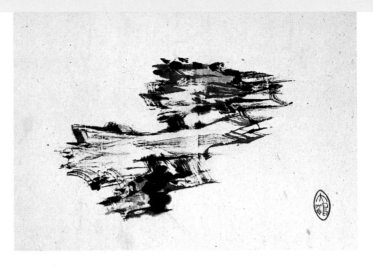

These four paintings of scholar rocks are by **Cai He Ding** and are good examples of *xiao pin* painting on their own (see information feature four). Each shows a different aspect and shape for you to observe and copy.

This example reminds you how to hold the brush.

FOUR SCHOLAR ROCKS

The pictures on this page and the top of the next page are examples of scholar rocks that are especially suitable for Flower and Bird painting. Copy them carefully many times. When you are satisfied that you can paint them swiftly from memory, seek out rocks for yourself and build up a personal library of images. When painting, you should always have a particular rock in mind which you have learned from nature or from looking at pictures.

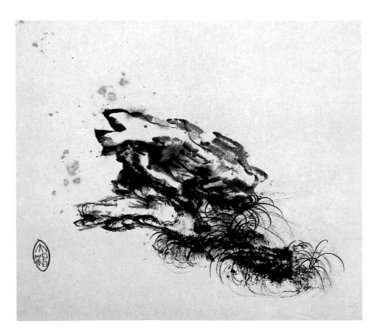

The rocks in these paintings are just like those around Lake Tai in China that so intrigued the scholars and that they later incorporated into their private gardens. In the same way as the scholars sat in their gardens and imagined a broad landscape from the scenery they had constructed, so can the viewers of these paintings derive their own interpretations.

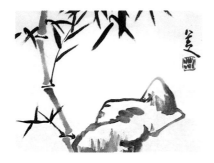

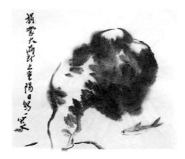

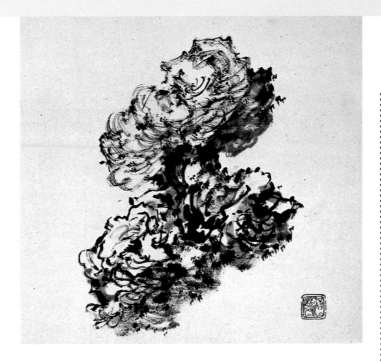

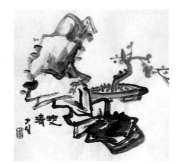

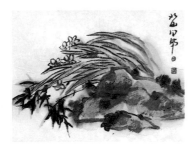

 Notice that each of these rock paintings is a finished picture in itself. You can add suitable flowers and birds to them, although that will, of course, create a different sort of painting.

 The "Four Gentlemen" from lessons four to seven all go well with "scholar rocks." Here are four ways of combining them. Try making other combinations yourself. By putting these elements together to suggest the various seasons you will be well on the way to a basic understanding of Chinese composition.

SILENCE

(li shu)

FURTHER EXAMPLES

Although it is important to try and understand the way the Chinese view subject matter and composition, the eventual choice of elements to put into your painting must be yours. The juxtaposition of certain flowers or birds and rocks, described in this lesson, obviously creates an artificial environment. We could also depict a flower by a mountain pool, as in the painting by Cai Xiaoli on the next page. Although this is ostensibly more natural, the artist has made a careful selection of leaves and flowerheads.

You might think that because the techniques must be studiously followed and there are already associations in whatever subject matter you choose, there is little scope for free expression. We would say that the opposite is true: the more technique you master and the more you know of Chinese thought, the more freedom you have to express what is really in your heart.

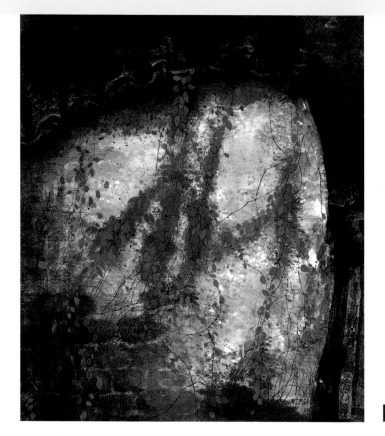

The **Red Leaves of Autumn** is a joint painting by **Wang Jia Nan** and **Cai Xiaoli**. In late summer the leaves of wild grapes climbing up the walls of many old Beijing houses turn a fiery red. The artists were inspired by the contrast of the red leaves against the white walls with the black roof. The door with its peeling paint looks to times past; the new shoots herald times to come.

Despite the subject, **Golden Vase** by **Wang Jia Nan** is not a still life. It is full of symbolism recalling former days in Chinese history, and is part of a long tradition of painting ancient ceramics, bronzes, and so on. It invokes a great sense of continuity. This is a popular contemporary approach. Such subjects must have appropriate settings: the high-quality vase is on a Qing-style table.

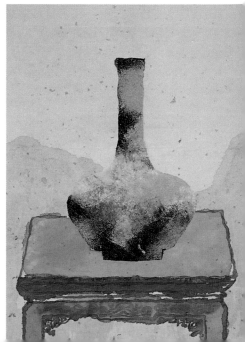

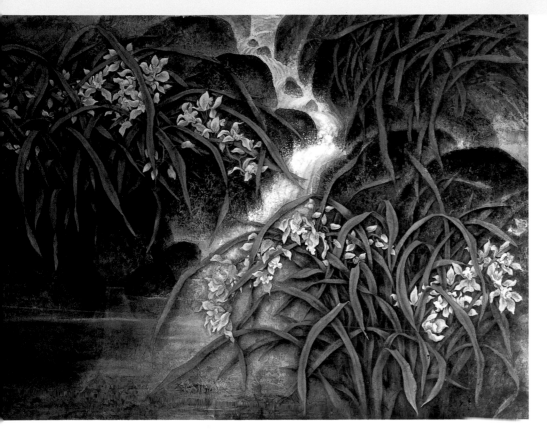

Just like humans and animals, flowers seek the best place in which to survive. The frail orchid often grows beside running water in wild mountain scenery. In **Orchid by a Mountain Waterfall** by **Cai Xiaoli** the orchid has found a home alongside a torrential stream, which brings out the delicacy of the flower.

Veiled Blossom by **Cai He Ding** illustrates how simple ideas can be extended into more complex ones. The painting shows a rock with plum blossom half-concealed behind a bamboo screen. This causes interesting shadows. As the curtain sways, the flower is sometimes hidden, sometimes not, but its fragrance is always present. The inspiration came from a 10th-century poem. The painting encapsulates the atmosphere of a languorous day with a secret to conceal, like a girl hiding demurely behind a fan.

BIRDS IN FLOWER PAINTING

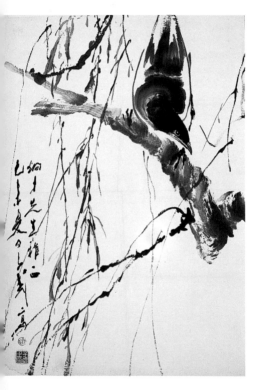

MAGPIE

by Wang Zi Wu

This painting shows the depth of expression that can be obtained using few brushstrokes and no color. The broad strokes that depict the form of the bird are balanced by the delicate painting of the willow. The bird's character is conveyed by the eye and the turn of the head.

MATERIALS FOR THE LESSON

BRUSHES
Medium Sheep (9)
White Cloud (12)
Orchid and Bamboo (19)
Plum Blossom (20)
Fine Wolf (24)

COLOR
Ink
Indigo
Earth Brown
Rattan Yellow

PAPER
Xuan

China has a history of painting birds that dates back at least 2000 years. By the Song dynasty there was a tradition of emperors commissioning bird painting. Emperor **Hui Zong**, known as **Zhao Zhe**, who became famous for his own bird paintings, gathered together many species of birds at his palace and encouraged the country's best artists to study their behavior. The artists produced delicate, detailed paintings in fine brushwork, *gongbi*, that became known as the Royal Court style, and this has influenced artists up to the present day.

From this time also, a separate tradition started to emerge, as the scholar-painters, who were highly trained in calligraphy, developed the "free brush" painting style, *xieyi*. Both the "fine brush" and "free brush" techniques were based on line rather than form. Many artists began to concentrate on bird painting as their main subject. Then birds were increasingly combined with flowers to suggest poetic and philosophical ideas. This was the birth of one of the most important genres in Chinese painting, which became known as "Flower and Bird." Artists realized that birds could give life to a painting through movement. The bird often represents the mood of the artist: happy or sad, active or contemplative. In addition, the bird was on a more equal scale with the flower, so the artists could explore their feelings about the human relationship to nature in this miniature world.

THE AIM OF THE LESSON

How to paint a simple bird to add movement to a painting

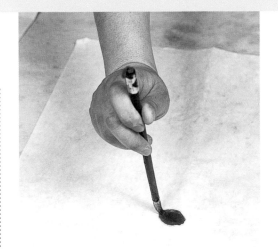

The painting of birds is a complex subject, involving the detailed study of skeletal and muscular structure. But in this lesson we show you a simple free brush method of producing impressionistic birds suitable for your flower paintings. This will help to convey a sense of movement and add expression and color. The aim is to suggest the general characteristics of the type rather than a specific bird.

We start with the sparrow, because it is one of the most typical Chinese birds. Larger birds need more detail. There are four basic steps to painting such a small bird: head, body, feathers, and eye. Sparrows are usually associated with bamboo or willow, as in the finished painting on page 83. Study this before you begin. As with clusters of leaves, look for different angles, and pay attention to the grouping of the birds. Birds fly facing the wind, which creates a contrast with the opposite movement of the bamboo.

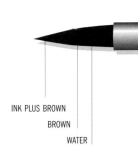

◄ 1

Load a White Cloud brush (12) with brown, mixed with a little ink, then dip the tip into slightly darker ink. Use a rounded brushstroke to paint the head and body, which are basically egg-shaped.

INK PLUS BROWN
BROWN
WATER

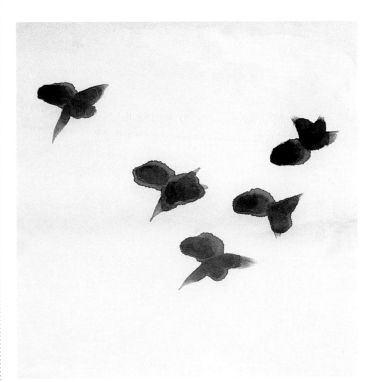

◄ 2

Add the wings, pausing before lifting the brush from the paper, thus causing the pigment to spread. This helps to suggest movement. Then add a little dark ink to the top of the head and the end of the wings. Notice that you should already be thinking about setting up the composition.

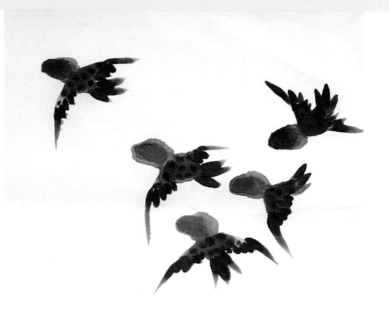

3 ▶

Using darkish ink on an Orchid and Bamboo brush (19), dab the wings while they are still wet to suggest feathers. Here you are again using the "ink breaking color" technique (see lesson six). Take special care with the strokes at the wing tips and the tail feathers.

While the pigment is still wet, use very dark ink to paint the eye and the beak using a Plum Blossom brush (20). This stage needs a great deal of control, because you must not let the ink run, even though you are painting onto wet. Finally, use a very thin Wolf-hair brush (24) to paint the feet. Remember that when the bird is flying, the feet are tucked against the body to make the bird aerodynamic.

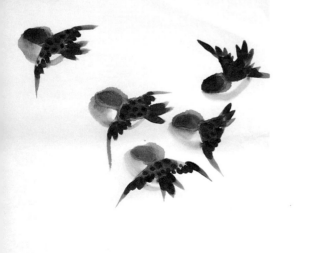

◀ 4

Use very light ink to paint the throat and outline of the underbody. The throat is usually gray and slightly darker than the breast, which can be left white.

▼ 5

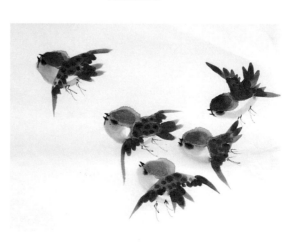

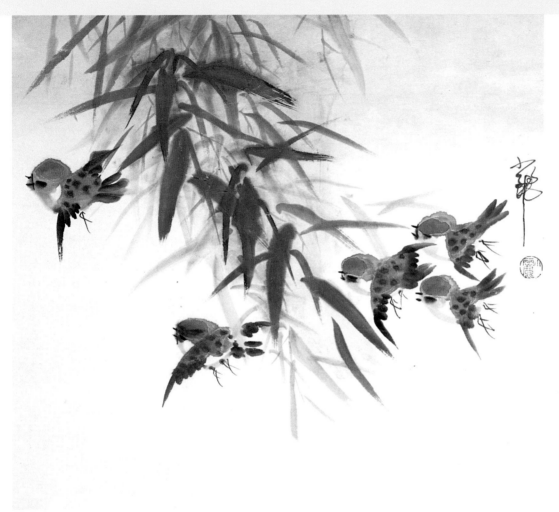

Birds Playing in Bamboo by **Cai Xiaoli**, is a finished painting using the example of the step-by-step in this lesson. Notice how the artist has differentiated between the five birds and used all the shapes. The leader is very strong. The bottom one is struggling hard to follow him through the bamboo leaves. The group of three on the right appear to be in conversation and form an interesting triangular shape. The overall group of birds forms an inverted triangle – an unstable shape that contributes to the sense of flight.

There is a correlation between the points of the bamboo leaves and the extended wings. The slightly gray background conveys the atmosphere of very early morning. The signature is reminiscent of bird flight, supporting the painting without being intrusive. The large area left blank gives a feeling of an airy space for the birds to play in.

The further examples on these pages show an exciting variety of moods and expression: two are humorous and happy pieces; and another shows the dramatic use of minimal color.

Thinking Bird by **Li Ku Chan** (1898–1986) is an excellent example of *xiao pin* painting (see information feature four). It uses the same basic technique as the step-by-step, but, the strokes for the throat, head, and back are slightly stronger and darker. The most characteristic features of different species of bird are the eyes and beak. The artist has emphasized these, making them much bigger than in reality, which adds to the humor of the piece.

DANCING

(*slim golden*)

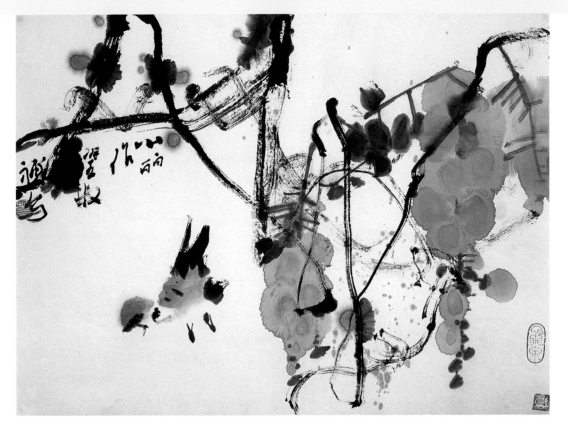

The Little Thief by **Cai Xiaoli** and **Ni Guang** is Chinese bird painting at its most simple, yet the message is immediately clear. The bird has stolen a grape and is making his getaway. This is shown in the movement of the head and eye. The vine is treated in an abstract, calligraphic manner, with the writing and seal providing balance.

Conversation Piece by **Li Qu Zhou** shows the dramatic effect which can be gained by adding just one color to the inkwork. The two birds are painted with particularly dark ink, the artist produced "flashing white" with a dry brush to indicate the feathers and character of the bird. In brilliant contrast, the atmosphere of fall (autumn) is generated by the different tones of the red leaves. The composition is also exciting. The unpainted area in front of the lower bird gives the bird freedom to fly out, and prevents the work from being static.

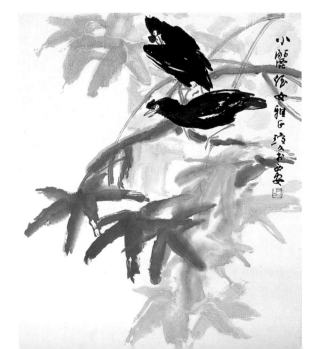

COMPOSITION

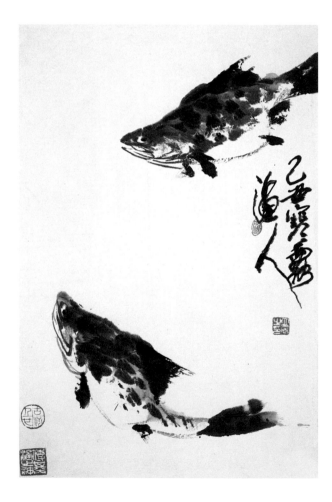

LI RIVER FISH

by *Zhang Li Chen*

*In this painting the fish form a
perfect gyratory composition.*

The composition of Flower and Bird painting depends as much on the underlying philosophical ideas of balance, contrast, and energy as on the arrangement of elements within the picture space. These ideas come from the individual artist, or from tradition, and not directly from nature. First we look at the subject; then we think about its meaning and our response to it; finally we organize the images according to these criteria. From a practical point of view, the process begins with the selection of a main element, known as the "host," and one or more related elements, or "guests." Composition is largely about the disposition of these on the paper.

In this lesson, paintings by several famous masters are analyzed from the point of view of their composition, and there are studies to illustrate particular points. In some cases, sketches have been added to help you see the host and guest relationship, their organization in the painting, and the way the energy moves.

We can only give a few examples, and these should not be regarded as infallible rules, because it is how they are applied that makes a great painting. In a finished work, several of the functions illustrated would be used simultaneously and with apparent spontaneity.

THE AIM OF THE LESSON

To learn the more common compositions of Chinese Flower and Bird painting

Choose one element as your main subject (the host), and one or more elements to relate to it (the guests). The host does not have to be in the center of the picture; nor does it have to be the largest element. What is essential is that host and guests are in a reciprocal relationship. They can be arranged in various balancing or contrasting ways: large and small; long and short; up and down; solid and void; crowded and empty; and so on. There can also be supporting images in the painting.

Study the examples here, and then take another look at the Flower and Bird paintings in the previous lessons to see how the practices apply. Remember also the advice on composition in lesson two.

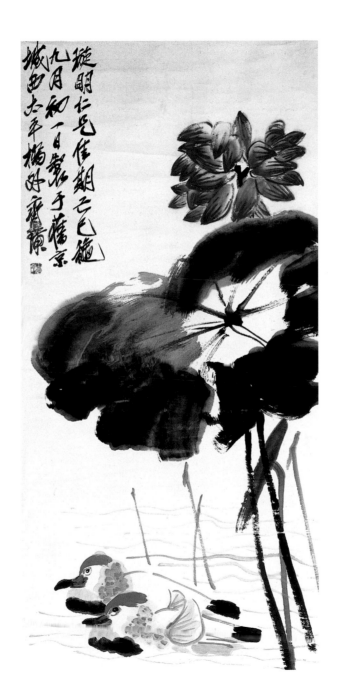

CIRCULATORY AND FLOWING MOVEMENTS

The arrows in the small sketches indicate the direction of movement.

Qi Bai Shi (1863–1957) is one of the most famous masters of the 20th century. In his **Lotus with Mandarin Ducks**, the lotus is the host and the two ducks and the calligraphy are the guests. The two movements are circular: in one, the ducks curve up toward the lotus; the other goes counter-clockwise (anti-clockwise), beginning from bottom right, where the big root supports the large leaf. At the top right, the plant inclines to the left. The impetus is taken up by the calligraphy, and then falls, to subside at the bottom left. These two movements are in tension and cause the energy to flow.

INTERWEAVING MOVEMENTS

The examples on this page show the varying approaches to questions of composition by two leading 20th-century artists. Both were influenced by the great Qing dynasty artist *Ba Da Shanren* (1626–1705).

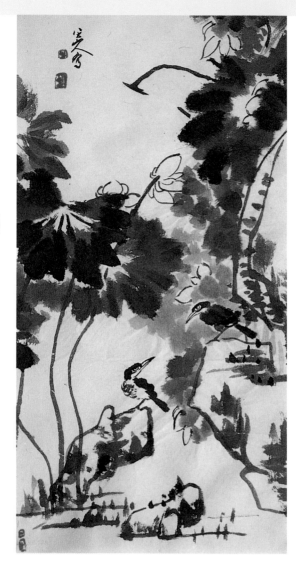

In this study entitled **Two Birds, Lotus and Rock** by **Ba Da Shanren** the most telling point is the eye contact between the birds. When you look at the whole painting, it appears complicated, but the sketch gives you the key to the movements of the *qi*. Follow the arrows to trace where it goes.

Observe how the internal structure is organized in this painting of **Autumn Lotus** by **Cai Xiaoli**. Notice in particular the relationship between line and space.

SEPARATED FLOWERS AND BRANCHES

This is where Chinese painting comes closest to Western still life. From the 10th century, artists cut branches from trees, or picked a few flowers, and took them to the studio. Sometimes they put them in a pot, but more often they simply arranged them on the picture space—making no concessions to natural growth directions; the movement could come from any border with implications of there being more beyond the picture frame.

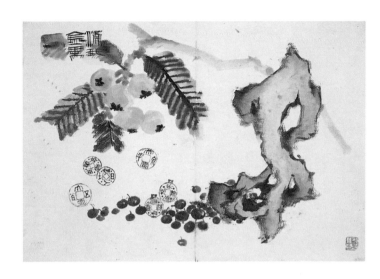

In **Fruit with Scholar Rock** by **Chen Yao Sheng**, there is an arbitrary choice of objects: cherries, coins, and *piba* (a type of plum). They were chosen because of their associations with good luck. The circulatory movement is clear, but also consider the spaces. When two of the corners are left clear like this, the picture takes on a fresh, light aspect.

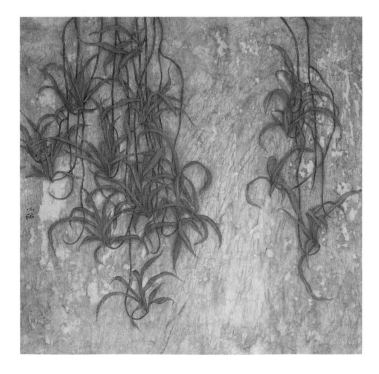

This painting of a **Spider Plant** by **Cai Xiaoli**, shows you how to select part of the plant for your painting.

CONTRAST

There are two obvious ways of creating contrast; heavy and light or large and small, but care is needed in the selection.

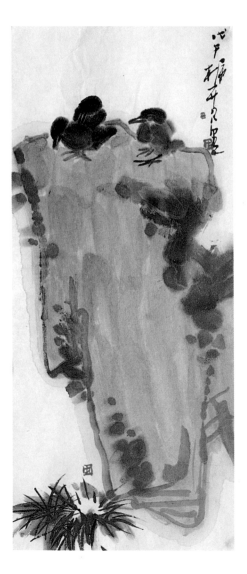

 In this study of **Birds and Pine with Rock** by **Pan Tian Shou**, the birds are the hosts. The rock, which is a guest, serves to accentuate their blackness and featheriness, by its whiteness and solidity. You must also find room for the pine, which helps to emphasize the heaviness of the rock.

SOLID AND VOID; BLACK AND WHITE

One of the most important aspects of Chinese composition is the balance of dark spaces against light ones. When you do a simple ink drawing with the brush, do not view it as merely a black solid on the white void of the paper—the white shape makes an equal contribution.

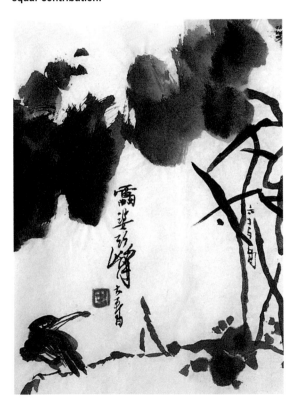

Look at this study of **Birds and Lotus** by **Pan Tian Shou** to see how the artist managed the large leaves, which take up much of the picture space. Their weight is supported by their stems and the calligraphy. The balance of the four major spaces—top, bottom, middle right, and middle left—is also vital.

MORE AND LESS

Here we consider the balance between several objects and one. The grouping of the objects needs attention, especially since they will probably be the host image.

In **Little Chicks** by **Cai He Ding**, the birds are treated as though they were children playing. An animated debate is in progress among the top group, while the painting is enlivened by the one chick walking away. The composition is supported by the placement of the calligraphy and the three seals.

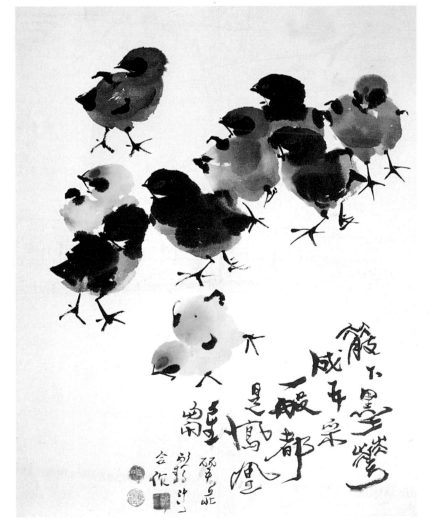

FASCINATING

(xing shu)

FURTHER EXAMPLES

When you study a great number of finished paintings, such as these four examples, you will *begin to get an understanding of the movement and type of composition that the artist has tried to achieve.*

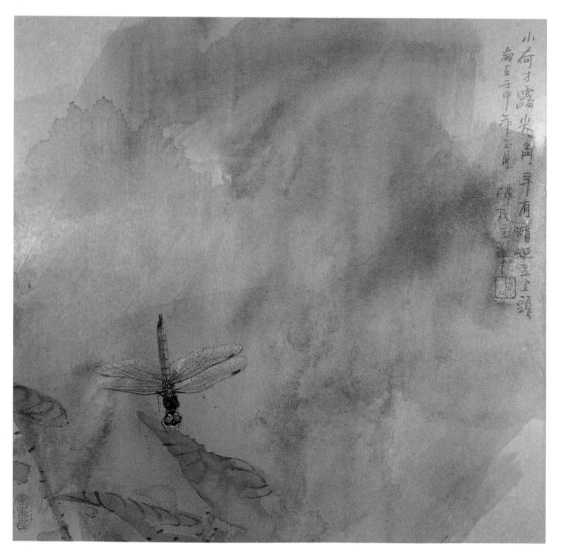

In **Dragonfly and Lotus Pond** by **Wang Ming Ming**, the contrast is between heavy and light. In this case, heavy does not mean weight, but the clearly and opaquely painted dragonfly, which stands out against the soft, transparent background. This has the effect of making the insect appear to hover.

Bird and Lotus by **Zhu Hong** is
a southern style contemporary
Chinese painting, using
decorative techniques.

In **Bamboo and Rock** by **Cai Xiaoli**, the bamboo host warmly greets
the rock, its guest. Both must be given space to breathe.

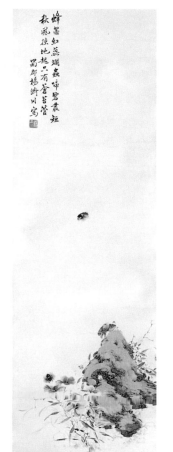

In **The Insect** by **Yang Ji
Chuan**, the empty space is
even more difficult to control,
because there is so much of it.
The smallness of the insect
relates in the mind to the whole
of the universe.

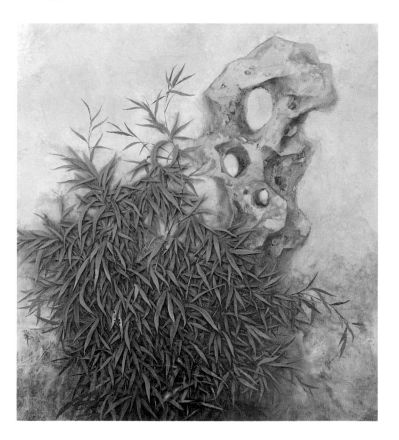

ANIMALS

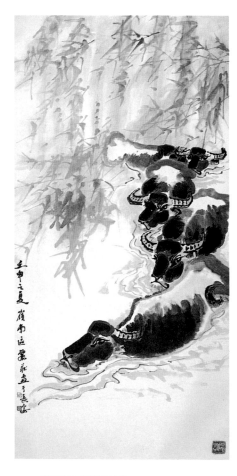

WATER BUFFALO

by Ou Li Zhuang

Notice the movement of the animals' bodies as they travel in stately convoy.

MATERIALS FOR THE LESSON

BRUSHES

L Sheep (7)

Medium Sheep (9)

White Cloud (12)

Orchid and Bamboo (19)

Plum Blossom (20)

Small Wolf (21)

Fine Wolf (24)

COLOR

Ink

Indigo

Earth Brown

Cold Red (rouge)

Rattan Yellow

PAPER

Xuan

The classification of animals alongside Flowers and Birds has less to do with subject matter than with the Chinese view of animals and their relationship both to nature and to people. Animals help to convey meaning about the position of human beings as infinitesimal contributors to some vast cosmic scheme. In this lesson, we take a microscopic viewpoint, and see how animals are regarded within the immediate environment, as part of everyday life.

The tradition of depicting animals goes back to the earliest recorded times, when animal shapes, with accompanying inscriptions, were painted by hunting peoples on the walls of caves. By the Tang dynasty, animals were domesticated, and were considered part of the family, even though they were used for working purposes. A famous painting of **Five Buffalos** by **Han Huang**, in the Palace Museum, Beijing, shows that animals were being painted with as much differentiation of expression as humans. The buffalo ranks with the horse as the most popular animal subject in Chinese painting. These two animals used to represent the differences between peasant and aristocratic life, and, even today, we can discern a distinction in the way they are painted. The buffalo is still a life-support vehicle for many Chinese living in the countryside. It is seen as hard-working, reliable, and brave. The strokes used for painting buffalo are slow and deliberate to bring out these qualities. The horse, on the other hand, is associated with nobility and speed.

THE AIM OF THE LESSON

To apply techniques already learned to the painting of animals

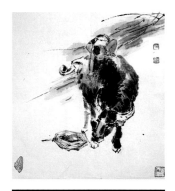

STUDIES AND SKETCHES

The xieyi (free brush) method used for flower painting can be applied to the water buffalo example (pp.95–97). Practice depicting buffalo and other herd animals in various positions, so that you can arrange them in natural-looking groups both in and out of water.

For the cat project (pp.98-99) gou and ran techniques are needed. Practice sketching the animal's outlines, and also the painting of the tail, so that you will be able to execute it with a suitably dexterous flourish.

Cat in the Wisteria, by **Lin Jin Xiou**. The cat is poised ready to pounce on something moving below. Notice how the softness of the fur is painted differently from the gnarled, old wisteria branch, even though both are pure inkwork.

You will see the buffalo in every aspect of its life in Chinese painting: working, relaxing, and playing with children. Children grow up regarding buffalo as members of the family, and spend much of the day riding on their backs. **Companions** by **Cai He Ding** shows the empathy between child and animal in the free-flowing, curving lines.

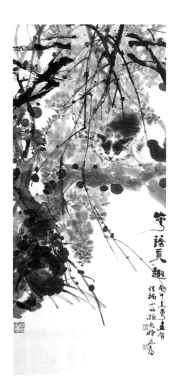

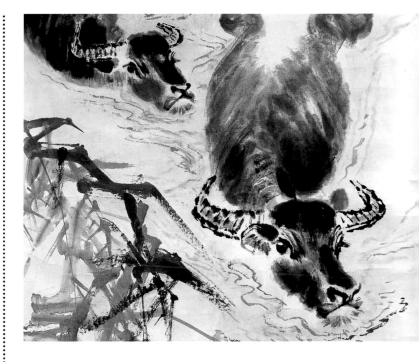

WATER BUFFALO I
This first example shows you how to paint water buffalo.

Look carefully at this detailed example of what you are aiming to paint, and consider the composition before you begin. If you are unsure you may draw the main outlines lightly in charcoal.

◄2

Draw the horns, using an Orchid and Bamboo brush (19). Do not have the ink too wet.

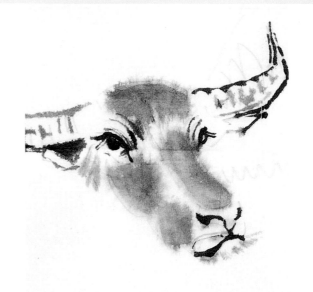

▲3

Draw the eyes, while carefully controlling the flow of ink. This is the most important feature of animal painting, because, just as in humans, the eyes express most of the feeling. Then, indicate the head with a few strokes, using a soft sheep-hair brush (9 or 10) on its side. The ink for the strokes nearest the muzzle should be wetter, and those for the jowls should be slightly dry.

◄4

Paint the shape of the body with a large sheep-hair brush (7). Do not make the hide too dense; introduce some light and some shadow. Soften the outline of the body, using clean water on a soft brush to suggest the hair.

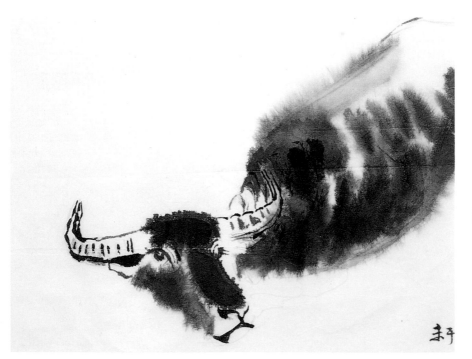

5 ▶

This shows you how to build
up the inkwork on the body.

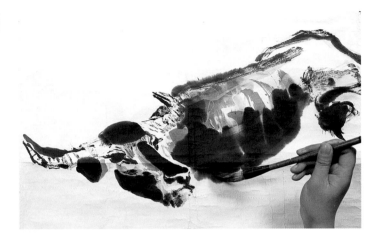

WATER BUFFALO 2
Practice painting the head of each
animal in different attitudes, so that
the animals will appear more natural
when you group them.

Color the nose, eyes, and
horns, if required.

▼**6**

▼**1**

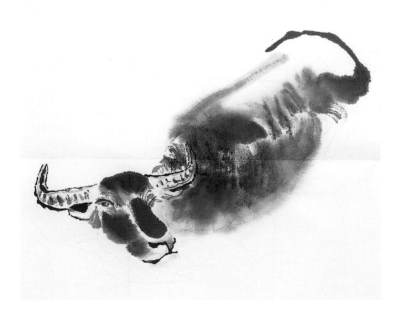

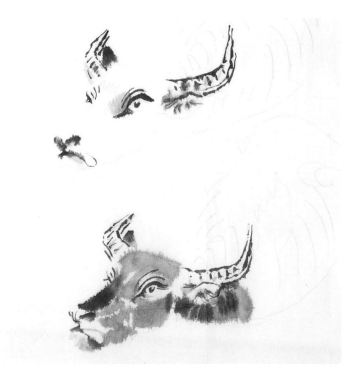

THE CAT

1 ▶

Draw the eyes and nose with a small wolf-hair brush (21). Add outlines, working from the head to the rest of the body. Use a stronger line for the ears, claws, and front leg. Draw the whiskers with a very fine wolf-hair brush (24). The fur needs a new technique: spread out the hairs of a medium wolf-hair brush (20) with your fingers, dip it in light ink and use it to follow the curves of the body. Before the ink is dry, go over the body area with a sheep-hair brush (9 or 10) loaded with clean water to soften the effect.

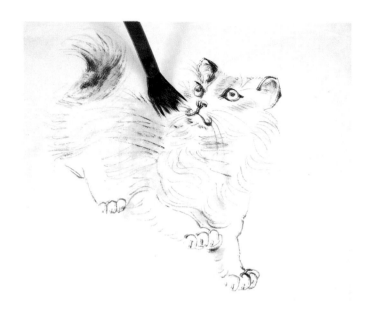

◀ 2

Use a medium sheep-hair brush (9) to put in some shading. Leave the paper blank where the fur is white. After the inkwork is dry, paint the eyes green or yellow.

▲ 3

Practice painting the tail with a flourish, on a spare piece of paper, before putting it on your picture. This is where the *qi* is transmitted and it must be done correctly, or the movement will be lost.

Take a long look al your painting to see where additional accents are needed. Leave any good brushstrokes alone. You are now trying to bring out the spirit of the painting. Make sure that the eyes, which convey the character of the cat, are the focus of attention.

▼4

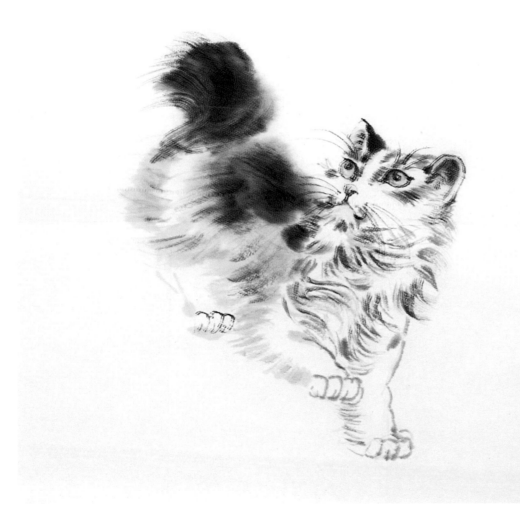

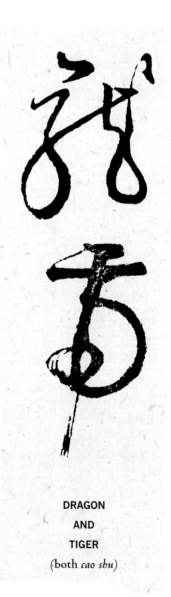

DRAGON
AND
TIGER
(both *cao shu*)

FURTHER EXAMPLES

Working animals, loved companions, noble and respected beasts: all are depicted in Chinese painting. Here are two more examples from the wide variety of wild and domesticated animal subjects.

Running Horse is by **Xu Beihong** (1895–1953), one of the most important Chinese artists of the 20th century. He excelled in all genres, but is especially known for his lively painting of horses and people. This example captures the free spirit and dynamic action of the noble beast. If you compare it with the buffalo, on p.94, you will see how the contrasting characteristics of the two animals are brought out by the different types of stroke used.

Similar techniques to those employed in the cat example are needed for big cats. The tiger is a favorite subject for the Chinese. **In the Moonlight**, by northern artist **Feng Da Zhong**, depicts the awesome creature in a realistic style.

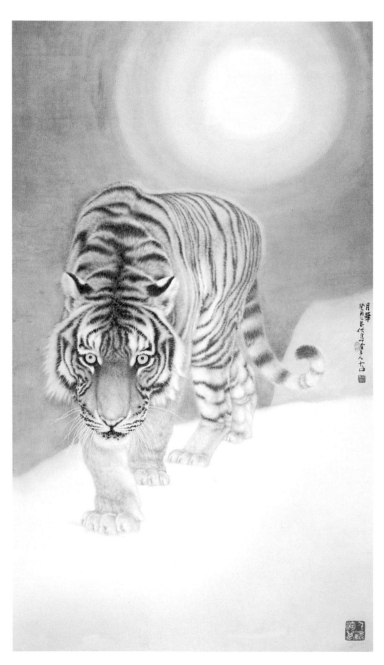

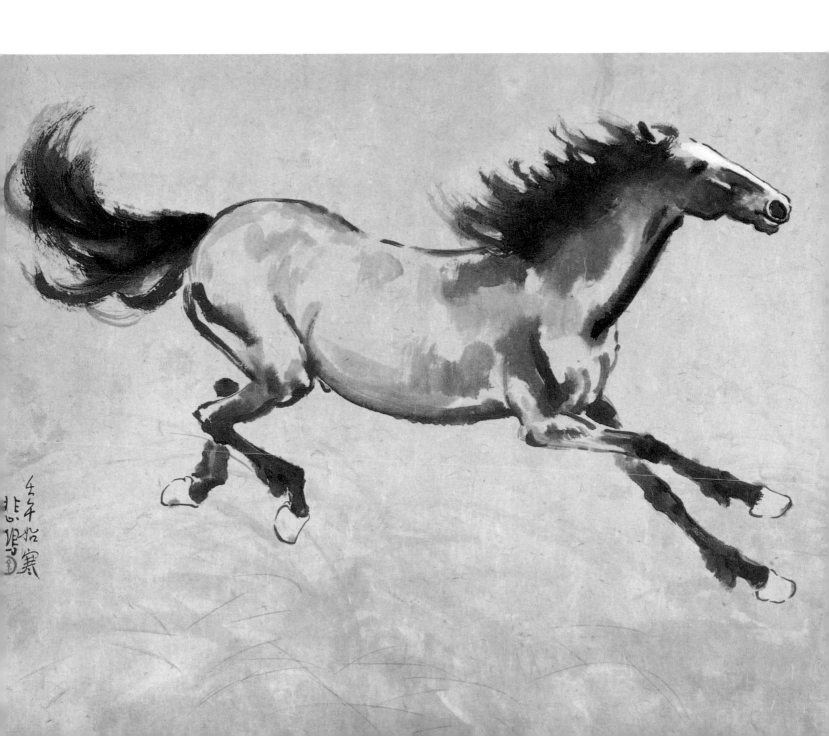

SECTION 3

LANDSCAPE PAINTING

Here we introduce more

techniques, along with

Chinese ideas of composition

in Landscape painting. We

draw lessons from the works

of past masters, and discuss

the development of

distinctive schools of Chinese

painting. The final two

lessons deal with figure

painting.

SUBJECT MATTER

**TRADITIONAL LANDSCAPE OF THE
LATE MING/EARLY QING DYNASTIES ON SILK**

Artist unknown (17th Century)

In the three paintings on these two pages, the basic techniques of *gou*, *cun*, *ran*, and *dian* can be clearly seen.

To begin thinking about Chinese landscape painting, first consider the Chinese characters for landscape. We call it *shanshui*, which literally means "mountain/water." These two features form the structure of landscape painting onto which all else is laid. To them is added a third important element, trees, which may be regarded as the adornment of mountains and water, giving them increased character and definition.

The reason why we concentrate on these features is because Chinese landscape painting is not primarily interested in how nature looks, but in how people relate to it, and how they can fathom out the intricacies of life itself by studying it. There are, of course, paintings without people in them, but even these are not concerned with a photographic reproduction of natural phenomena, but with the assembling of natural features in a significant way. Students of Chinese painting do go into the countryside to sketch what they see. However, back in the studio, these elements are selected and combined to give the greatest liveliness and point to the finished work. So a picture of mountains can engender a feeling of awe by the sheer majesty of their rendering. This sense of involvement is even more concentrated when people or their artifacts are present. For example, if you put a cottage, a pavilion, or a boat into the picture, you change its focus from a general statement about people's place in the world to the direct relationship of human beings with their particular environment.

There are two main ways to begin your study of Landscape painting. First, take a careful look at as many old master paintings as possible; and second, go into the countryside to absorb the

messages it is sending out. In China, veneration for the ancestors is taught from an early age, and even established artists copy famous paintings. They consider that they have much to learn from their predecessors, and it is also a way of paying tribute to those whom they respect. When students sit with the masterpiece in front of them, they are like apprentices learning from the greatest expert first hand. The culmination of years of study is all before them; as their eyes traverse every crevice and cataract, they absorb that accumulated vision.

When you go to the countryside, record what you see as accurately as possible. You can do this with a pencil and sketchpad, or in the Chinese way, using a block of ink, a little water in a bottle, and rice paper. The latter has the advantage of obliging you to work more quickly, and you will therefore soon learn to select the essential. Try to "read" the landscape and comprehend the message it is sending to you. File the body of knowledge that you gain from study in your memory also, so that you can select from it when needed for your own landscape paintings.

TRADITIONAL LANDSCAPE OF THE LATE MING/EARLY QING DYNASTIES ON SILK

Artist unknown (17th Century)

A practical approach to Chinese landscape could combine the following activities:

● Practicing the techniques in the following lessons
● Observing and copying the old masters that you personally find appealing
● Visiting the countryside to "read" the landscape
● Sketching from actual sites
● Reading Chinese poetry and background literature

TRADITIONAL LANDSCAPE OF THE LATE MING/EARLY QING DYNASTIES ON SILK

Artist unknown (17th Century)

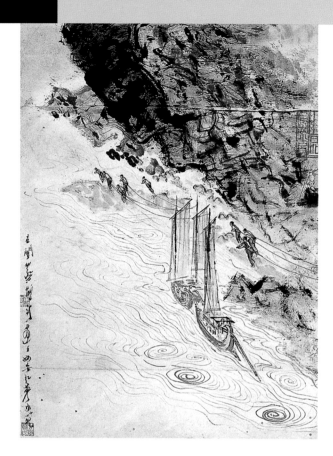

GREEN AND BLUE LANDSCAPE

by *Wang Jia Nan*

Although this is a modern work, the techniques and materials are very similar to those of early Chinese landscape painters, using a combination of fine- and free-brush techniques. The mountains are painted with translucent stone colors: special pigments made from copper and cobalt crystals. This gives them a luminosity. The trees have become very stylized but are essentially based on traditional forms. *Mi* dots (see lesson fourteen, p.121) are used to depict the shadows of the mountains.

LIFE ON THE YANGTZE RIVER

by *Cai He Ding*

This is an excellent example of the artist using natural elements to describe the human condition. It does not matter that the workers pulling on the ropes are diminutive in scale. All their toil is expressed in the heaviness of the pendulous rock overhead, which threatens to crush them. Their exertions are also described in the very active brushstrokes used to show the fast-flowing river.

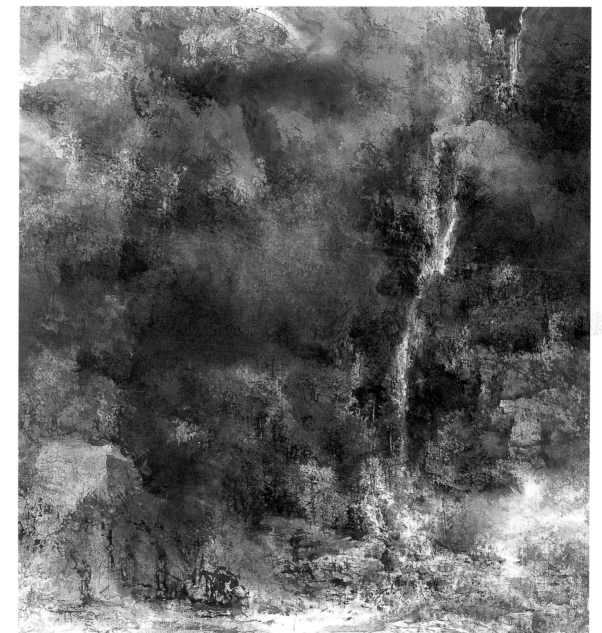

SPRING MOUNTAIN WATERFALL
by *He Bai Li*

This is a pure ink painting, using a straightforward free-brush technique, without bone. The brush performs a joyous dance over the paper, leaving its wet footprints as a record of its progress. Energy is also expressed through the tumultuous, tumbling torrent. It is like an indefatigable person always driving onward, no matter what the difficulty.

THE TWO FISHERMEN
by *Wang Jia Nan*

This painting is based on a poem which says that the two scholars have not caught any fish but they have captured a tranquillity of spirit which is more enduring, lasting the whole summer. They seem to be cocooned in a kind of nest surrounded by the trees, the distant mountains, and the lotus leaves, which incline their glossy faces in a gesture of welcome. All the lines in this work direct the attention toward the pair, and their contentment is reinforced by the harmony of the inkwork and the warm green hues.

LISTENING TO THE SOUND OF THE WATERFALL
by *Wang Jia Nan*

(BELOW) The mood of this picture of two scholars listening to the rushing water is perfectly described by the inkwork. You feel the chill of the still fall night through all the elements. The composition is interesting, with everything restricted and crowded. It is like a frieze telling a story: the narrow watercourse forces the torrent to gush with even greater force, exploding right by the pavilion where the two men sit drinking wine and thinking of loved ones far away. The huge tree is like a sentinel, barring the way, as he raises his arms silhouetted against the watery moon.

**THE RIVER
ROARS THROUGH
THE HIGH
MOUNTAIN**

AUTUMN

by *Lin Feng Mian*

In this painting of autumn, the artist has subtly
suggested the season by the judicious splashes of color.

PAINTING TREES

AUTUMN HILL

by *Wang Jia Nan*

In this modern painting a line of trees stands guard over the hill. Although the trees are not in the front plane of the picture, the eye is drawn to them by the positive, dark inkwork with which they are drawn and by the intricate yet distinctive interweaving of the branches.

MATERIALS FOR THE LESSON

BRUSHES

Medium Sheep (9)
White Cloud (12)
Orchid and Bamboo (19)
Plum Blossom (20)
Small Wolf brushes (21 & 22)

COLOR

Ink, Indigo, Earth Brown, Rattan Yellow

Landscapes consist of two main elements: mountains and water. The tree, however, is an important feature in many paintings. The contrast between the sturdy structure of the trunk and the delicate forms and groupings of the leaves is itself the subject of many beautiful pictures.

Even when the tree is not the main subject, it may be used to set the mood of the painting. It is our means of knowing whether we are looking at a southern or northern scene, and which season we are in. For example, bare trees with rugged bark are evocative of a bleak midwinter; trees in spring have branches reaching to the sky and leaves tinted with greens and yellows to suggest new life and hope. Northern landscapes tend to have skeletal trees growing from rocks, which reflect the harshness of the climate and the terrain; sunnier southern landscapes often show trees full of blossom growing on grasslands.

Another convention is to depict trees that are rooted in soil with upright trunks, whereas the trunks of trees growing from rocks are twisted or bent. Rocks provide a solid visual foundation, and it is therefore easier for the beginner to paint rock-based trees.

THE AIM OF THE LESSON

To learn some of the techniques needed for trees in landscape: trunks, branches, and leaves.

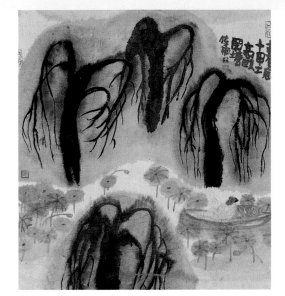

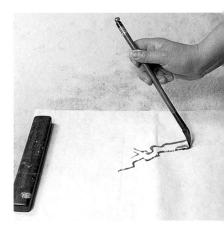

Fishing in the Lotus Pond by Wang Jia Nan. The scholar is closely surrounded by willow trees, which stand sentinel to guard his peace.

COMPOSITION

We will explore the composition of landscape in more detail in lesson seventeen. However, three points are particularly applicable to trees. First, attention must be paid to the horizontal division of space. Imagine the paper divided into three equal sections. The lowest portion is where the roots of the tree or the base of the rocks are placed. The tree often rises up from this point but does not extend far into the upper section of the picture, which should be left almost blank. These proportions reflect the infinity of the heavens above and the rooting of objects to the earth. Second, remember the overall contribution of space to a Chinese painting, especially when painting the leaves. Stop before too many details are included and when the white area is still significant. Finally, consider the impact of the outline of the shapes you have created against the white background.

TECHNIQUES

The two leading styles, *xieyi* (free brush), and *gongbi* (fine brush), are used in painting trees. Trunks and branches should be drawn with lively, fluid modeling strokes to define their structure. Once again you will make use of *gou, cun, dian,* and *ran* techniques.

The many varieties of tree are explored in detail in most manuals of Chinese painting. Here we provide you with a few simple types that you can incorporate into your work.

STUDIES AND SKETCHES

Look at old masters and make some preliminary sketches to concentrate your mind on the essential characteristics of the type of tree depicted. Try to see the trees as though they were people: some, like the pine, are steadfast; others, like the willow, are compliant.

Remember that, in Chinese painting, we are not trying to make the tree trunk appear three-dimensional. The emphasis is on the yin and yang qualities of the two sides: the sunlit and the part in shadow. Therefore we do not usually color the trunk but make use of the white paper for the decorative effects of texture.

Concentrate first on drawing the two sides of the trunk, working from the ground upward. Draw one side with a heavier line, reflecting the *yin* and *yang* principles. The dark line creates a sense of shadow on one side to contrast with the lighter, more diluted ink tones of the sunlit side. Add texture, using thick strokes to delineate the rough edges of an old tree's bark.

◄ 2

Continue building the skeleton of the tree by adding roots and a few gnarled branches.

● ● ● ●

The first step-by-step painting shows you several species of tree and a possible way of grouping them. As with Flower painting, your aim is to capture the spirit of the type and not an exact likeness. Many of the techniques are the same as those you learned in the Flower and Bird painting section of the book.

◄ 3

Put in a second, contrasting tree. Paint rocks around the root area and introduce the first leaves. Refer to the example on p.115 for basic leaf types. Notice that the trees grow crooked because they are in rocky ground.

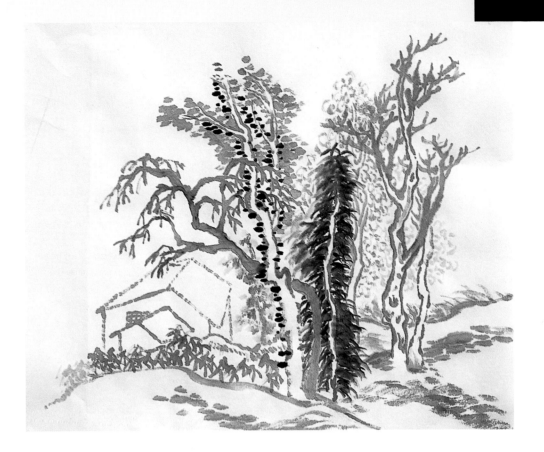

▲4

Another tree joins the back of the group, along with a dark tree put in for contrast. This is the opposite of the normal method of placing dark objects to the front, but you can break the "rules" when proficient. Make sure the inkwork is varied.

◄5

The composition is completed by placing different species to the left and behind that adjust the shape of the group. The shading is finished and minimum color is added.

BRANCHES

▲1

This painting includes two basic ways of depicting branches: the "deer's horns" accumulate branches in an upward direction; and the "crab's legs" extend downward. Practice drawing them first. Copy the examples, using light ink on a Wolf-hair brush to begin, and working up to the darker parts.

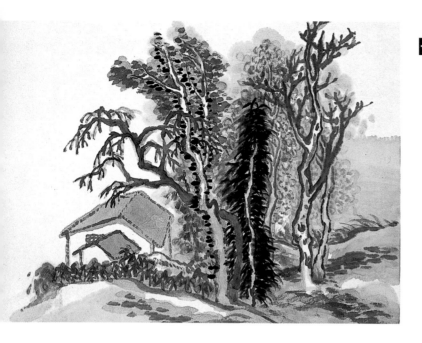

◀ 2

These two types of branches are used to show the different movements in this example. Note the left-hand pair, where the dark tree bends behind the white one, which is further accentuated by dots. A little indigo appears in the background to the black tree and the shadow of the small bamboo in front of the cottage. Brown is used on parts of the white trunk and the back of some leaves.

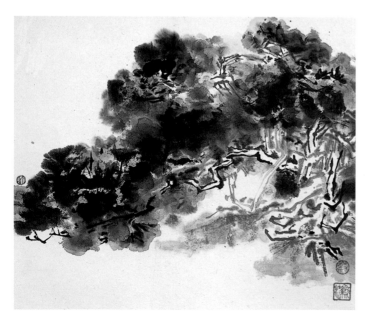

◀ 3

Many tree paintings are left uncolored. The different ink tones are enough to describe all the details. If you want to add color, use it sparingly. It should support the inkwork and not overwhelm it. For ways of coloring the leaves, see the examples in this lesson.

• • • •

TIP
Always make sure your inkwork is dark enough before adding color.

SAINT
(*xing shu*)

FURTHER EXAMPLES

The examples of leaves on these pages will be useful to refer back to when you want to include a particular type of tree in your painting. We also show you how to bring out the characteristics of the pine, and another way of grouping trees, an area that students often find difficult.

On pp. 116–117 paintings by **Wang Jia Nan** *exhibit some of the techniques and principles covered in the lesson and how different moods can be achieved.*

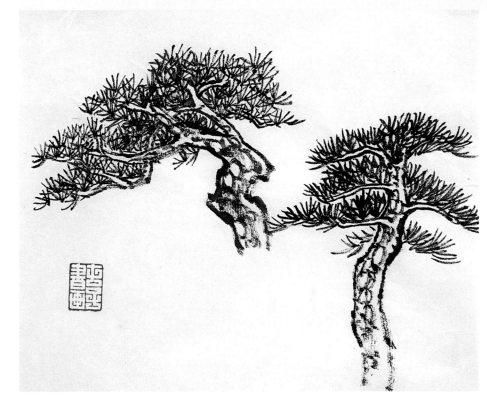

This example shows two ways of depicting the particular characteristics of the pine tree. Notice the needles and the ring-like texture on the trunk.

Here are three types of leaf painted in both *dian* (dot) and *gou* (outline). The two types can be used with color: the *dian* can be done in restrained hues mixed with ink; the *gou* is often drawn in ink before applying a small wash behind to create structural shapes in the composition.

This demonstrates to you how to arrange trees. In the group of three, the darker one is placed in front, with another crossing it; that tree also crosses behind the third and inclines toward a pair that are set slightly apart. Notice that the four rear trees lean toward one another as though in conversation.

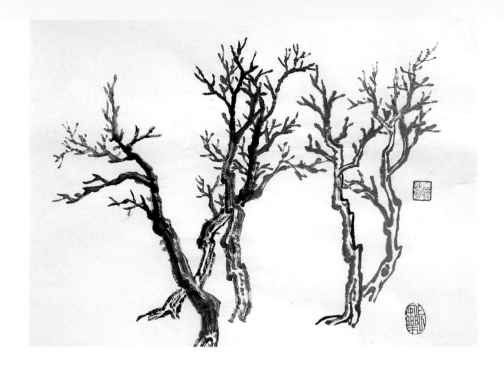

Spring Water by **Wang Jia Nan** shows a group of trees by a river in early spring. Rapidly moving water reflects the arboreal blueness that pervades the entire picture. The main tree images resemble the ages of man. The one at the top right has retained an almost perfect symmetry. The one to the left of center has become more interesting; its asymmetry, no doubt caused by the ravages of time, make the composition very active. A third is almost falling into the water. This personification is close to the feeling of the scholar-painters.

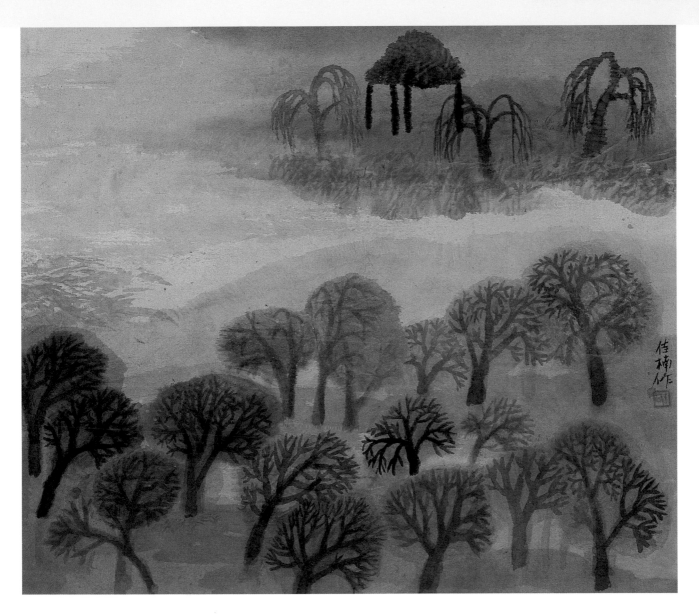

Misty Landscape by **Wang Jia Nan** depicts a late summer afternoon with the rays of a fading sun touching every image. Three willows stand close to a small pavilion, which has an early evening mist behind it. The trees to either side of the pavilion are lit from the front, creating an X-ray effect. Their trunks and branches are silhouetted in ink, and an aureole of translucent blue-green paint indicates the leaves.

MOUNTAINS

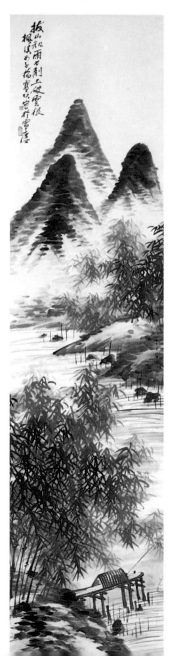

QING DYNASTY LANDSCAPE
by Yang Xue Mei

This traditional landscape suggests recession into the distance by dividing the land mass into three distinct areas (front, middle, and back), and separates them by water. The trees in the foreground help to make the illusion convincing. Such a view invites you to go on a journey through this landscape.

This lesson covers techniques for painting mountains. An entire vocabulary of terms has evolved to describe particular strokes used in painting mountains. This lesson explores the main ones. Out of the four main ways of using the brush: *gou*, *cun*, *dian*, and *ran*, the most important for painting mountains is *cun*.

Cun literally means "roughened," but it has become the general term for texturing and shading on mountains. Over the years artists have used different words to describe the various sorts of texture and shadow. These may be divided into two main categories: *pima* and *fupi*. *Pi* is Chinese for "chop" or "split," and it refers to the appearance of a surface after it has been split by an ax or a knife. *Ma* is hemp; its fibers are strong and when shredded by a knife, it forms interesting threadlike shapes. *Fu* means "ax," and it refers to marks left by the blade on a hard surface. Generally speaking, the *pima* techniques are utilized for mountains that have a covering of earth, such as those found in the south of China; the *fupi* are employed for rocky outcrops and dramatic mountain shapes of north and central China. Along with these two categories of *cun* techniques, *dian* (dots) are used: to give shading, to suggest bushes, trees, and so on, or to add emphasis. Finally, light shading and coloring may be added, using the *ran* technique.

STUDIES AND SKETCHES

You can combine the cun, dian, *and* ran *techniques in various ways in a painting, but keep to one technique for each particular area of the painting. Do not mix them within any one outline frame. You can only learn where it is appropriate to use them by continual, careful observation. Copy the examples on these pages until you become proficient. This will give you a basic vocabulary of techniques which you can apply to finished paintings. Once you are familiar with the techniques, try to identify them in the paintings you see in books and museums, and notice the preferences of individual artists.*

●●●●
TIPS
Before you start, remember: Use clean, rich ink or your strokes will lack energy.
Do not hold the brush too tightly or you will not be able to vary the stroke. Alter the pressure to differentiate your strokes.

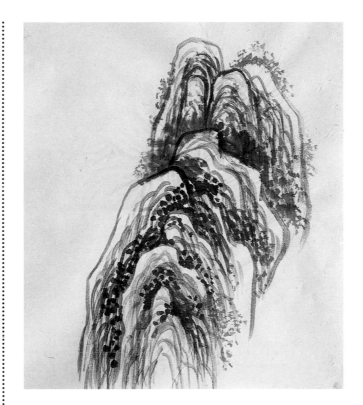

PIMA
The first three examples are pima and all use center brushstroke.

This is a long threadlike stroke suitable for mountains with a covering of earth.

This stroke is more refined than the first. It is called "lotus leaf vein," because it resembles the stroke used for that plant. Notice the delicate *ran* shading.

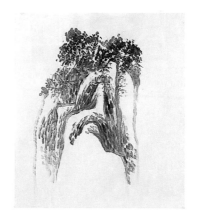

This stroke looks like a bean. It is suitable for mountains with a lot of trees on top.

FUPI

The next three examples are from the fupi group. They are done with a side brush. Start by drawing the outline, then build up the texture.

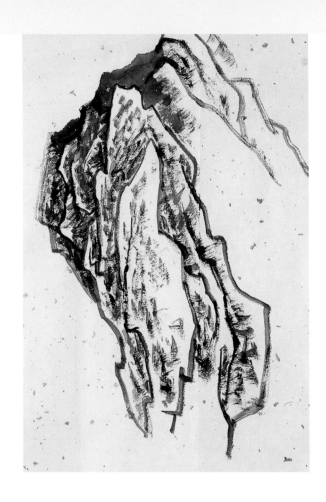

This *cun* is known as "folded ribbon" and is suitable for flat horizontal rock formations. This type is associated with some covering of earth. Although it is basically a side-brush technique, you may need to use a center brush in some places.

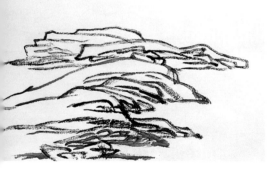

This is also a "folded ribbon" *cun*, but here it is used for hard rock with no vegetation. This is found in some areas of south China.

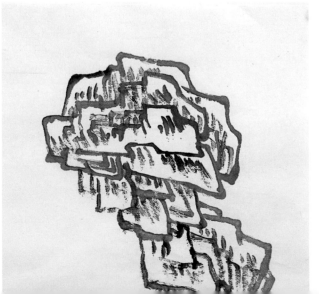

Here the ax-cut stroke can be clearly seen. Do not build the texture haphazardly. Every stroke should contribute to the whole and should be motivated by energy. Remember to vary the density of in-filling within the outline frames and to leave some empty spaces.

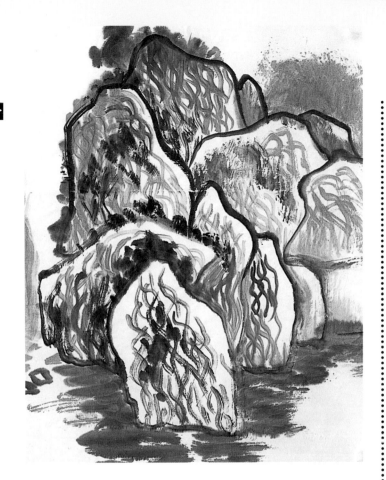

This is another example of pima. The stroke is known as "unraveled string." It is suitable for mountains where there are different textures. It goes well with plants of all types.

• • • •

Mi Fu was an 11th-century artist who invented the technique of horizontal dots to create cloudy and rainy atmospheres typical of the lower Yangtze area.

Here is an example of the *mi* dot technique invented by **Mi Fu**. It is often used for distant mountains and for misty effects. Use a flat brush, fully loaded with ink.

BLUE MOUNTAINS
(*xing shu*)

ROCKS AND MOUNTAINS

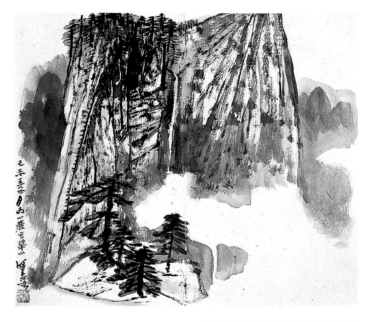

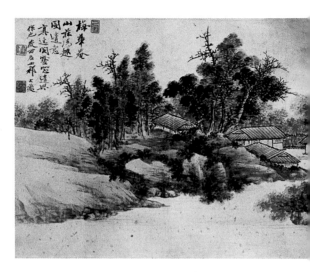

HUA MOUNTAINS

by He Hai Xia

Here the artist focused on a small section of the range, but he captured the essence of these precipitous north China mountains with assured brushwork. Positive strokes describe the texture of the rockface and the vertiginous clinging trees.

Rocks are basic to the study of mountain painting. Once again you need to consider what gives the mountains of a particular region their special characteristics. They may be seen as essentially a combination of rock and earth in various degrees. In some places, rock will predominate; in others, it will be earth. Continuing the theme of personification in which we see our world as a huge living entity, we refer to the rock as the bones and the earth as the muscle. As far as painting is concerned, this earth is a connecting tissue which not only unites different parts of the rocky skeleton but also gives it character. For example, in China's southern landscapes the earth covers the substrata, the overall impression is of an undulating landscape, while in

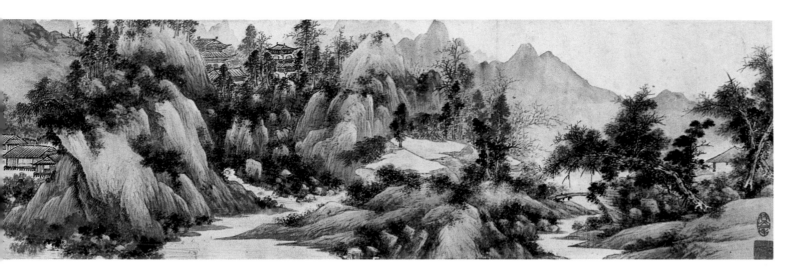

the north, the rock exerts its dominating presence, leaving the earth to cling where it may. In order to differentiate between these two in our painting, we will need to use the *cun* technique discussed in the previous lesson for the rock, and the *ran* for the earth.

In this lesson we are going to use the *gou* technique again. Just as in Flower and Bird painting, line is the basis of everything. In landscape it is especially important in establishing the relationship and flow of energy between the various elements of the composition. In former times artists called this the movement of the "dragon" in the painting. We hope that you have practiced the early lessons assiduously, because you are going to need complete control of brush and ink as you draw the line in every conceivable way: long and short, wet and dry, thin and thick, slow and fast, side and center. It is through this constantly changing line that the painting becomes active. It is the source of *qi*.

This 19th-century hand scroll by **Qi Da Kui** shows many of the concerns that need to be addressed when painting a mountain landscape. It entices the viewer to enter this enchanting world by any of a number of sinuous routes.

The mountain represents human beings reaching up to heaven. They are the body of the earth waiting to be clothed in a variety of garments throughout the seasons.

Begin your mountain studies with rocks. Practice them separately and in linked groups, and then move on to ever larger mountains. But remember that mountains are not merely rocks added to rocks. Read poems about mountains, do your own research into the work of past masters, and make sketches.

BUILDING GROUPS OF ROCKS

Mountains may be considered as the accumulation of rocks. We therefore begin with the smallest unit of individual rocks, using the gou technique.

◀ 1

Think of each rock as having three aspects, which must be conveyed differently, using a side brush. The front part, facing the sun, is dry and rough; the side in shadow is wet; and the top is thin. This gives a three-dimensional effect.

▲ 2

Begin to add slightly higher rocks behind, always considering their relationship to the first group. Use the *cun* stroke to indicate the shadows and define the form.

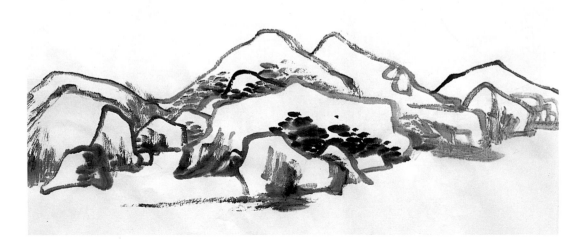

◀ 3

As you continue to add groups, bear in mind the need for a connecting line between them. This grouping is in preparation for mountains proper.

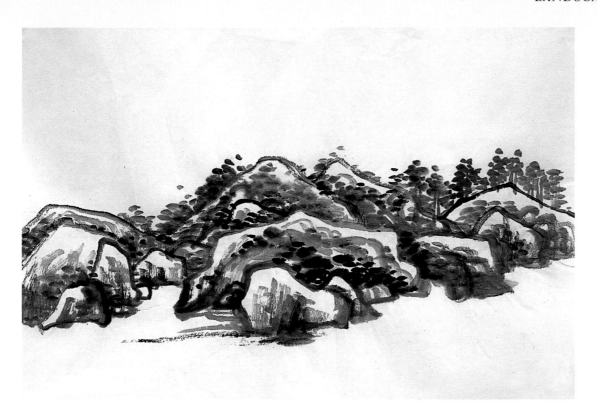

The finished painting, with
suitable trees added to
complete the picture.

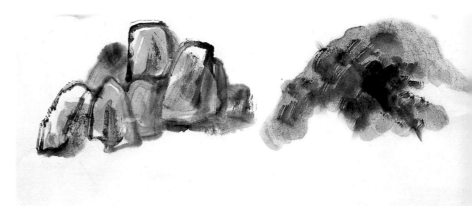

This shows you how to add color to
the rock. For the group on the left,
draw the shape with dark ink, then
use ink mixed with a little brown
and indigo to break the line (see
lesson six.) For the right-hand
group, make the texture of the
mountains with a dry brush, then
use color with light ink to break it,
which gives a soft effect of grass or
shadow.

ROCKS INTO MOUNTAINS

This example demonstrates the classic method of painting mountains and introduces elementary composition. Color was added to the finished example. You will find more details of composition in lesson seventeen, but here you should concentrate on achieving a wide variety of ink tones.

1

Start by looking at the finished painting. The foreground, middle distance, and background mountains are clearly separated by a series of horizontal planes. Yet they are connected by a serpentine line, which weaves from the group of trees on the rocky outcrop in front, past the pavilion, then slowly up the foothills of the mountains until it achieves a dizzy verticality as it climbs to the summit. The variety of tones in the inkwork supports this impression.

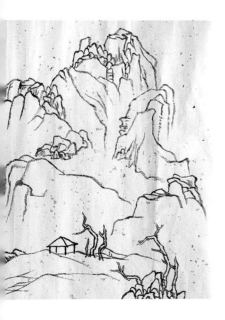

2

Set up the basic composition by using the center of a Wolf-hair brush loaded with light ink. Make sure that your spaces are well defined and that the two wings of the mountain are distinct, before they finally meet far above the diminutive pavilion.

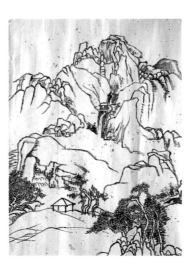

3

Paying great attention to your inkwork, add some details, such as a variety of the leaf types learned in lesson thirteen, and shading and texture, using the *cun* technique from lesson fourteen. You will also need to introduce some water.

Reconsider whether your foreground, middle, and rear planes are clearly visible. If not, use darker ink to reinforce them. In doing this, make sure that you do not negate the important connecting lines. Finally, use *mi* dots (see p.121) to highlight particular areas.

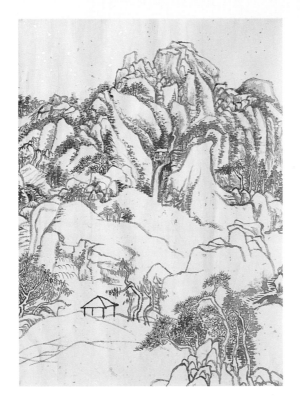

An ink sketch of the distinctive mountains in southern China's Guilin area, with the Lijiang river. This shows what you should aim for when you draw directly from nature, recording all the nuances in the rocks, the variety of trees, and the buildings that identify the location.

Spring Mountain by **Wang Jia Nan** is a modern example based on the images of traditional Chinese painting, in which the artist developed the color and techniques according to his personal inspiration. The use of line as a unifying factor is clearly visible.

The **Yellow Mountains** by **Dong Shou Ping** (b.1904–) is a typical traditional painting of this area. The brushstrokes used for trees and mountains are completely unlike those in the picture above. Compare the two to see just how distinctive and personal the style of an artist can be.

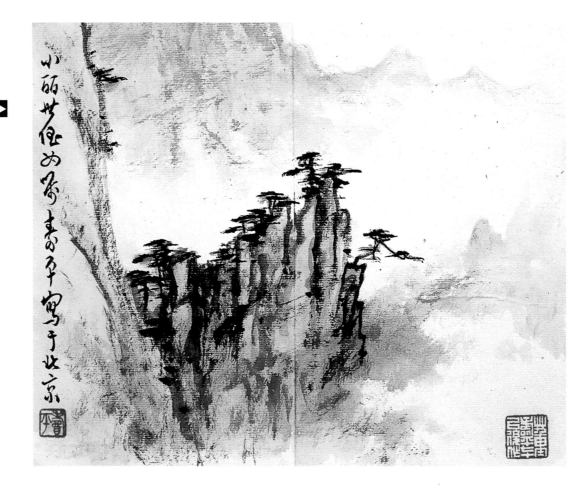

Snowy Mountains by **Wang Jia Nan** is a contemporary way of painting snow-covered mountains. But all the traditional techniques of brushstrokes, inkwork, and coloring are used to bring out the texture of the rocks, with emphasis on the play of light and shadow.

Mountains in the Sunset by **Wang Jia Nan** explores the textures of cloud and mist against the shapes of huge mountains. The painting uses the *pomo* technique of splashing ink (see glossary). It depends for effect on the combination of well-prepared ink with a generous use of color, prepared by mixing copper and cobalt crystals with glue and ink.

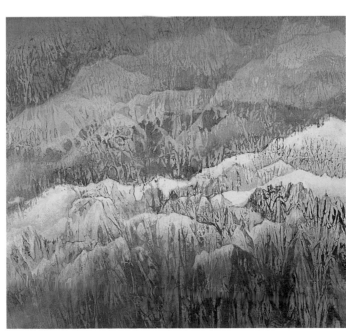

THE EXPRESSION OF *QI*

(*xing shu*)

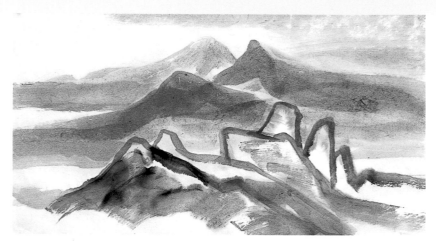

On these pages are examples of different ways of painting mountains and capturing their particular characteristics. Take special note of how the artists use the brushstroke vocabulary.

DISTANT MOUNTAINS

Our final project shows you how to depict mountains in the background of your paintings.

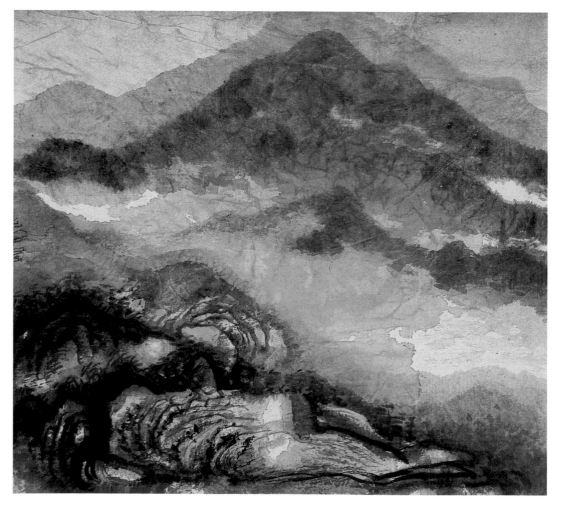

A mixture of light ink and glue is used to make the shape of the mountains in the distance. In spite of their solidity, they appear to be almost transparent.

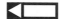

Mountain Mist is a modern painting by **Wang Jia Nan**. It shows the crucial importance of inkwork even when color is used. The texture of the rocks in the foreground is graphically rendered by sophisticated wielding of the brush. The difference in ink tone between the foreground and the rear planes makes the space patently clear. Transparent and opaque colors enhance the misty atmosphere.

Distant Prospect by **Wang Jia Nan** shows how the techniques for distant mountains can be incorporated into an advanced painting. The composition is well balanced, with a foreground, middle distance, and back. The ink and water were skillfully controlled to give the impression of a deep recession into space. This adds poignancy to the lonely figure of the scholar gazing to the horizon. If more details had been added to the background the effect of space and isolation would have been lost.

RIVERS AND WATERFALLS

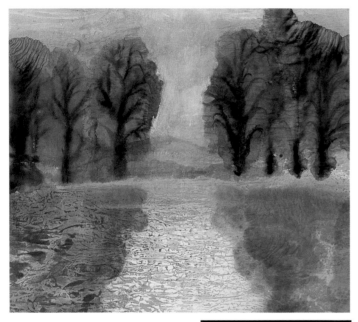

AUTUMN RIVER

by Wang Jia Nan

The autumn tones in this painting add to the serene image of the river.

MATERIALS FOR THE LESSON

BRUSHES

*XL Sheep (6),
Medium Sheep (9), White
Cloud (12), Small Badger (18),
Orchid and Bamboo (19),
Plum Blossom (20),
Small Wolf (21)*

COLOR

*Ink, Indigo, Earth Brown,
Rattan Yellow, Mineral Green,
Mineral Blue, White*

The second most important element in Chinese landscape painting, after mountains, is water. The two elements together help to explain the Chinese attitude to Nature. They are *yin* and *yang*, opposites in every way. Rock is hard and unyielding; water is soft and conforming. Yet water can penetrate rock: the soft can be stronger than the hard, and it is best to let the *qi* go with the flow. These two principles of Daoist belief are fundamental to Chinese landscape painting, which often depicts a progress or a way through difficult terrain.

Water as the main image in a painting is usually full of movement and dominating. As an accompanying image, it can be tranquil and supportive. In neither case does it depend on the space it occupies in the painting. It depends on the mood and atmosphere you wish to project. For example, in the painting titled **Spring Water** in lesson thirteen, you will see that the river occupies a relatively large space, but its purpose is to accompany the trees that are the actual subject of the painting. If you compare that painting to **Waterfall** on p.137 you can see that, although there are a lot of rocks, they are subordinate to the water. Their purpose is to reinforce and explain the power and movement of the water. The water itself occupies very little space, but its great spirit is unleashed by reaction against the rocks.

THE AIMS OF THE LESSON

To show three ways of painting water

To use water as the main or subordinate subject in a painting

STUDIES AND SKETCHES

There are many different forms of water, and you must consider how best to bring out their characteristics. First you need to understand how water behaves; then decide on the best way of rendering it. Various methods of depicting water are shown here for you to practice. Paradoxically, a favorite technique is to leave the water unpainted, and to describe it by means of the surrounding images, leaving much to the imagination of the viewer.

WAYS OF DEPICTING WATER

1 ▶

This is one way of indicating calm water. Draw the shapes of the waves with a fine wolf-hair brush, using the *gou* technique. This method is stylized and decorative.

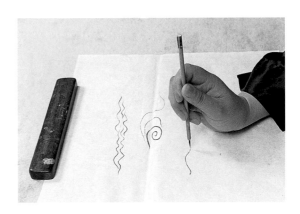

◀ **2**

Increase the effect by adding subtle shading, using the *ran* technique.

3 ▶

The conformation of the waves needs to be different to show the flow of a stronger current.

● ● ● ●

● Remember, the *gou, ran, dian,* and *cun* techniques are explained in lesson three. Also, see Glossary.

WATERFALL IN A LANDSCAPE

Our two examples are of waterfalls with distinctive characteristics. The first is more gentle and forms part of a landscape; the second is a torrent that dominates and is the subject of the composition.

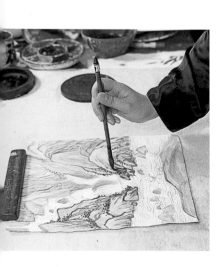

Turn the paper over and use a little watered-down mineral green to paint on the back of the rocks. Do not make it too bright. On the right side, carry out any further adjustments to balance the composition.

▲1

With light ink and a center brush, use a *gou* stroke to draw the contours of the mountain. Then begin to trace the water, which forms into eddies. There should already be some differentiation in the inkwork.

◄2

Finish the drawing, and go over the inkwork, using brown and indigo mixed with a little ink, and a *ran* stroke to soften the outlines. Without waiting for the ink to dry, use the *dian* technique to make the structural lines clearer, where necessary.

Repeat the washing techniques, but paint in different places from before. Use a second brush, loaded only with water, to wash the color well into the paper. Then add contour-reinforcing dots.

▼3

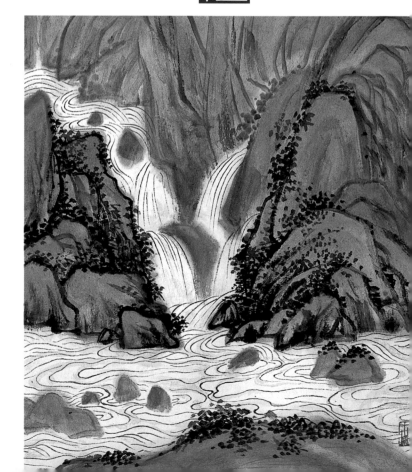

MOUNTAIN TORRENT

This waterfall is painted much more broadly than the last. For this type of technique, we say: "Begin boldly, finish carefully."

Use both the tip and side of a large sheep-hair brush to put in the main contours. Make sure that your different groups are distinct from one another.

● A more advanced technique which can be used at this stage is *pomo*, or "splashing ink".

◄ **2**

Soften the ink lines with light ink, as in the previous example. This will help to accentuate the whiteness of the water, which comes from the brilliance of the rice paper.

Add details using a *cun* technique and a brush that is half-dry, half-wet. Work more on the rocks at the bottom of the composition, which are closer together, using brown mixed with a little light ink.

▼ **1**

▼ **3**

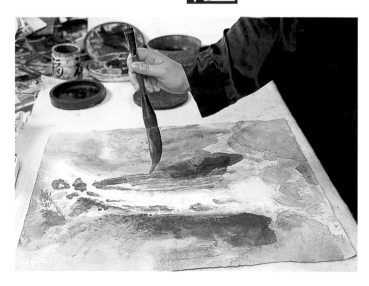

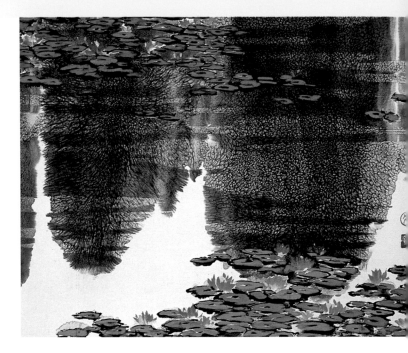

▲4

Put in more details, paying particular attention to the rocks sticking out of the water They should be carefully washed to make them more subtle, because the rushing water blurs their outlines. With very light ink, gently indicate the shadows on the water to suggest splashing. Adjust the details. Try to capture the power of the torrent as it falls from on high. The spray should convey the impression of steam. The effect depends on the differentiation of inkwork.

FURTHER EXAMPLES

Rivers and waterfalls complete the section on the main elements of Chinese landscape painting. Next we will begin putting them together in a composition. Before moving on, consolidate your knowledge by practice and by observation. Try to understand the approach of Chinese artists to landscape painting by reading poems, making sketches, and studying professional work, so that you will be able to interpret what you see in your own way.

Reflections by **Yao Zhi Hua** shows the traditional way of painting water, but with contemporary overtones. Water was used to soften the ink. The method adopted was first ink, then color. The modern touches are in the impasto on the front of the paper, and the introduction of a little opaque color on the back, behind the leaves.

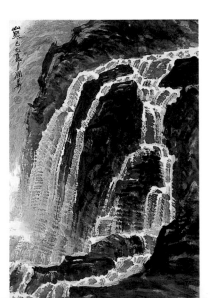

This traditional painting, **Waterfall** by **Huang Ren Hua,** uses built-up layers of ink, mixed with a little indigo. No white paint was used on this picture.

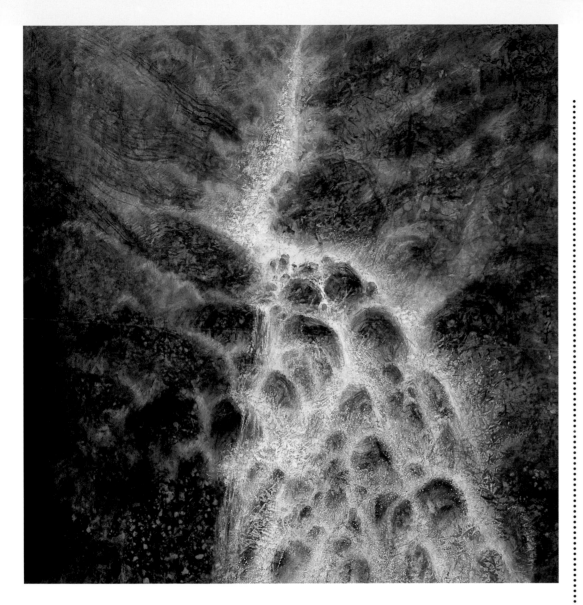

**THE POWER OF THE
WATERFALL**
(li shu)

In this painting entitled **Waterfall**, **Wang Jia Nan** used some white paint to add highlights. This artist often paints waterfalls. He sees them as a mirror of his own life's journey. He travels with energy and spirit, but is often impeded by obstacles which he must struggle to surmount.

LANDSCAPES OF NORTH AND SOUTH CHINA

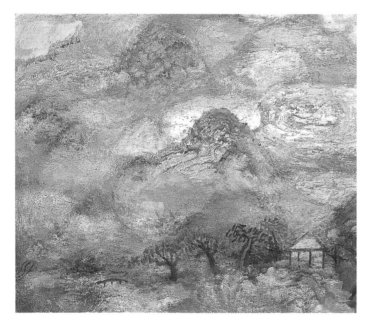

IMPRESSION OF SOUTH CHINA
by *Wang Jia Nan*

Here is a northerner's view of the south. The painter sees a welcoming land of rich colors, flowing rivers, and pavilions, where the traveler can rest for a while.

Since China covers such a vast area, it is only natural that there should be a diversity of styles, especially in landscape painting. The distinction most often drawn is between the styles of the north and south. For the Chinese, north and south means the country above or below the Yangtze river; in earlier times the area around Shanghai marked the boundary of the south. In simple terms, the south is seen as verdant, easy-going, and hot; the north as dry, harsh, and cold. Historically, there were also held to be characteristic painting styles belonging to each: fine brush in the north, and a freer style in the south.

The first attempt to divide painting in this way was made by **Dong Qi Chang** (1555–1636), during the Ming dynasty. He was a theorist rather than a great artist, and derived his ideas about the division of landscape in accordance with the situation of Buddhism at that time, which had also divided between north and south. Dong saw the northern style (epitomized by the professional court artists) as restricted by fine line work, decorative tendencies, and polychromatic coloration, especially blue and green. He preferred the southern style of the scholars, with its free brushstrokes, apparent spontaneity, and monochromatic emphasis. His ideas were influential on art criticism for a long time, but not on artists. Even in **Dong's** time, there were artists attached to the Ming court who painted in a free style, and some scholars used fine line painting.

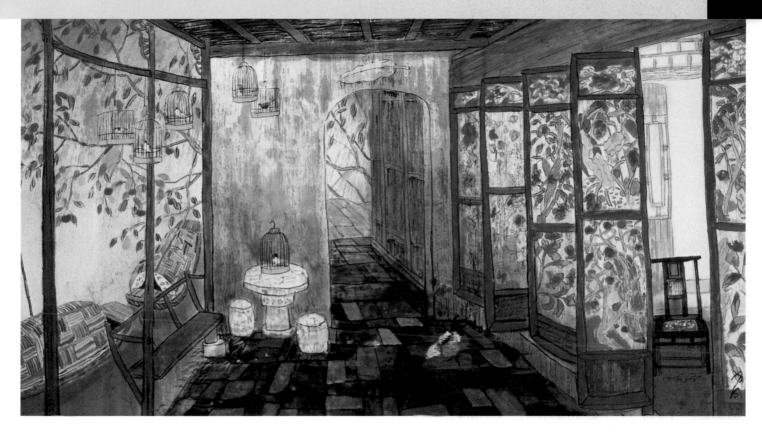

Therefore, any division on a purely geographical basis does not tell the whole story. The two basic categories of Chinese painting, free brush and fine brush, were used long ago, even before the scholars left the cities for the less restricted life of the countryside. Nowadays, artists often mix fine and free brush painting. The climate, the terrain, the architecture, all vary from place to place, and these will play a greater role than arbitrary stylistic differences in determining the artist's individual choice.

An additional element of the north-south divide that can sometimes cause confusion is the fact that Westerners often receive their first impression of Chinese landscape painting from the province of Guangdong in the far south of China, on the border with Hong Kong. At the beginning of the 20th century, a group of artists in this area, who had studied in Japan and there gained a knowledge of Western techniques, founded the Lingnan school of Chinese painting. Since the name Lingnan also designates the south, references to the southern painting style can sometimes be misinterpreted as meaning the Western-influenced approach of this particular group.

VERMILION VERANDAH
by *Fang Xiang*

This painting and the one by **Zhu Hong** on p.141, are characteristic of southern painting today, in color, subject, and atmosphere. Both express a similar attitude to life as the scholars of old. This is a land where the climate is hot, and you need pavilions and verandahs to shelter you from the sun, as you sip tea in the shade and let the world drift by.

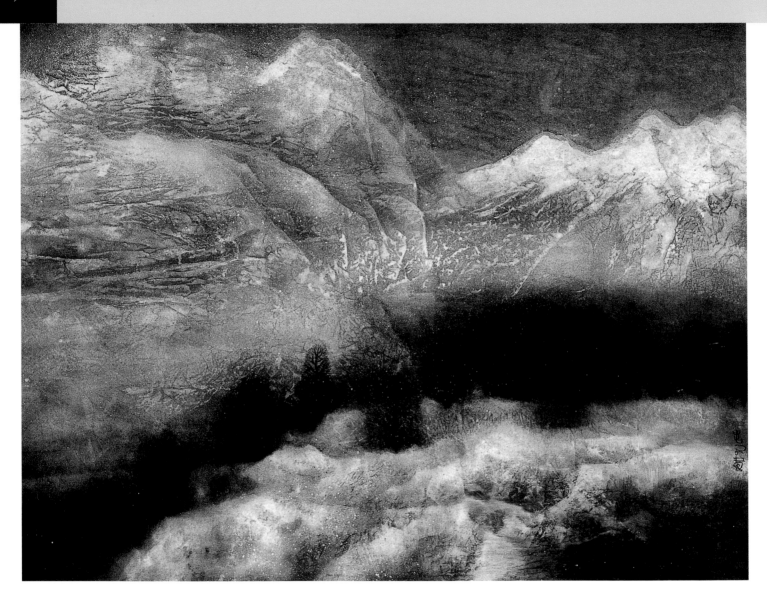

SNOWY MOUNTAINS
by *Wang Jia Nan*

This painting and **Leisurely Pursuits** (opposite) exemplify the differing regional viewpoints – and show the limitations of **Dong Qi Chang**'s pronouncements. This "northern" subject uses a restricted palette of black and white, and free brush techniques. It epitomizes the hard life in the north of China, where even the pine trees must struggle to survive. The mountains are like sheets of steel resisting the forces of winter.

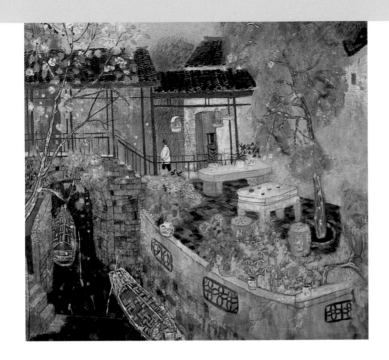

LEISURELY PURSUITS
by *Fang Xiang*

This "southern" painting, in contrast to **Snowy Mountains**, is a riot of color and is based on line. It shows a much easier way of life, with indolent days, spent amid luxuriant vegetation in the warm, humid atmosphere of a southern summer.

COURTYARD
by *Zhu Hong*

The typical black roofs of the south, the lotus pool, and the red chairs, all contribute to the mood of sweet relaxed idleness conveyed in this bird's-eye view.

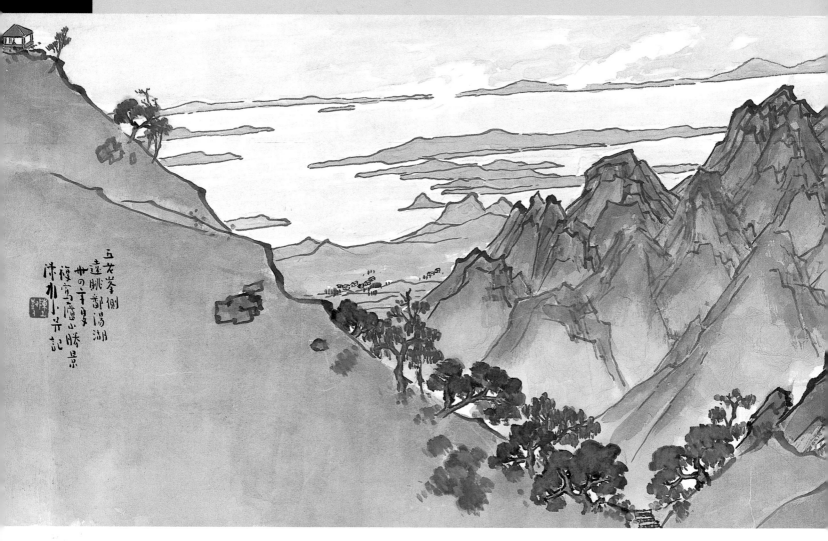

五芳峯側
遠眺都陽湖
卅の辛夏
復寫廬山勝景
陳水仙弟記

SEASCAPE
by *Chen Shuren*

This artist, along with the brothers **Gao Gifeng** and **Gao Jianfu**, founded the Lingnan school of painting. Lingnan is more realistic than mainstream Chinese landscape art. It incorporates Western techniques, such as washes and splashing. **Seascape** is typical of the school. It is painted on non absorbent paper with hard brushes, so that there is less flow and ink variation than in *xieyi* painting. It is more akin to Western watercolor. The style was admired and adopted by Chinese emigrants to Southeast Asia.

LANDSCAPE
by *Gu Rou Pe*

This example is typical of the southern style during the Qing dynasty. It is known as a "small blue and green landscape," because it follows the Tang dynasty convention of painting mountains and water with blue and green pigments. In the Tang period, the colors were vivid and jewel-like, but by the time of the Qing, more subdued colors were preferred.

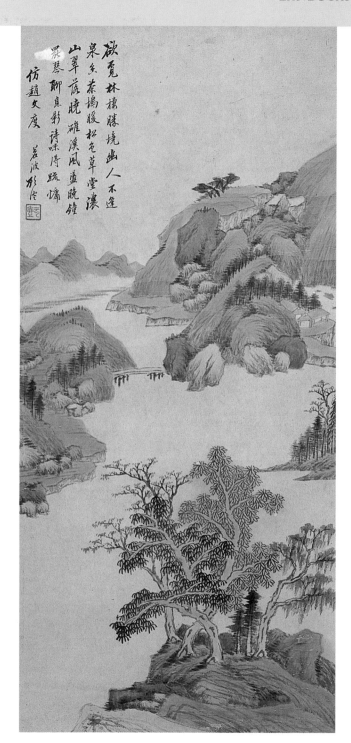

**A NEW PLANT
GROWING IN THE
OLD WOOD**

COMPOSITION

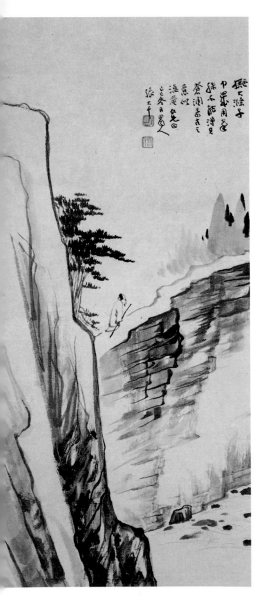

LANDSCAPE

by *Zhang Da Qian*

(1899–1983).

Here, the two dense mountain elements are connected. Energy comes through the two opposing movements of the looser parts: the river flowing one way, and the man wending his way uphill in the opposite direction.

The composition of Chinese landscape painting is about the organization of the picture area, and the important concepts are shape, space, and movement. The study of composition is about how the artist relates the first two to each other, and then introduces movement, as discussed in information feature three on *qi*.

The idea fundamental to the relationship of shape and space is once more the concept of the host and guest (see lesson eleven). Shape is largely the same as form in Western painting. Space, however, is regarded very differently. It derives from the way we think about the pure contrast of black ink and white paper. Even if the painting is colored, we must bear this in mind all the time. Space is not just the areas where there is no image or pigment. It has a positive contribution to make to the picture, which is why we must carefully control its shape and position. Movement within the picture is often referred to as the "dragon in the painting:" a flowing, energetic force (see the seal on p.149). Chinese composition is much concerned with ways of putting in movement to make the painting more interesting. In this lesson we suggest how you can relate shape and space and introduce movement to obtain different effects. These are only a selection from many possibilities.

THE AIM OF THE LESSON

To demonstrate the basic methods of landscape composition through examples from famous masters

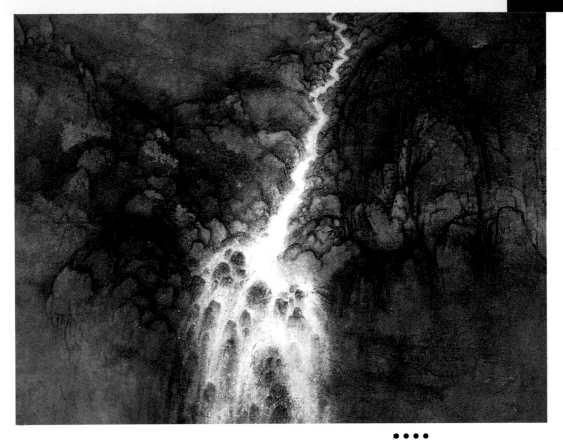

STUDIES AND SKETCHES

Many of the remarks made in lesson eleven on the composition of Flower and Bird painting apply here, but there are some important additions. Landscape is more complex than Flower and Bird painting because of the multiplicity of images. When you look at a finished painting, it is difficult to analyze the underlying structure. By concentrating on the main elements of mountain, water, and trees, you will see it more clearly.

The main format for a traditional Chinese landscape painting is an upright rectangle, within which shapes, spaces, and movements are arranged to bring out the meaning of the work. Where there is more than one section in a painting, as in the case of an elongated hanging scroll, it is considered as a whole, but each part has its own movment, which is connected to the others. A good example of this is by **Fu Bao De** *on p.146.*

SHAPE AND SPACE:
Two opposing groups in equal proportions

MOVEMENT:
Through the middle

The middle space may be filled or empty as in the next two examples. This simple arrangement has been painted since the 10th century.

In the **Source** by **Wang Jia Nan**, the energy is in the waterfall rushing between the two groups of rocks.

TYPICAL BEGINNERS' MISTAKES:

● Images with a similar degree of intensity of ink or color work are put too close together.

● Shapes are made too similar, which is boring.

● An object in one part of a painting is balanced by another exactly opposite.

● Images are all on the same level, especially background mountains.

In this study of a painting of the **Yellow Mountains** by **Shi Tao**, the arrangement appears bizarre by Western standards. The strangely configured mountains seem to confront each other across the gap, where there is a dynamic tension.

> **Shi Tao** (1641–1707), also known as **Yuan Ji**, was a Buddhist monk. He is generally acknowledged as the greatest and most famous landscape artist and writer on art of the early Qing period.

SHAPE AND SPACE:
Dense and diffuse

MOVEMENT:
Across the picture

In these examples, the mass of a form is tightly packed against other areas, where there is little substance.

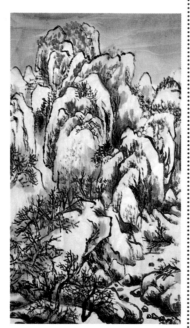

This is a study of a painting by **Li Cheng**, a great master of the northern Song dynasty. The large mass of mountains, with a more freely painted section in front, is a typical arrangement for a traditional landscape.

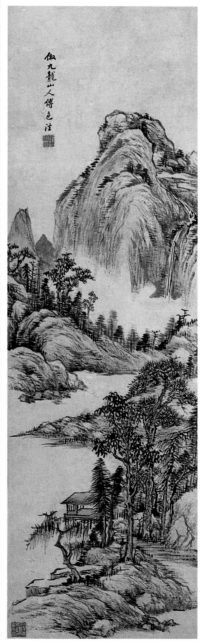

The most popular arrangement for a traditional landscape scroll was in three horizontal divisions, as in this Qing dynasty example by **Fu Bao De**. The analytical sketch shows that there are three points on which the eye focuses: the pavilion in the foreground, the middle distance promontory, and the mountains to the rear. This is not, however, an inflexible rule.

SHAPE AND SPACE:
Horizontal division into three by forms and voids

MOVEMENT:
S-shaped

One example of horizontal division into three forms and voids is the *Fu Bao De* scroll (left). This example is similarly divided, and based on an s-shaped movement, which enables your mind to travel along the river, winding back and forth.

Study of a Qing dynasty landscape.

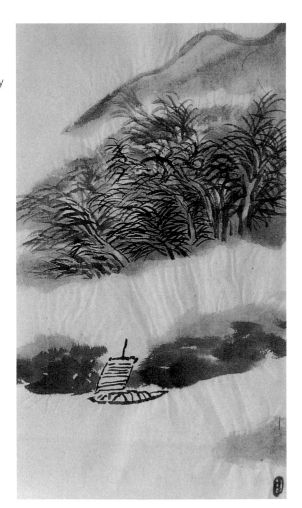

SHAPE AND SPACE:
Solids and voids

MOVEMENT:
Various

The balance of large and small shapes and spaces is one of the most enduring arrangements in Chinese landscape painting. Imagine them as white and all the shades of black. Even in a colored image, the forces of black and white prevail.

Study of a work by **Ba Da Shanren** (see p.88), also known as **Zhu Da**. He first became a Buddhist monk, then turned to Daoism. During this period, he was at his most creative. Notice how the three major empty spaces and the small spaces throughout the painting are related to each other and to the shapes.

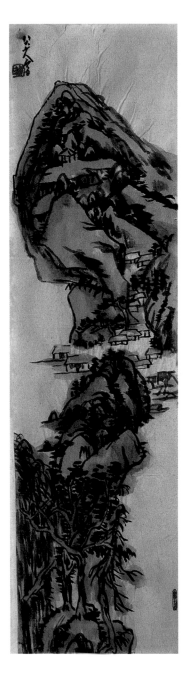

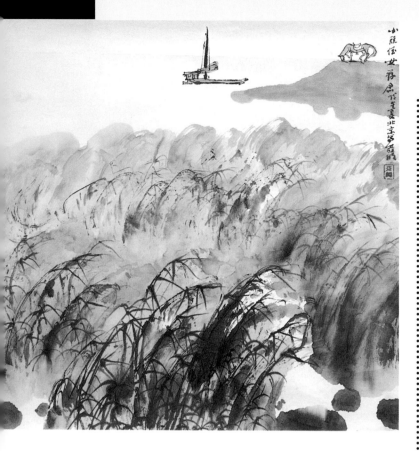

Anchored by **Ya Ming** is another good example of the balance of solids and voids, and black and white. Notice that it is absolutely clear that water is there, without its being painted. This extraordinary composition draws your eye toward the boat. The casual atmosphere is brought out by the grazing donkey.

SHAPE AND SPACE:
Corners and flat forms

MOVEMENT:
Various

The idea of the importance of the corner began in the 11th-century Song dynasty, when a landscape artist named *Ma Yuan* left some of the corners blank "as a means of escape from the Mongolian invaders." He became known as *Corner Ma*. The practice remained popular up to the present. The flat shapes are another way of making a contrast with large mountains.

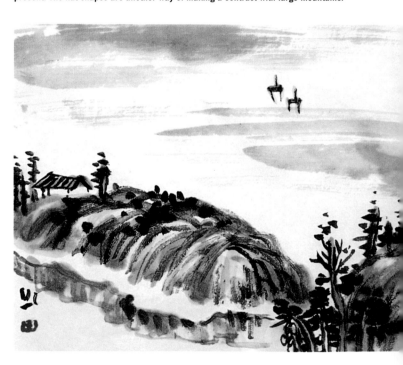

In this study of a work by **Shi Tao**, the corners are bare. The back areas are left flat, and the scene is pushed to the front.

This copy of a Song dynasty landscape by **Guo Xi** was done by **Cai Xiaoli**. It balances the bold mountains against a series of flat planes on the right-hand side, receding into the distance. In this arrangement it is difficult to take care of the corners, because of the mountains blocking the way, but the artist was inspired to put a waterfall at the bottom left-hand corner to lighten that area.

• • • •

Guo Xi (active 1068–85) followed **Li Cheng** in landscape techniques. He was a brilliant art critic as well as artist, who worked for the court of the Emperor **Shen Zong**. He said you should not only admire a good landscape, but live in it.

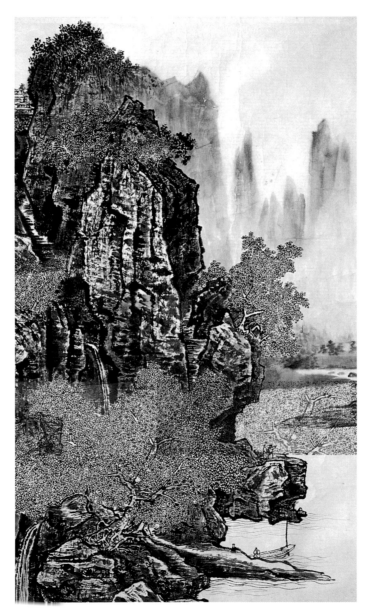

SURVEYING THE SCENE
(*kai shu*)

TIP
Above all don't break the dragon shape!

The more finished paintings by masters you study, the more you will be helped to avoid the typical beginners' mistakes listed on p.145.

This landscape by **Wang Jia Nan** is a contemporary interpretation of the "movement across the picture" idea shown on p.146.

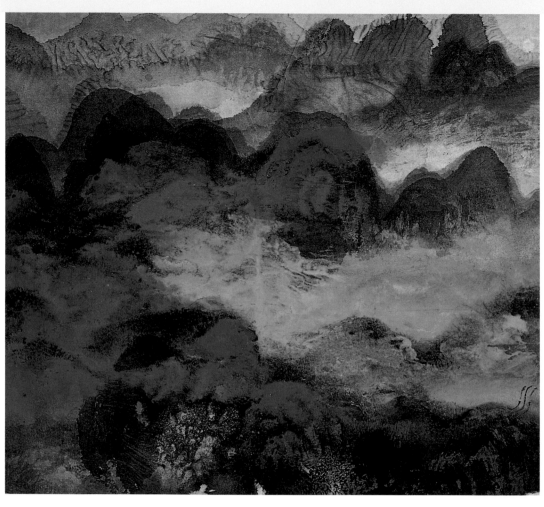

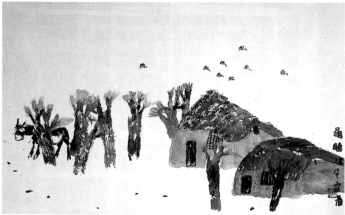

In a black and white arrangement, the white space should be the dominating image. In **Cottage in the Snow** by **Nie Ou**, notice how the white paper is used to bring out the snowiness of the scene. The shapes here are very telling.

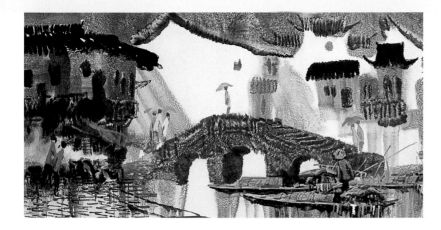

Spring Rain on Jiangnan Lake by **Xu Xi** also shows the effective contrast of black and white. This example owes much to the simplicity of woodblock prints (see information feature nine).

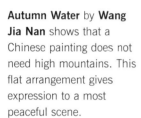

Autumn Water by **Wang Jia Nan** shows that a Chinese painting does not need high mountains. This flat arrangement gives expression to a most peaceful scene.

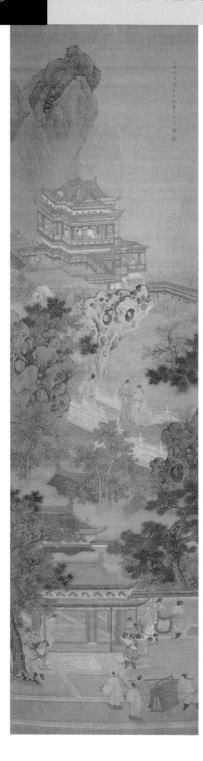

RECEIVING GUESTS

by *Chen Zhuo*

This painting employs several conventional devices. The figures and houses are a similar size, no matter where they are in the painting. The mist swirling up around the buildings suggests space between one plane and the next.

PERSPECTIVE

Perspective, in the Western sense of solid objects being accurately related to one another and diminishing in proportion as they recede into space, does not exist in Chinese painting. However, there are criteria for dealing with three-dimensional forms. The most important is that the viewer must feel comfortable when looking at a picture. In information feature six, we saw that the Chinese artist's main interest lies in exploring people's relationship to nature. Perspective is best considered on that basis. In order to establish the optimum view for painting and for viewing, the artist continually shifts position. Therefore, within a single painting, the artist will take as many different standpoints as necessary to present the complete picture. More than one angle may be chosen, and the back and front of objects may be shown at the same time. It is like a photographer taking a series of shots of a scene, and then making a montage. There are no rules for the selection of viewpoints. Artists organize the elements according to their personal ideas. This approach is said to have originated as far back as the Northern and Southern dynasties. Another accepted convention of Chinese perspective is that you employ certain devices to suggest height or distance, which are not scientifically accurate. What is important is the impression the viewer receives.

The continually shifting viewpoint has two major implications. In Western art you can have a person standing in the foreground, drawn larger than a mountain behind. This is impossible to the Chinese way of thinking: everything must maintain its correct relationship. Since a person is manifestly not bigger than a mountain, he or she must be shown as smaller. Second, if you want to show a person looking at several objects in the

same painting, you must make them all the same size. The person changes position in order to look at them from the same viewpoint (see the examples on the right.)

One of the first major artists to talk about perspective was **Guo Xi** (active 1068–85), who said that there are three ways to show distance in paintings. The first is *gao yuan* (high distance). This is suitable for stressing the extreme height of mountains. The viewpoint is taken from the bottom, looking up. It makes the mountain appear to be toweringly steep. The effect is gained through shape, not through proportion. The second method portrays *shen yuan* (deep distance). The intention is to make the mountains appear to be behind one another, so that you feel there is no end to the recession into space. The third distance is the flat, horizontal distance already described in lesson seventeen. To these traditional examples of perspective, we can add a fourth: *mi yuan* (misty distance). A scene viewed through mist, cloud, or rain appears to continue to infinity.

The artist

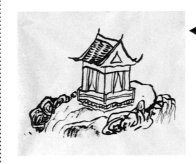

The artist

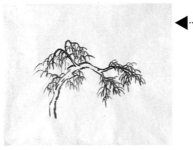

The artist

Shifting viewpoints
(LEFT) An artist looking at several objects in the same painting sees them all from different viewpoints. The artist changes position in order to look at them from a new angle, then groups them in the painting.

● ● ● ●

A BOUNDLESS WORLD
In the 5th century, **Zong Bing** wrote in *An Introduction to Landscape Painting* that a 3-inch (7.5-cm) high painted mountain is the equivalent of 7000 feet (2100 m) in the real world, and that one brushstroke was equal to 100 miles (160 km).

● ● ● ●

CHINESE PERSPECTIVE
Chinese painting is concerned with using perspective in a symbolic way. One element in a picture leads to another, without end. By inference, the artist and the viewer are connected to all the life that has gone before, and all that is to come. You cannot see either your ancestors or your heirs from where you stand, but you are aware of their existence.

PING YUAN
(Flat distance)

This painting entitled **Winter River**, by **Wang Jia Nan**, shows the effect of flat distance clearly. The river winding away from the foreground to some far destination inspires a feeling of sadness, partly because of the flatness used to suggest distance.

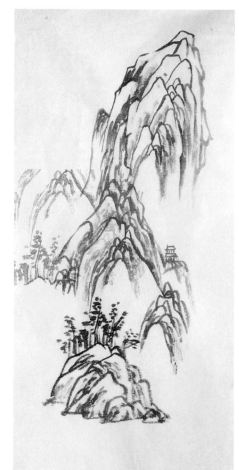

DEEP DISTANCE

In his book *Lin Quan Gao Zhi*, **Guo Xi** wrote: *"From in front of the mountain and above, you should be able to see the back."*

GAO YUAN
(High Distance)

(RIGHT) This viewpoint from below emphasizes the height of the mountains, giving the appearance of a soaring heavenward sweep. Notice how shape helps to convey the effect.

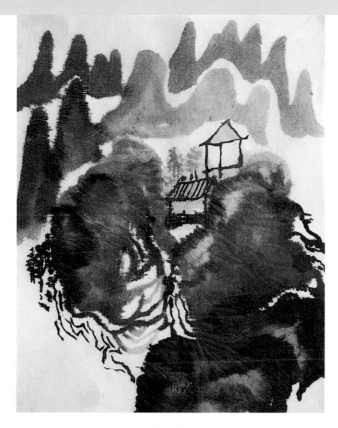

SHEN YUAN

(Deep Distance)

Portraying the mountains as if they were behind one another creates an impression of endless recession into space. Use this type of perspective for an atmospheric painting where the colors of the mountains change as they recede.

• • • •

MISTY DISTANCE

In the Tang dynasty, the poet **Wang Wei** wrote:

"The river flows to the limits of heaven and earth; The mountain color hovers between thin and unthin."

This is a paradoxical Daoist idea that something can exist and not exist, at the same time.

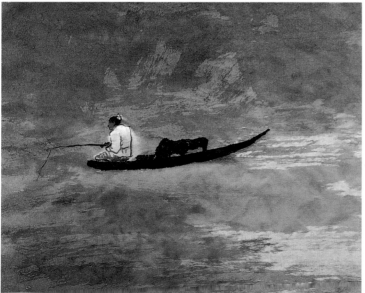

MI YUAN

(Misty Distance)

A veil of mist, cloud, or rain over a scene creates a special atmosphere, because you can feel but not touch it, and it appears unending. This is a useful way of introducing mood into a painting.

TWO MOUNTAINS JOINED BY A BLUE RIVER

INTRODUCING BUILDINGS, BOATS, AND BRIDGES

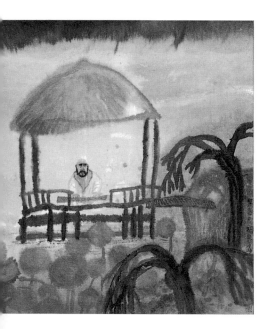

PLAYING THE ZHENG IN THE PAVILION

by Wang Jia Nan

In this painting the scholar's needs are fulfilled by simple surroundings: a wooden structure built over a lotus pond, with a roof made of rice grass for shelter.

MATERIALS FOR THE LESSON

BRUSHES

XL Sheep (6)
Medium Sheep (9)
White Cloud (12)
Orchid and Bamboo (19)
Plum Blossom (20)
Small Wolf (21)

COLOR

Ink, Indigo, Earth Brown, Rattan Yellow

Glue

PAPER

Xuan

Man-made objects, such as buildings, boats, and bridges, are not usually the main subject of a traditional Chinese painting. But their inclusion can convey the character of a region, and tell you more about the scene, or highlight essential features of it.

As soon as you put artifacts into a picture, you make a statement about the relationship between human beings and their environment. Buildings have an important function. The Chinese think that a building should both reflect its intended purpose and be fitting for the type of person who is going to use it, as **Wang Jia Nan**'s picture of the scholar in his pavilion shows.

Boats also serve figurative and informative functions. For example, a ferry means that people are arriving or departing: a cause for celebration or sadness. On a practical level, water transport is central to Chinese life, both for work and pleasure. Not only is the country traversed by three great rivers, but it contains a large number of lakes.

Many towns in China are built near water, and to cross a

THE AIM OF THE LESSON

To give added meaning and character to landscapes through the introduction of man-made objects

bridge is symbolic of leaving on a journey away from loved ones. It was once the custom to accompany relatives and friends to the limits of the city to bid them farewell, so the bridge was often the scene of much sadness. Bridges were also used as a practical way of crossing deep ravines and other difficult terrain, but since they were man-made, they were seen as a spiritual link between these much-admired natural features. In painting, they carry the *qi* across a space so that the flow is not interrupted.

In **Li Hua Shun's Living in the Mountains**, the tent echoes the form of the mountain, showing how closely the owner identifies with the surroundings. The flock of birds and the conformation of the trees also imitate these shapes. This makes for a total unity of idea and image. The brushstrokes reinforce this: a fine Wolf-hair brush for the details of the tent, trees, and boat; a soft Sheep-hair for the broadly painted mountain.

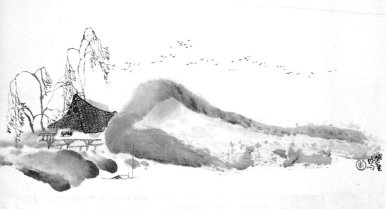

STUDIES AND SKETCHES

When you add houses to a picture, you alter its impact. White walls and dark roofs will draw the eye, and you must make sure that they do not overwhelm the subject. Conversely, they lead the viewer into the painting, acting like the eyes in a human face, and telling you more about the people who inhabit the land you are depicting.

Build up a repertoire of buildings, boats, and bridges, so that you know them thoroughly enough to portray their essential qualities. Copy the following examples several times and take note of the different brush techniques. Remember to connect similar elements. Observe examples in context, and be careful to choose the appropriate type and painting style for your picture.

It is not easy to introduce man-made objects into a painting successfully. Practice the individual elements, then experiment boldly.

BUILDINGS
Copy these examples, so that you can use them later in your own paintings. They show you how to represent and group houses, how to distinguish the types of house encountered in north and south China, and how to depict just two buildings in relation to each other.

This example and the next show the level of detail suitable for a village seen in the middle distance. Houses like these, with roofs made of rice grass, might be found north of the Yellow River.

The white walls and black roofs of these houses are more typical of the area below the Yangtze river.

Remember to establish links between buildings. These two double-tiered pavilions are similar but different, and stand in a reciprocal relationship to each other.

This example shows you how to paint a group in the foreground. You will need to include more details of the roof tiles and set up the relationship of the houses to the trees. This sort of construction, on stilts over water, is a popular way of building Chinese tea-houses.

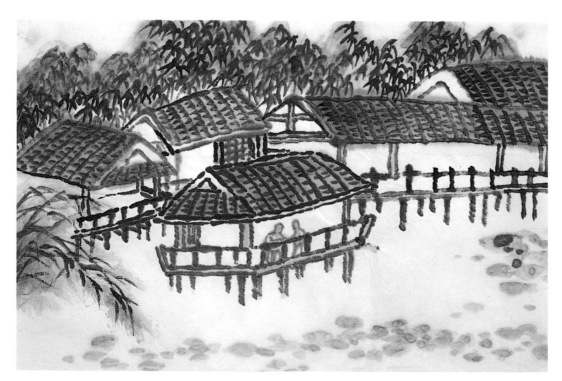

BOATS

Here is a variety of boats to copy and learn. When putting them into your paintings, you will need to decide whether or not to paint the water. Often you can leave the paper blank, as in these examples, where a reflection is all that is necessary to convey an impression of water.

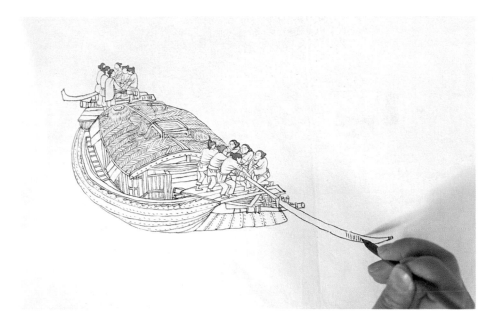

An old-style ferry boat. Notice how the wrist has to be rested on the table when you paint fine detail.

Although this is a 10th-century boat, the shape and method of construction remained the same until the 20th century.

This is a pleasure boat of the kind that a scholar might use. Unlike working fishermen, scholars could look upon sailing and fishing as a carefree pastime.

A close-up view of a similar boat, with figures, enabling you to study and portray the vessel in greater detail.

▼▢

▲▢

A similar type of boat designed for enjoyment. Between heaven and the water, the scholar could be at peace with himself, in an indulgence of calm.

BRIDGES

The bridge in a painting must suit the mood and the location. The following three pictures give examples of different types of bridges to use for varying purposes.

People gather on the town bridge to look at the fish in the water below, or simply to lean on the rails and gossip. A strong wooden bridge like this would be at the heart of community life.

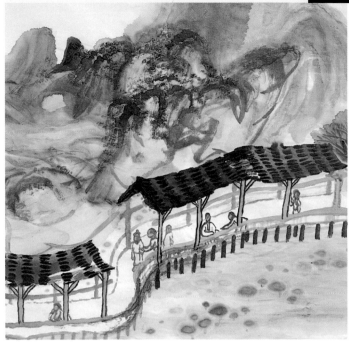

Some bridges are used mainly for decoration and pleasure. Many small lakes in Chinese gardens have a zigzag or serpentine gallery bridge, where friends can meet to watch the goldfish, admire the lotuses, or look at a view of distant mountains. Artists are fond of painting from bridges like this.

This is the typical shape of a stone bridge in China. Here two friends say goodbye; who knows when they will meet again?

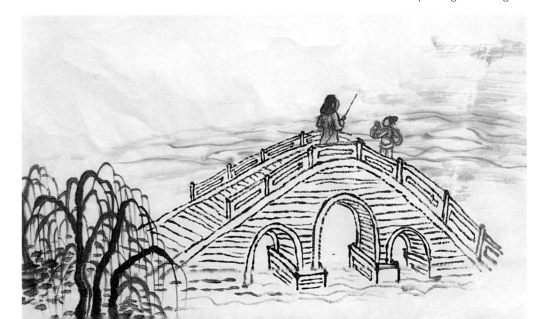

BRIDGES AND LANDSCAPE

▲ 1

Paint the mountain shapes with a large Sheep-hair brush. Draw the outline of the bridge, which will be the connecting feature between the two masses.

2 ▶

Build up the higher mountains behind, making sure that you differentiate the inkwork. Add boulders in the course of the river. Notice that the whiteness of the paper is used as the reflected light on the water, so that it stands out between the darkness of the mountains and acts as a foil for the silhouetted bridge. This is one way of making the *qi* flow across.

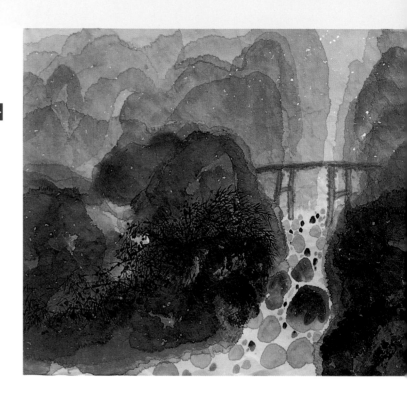

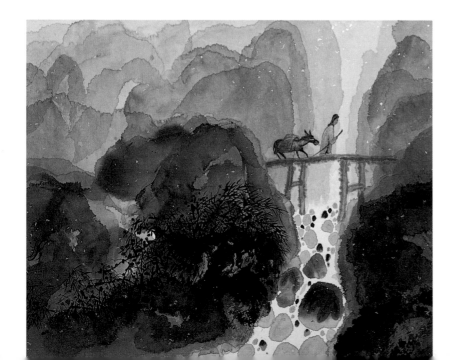

◀

The focus of this painting is the bridge, which is kept simple, without a barrier rail, suggesting the insecurity of the human journey through life. Complete the scenery with a few jet-black details for the foreground bush, and some stones in the river. The final touch is to add the scholar, who urgently presses homeward, while his donkey is more reluctant. The painting is full of energy, with the luminosity that often precedes a storm. The dotted paper conveys the effect of snowflakes being whipped up by the wind.

莫寫

**RESEARCHING
AND
COPYING**
(li shu)

*Even when there are no humans
in a painting, we gain powerful
clues to their character and way
of life through the symbolism of
the man-made objects, the
perspective from which these are
shown, and the firmness or
delicacy of the strokes with
which they are depicted.*

Palaces are traditionally painted by
the method of drawing with a ruler
known as *jie hua*. This style
records all the architectural and
decorative details. It is especially
used for religious and mural
paintings.

夜泊錢塘
江頭沙水
無波良盡
天淡蘆花
楓葉路入
茫茫晚風
漁帆瞳瞳
繁艇似篗
草家衣眠
漁家終年
水上燕入畫中

The boats anchored along the river in this painting by **Cai Xiaoli** form an effective pattern of distinctive inkwork against the soft colors of the landscape. The diverse angles of the hulls give an indication of movement, even though the boats are tethered for the night. These are working boats whose fishermen owners live on board. The serried formation seems to reiterate the business of their lives.

Although Chinese artists do not attempt to make a photographic reproduction of the subject, they need to know every detail of the boat to capture its essential qualities. This finished sketch by **Cai Xiaoli** shows one method of doing this. When transferring the image to a painting the minimum brushstrokes are used.

Shooting the Rapids by **Cai He Ding** shows the techniques needed to suggest a boat in motion. Here, painting of the water is essential to the meaning. The swiftness of the current is conveyed by the way all the strokes follow the direction of travel. The urgency of the journey is emphasized by the agitation of the water, and even the trees join this headlong rush. The struggles of the poor fisherman's life are brought out by this precarious voyage on a typical and disintegrating bamboo raft.

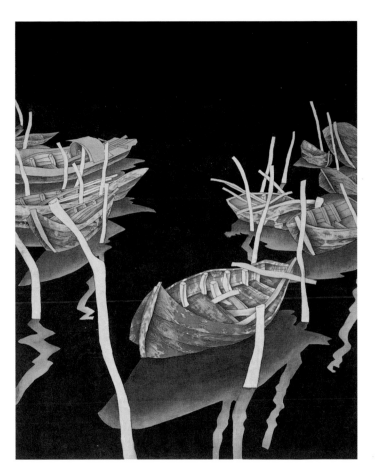

The Lonely Boats by **Cai Xiaoli** is a striking example of how mood can form the subject of a painting. The artist has reversed the usual order of black ink on white paper, making a sort of negative image. This immediately makes it strange. The eeriness is increased by the awkward jutting of the boat poles and their refracted reflections. The boats seem ghostly, and the absence of human life is mysterious and poignant. In fact, the boats have been laid up for the winter and will be used again in spring, but the artist encapsulated the feeling of this sad time of year, when their working life is suspended.

CLOUDS, RAIN, AND SNOW

LANDSCAPE SCREEN

*by Wang Jia Nan
and Cai Xiaoli*

*All the forms were stylized
into decorative shapes, yet the
clouds were still used to
describe the magnitude of the
mountain range.*

**MATERIALS FOR THE
LESSON**

BRUSHES

*Sheep-hair (2), XL Sheep(6),
Medium Sheep (9),
White Cloud (12),
Orchid and Bamboo (19),
Plum Blossom (20),
Small Wolf (21 & 22)*

COLOR

*Ink, Indigo, Earth Brown,
Cold Red (rouge), Rattan
Yellow, White*

Clouds, rain, and snow are all forms of water. Clouds are especially interesting because they represent much of what we seek to convey in Chinese painting. For example, mountains embody the strength, power, and solidity of the natural world; clouds, on the other hand, are apparently weak, docile, and insubstantial. These qualities are the typical antithetical complements of *yin* and *yang*. Yet the clouds envelop or encircle the mountains, changing their shape and character. They are even more rampant than water; nothing can contain them. Clouds are also an important way of transmitting *qi*; they seem in many respects to be the visible manifestation of this energy source.

There are two ways to capture this evanescent form on paper. The first is to leave the paper blank and use the outlines of the surrounding objects to suggest the clouds; the second is to draw the cloud shapes. We already met these methods in lesson sixteen on painting water, but here the tasks are more difficult because of the flimsy nature of the substance.

**THE AIM OF THE
LESSON**

*To learn techniques for
painting clouds, rain,
and snow*

STUDIES AND SKETCHES

Approach the effects of clouds, rain, and snow from the point of view of philosophy, which affects the way in which they are rendered. Chinese artists see the process by which clouds are produced as one of the continuous, self-renewing circuits that underlie all natural phenomena. The moisture that forms them is absorbed from the trees and rocks, so including clouds in a painting tells you more about those trees and rocks. Similarly, rain and snow can speak eloquently of the natural world and human survival in it.

In Chinese painting high mountains protruding through the clouds give the impression of being detached from the world below, and of being in the realms of the gods—a secret, enchanted world.

Practice the examples shown in the projects several times and study the additional pictures to see how these fugitive forms can be captured and conveyed.

▲1

This example uses the blank paper technique. Draw the shapes of the mountains with a dry brush in the center position. Add some *cun* strokes for texture (see lesson three), using a side brush. It is important to arrange the relative positions of the mountains correctly so that the *qi* can flow smoothly through. The shape left for the clouds should resemble the sinuous back of the dragon who inhabits this terrain.

◄2

Use a large, soft, wet brush to wash in a hint of the cloud shape, using the *ran* technique (see lesson three). Be careful not to overdo this. You need to keep the balance of solid and void. Remember also that clouds, like all objects whose form is defined by light, have a *yin* and *yang* side.

CLOUDS

Cloud in another form is rain. Landscapes with a rainy atmosphere are popular in China, because they show people contending with the forces of nature and surviving, thus proving their mettle. This battle is both physical and moral.

SNOW

Snow completely changes the landscape, in shape, color, and texture. It is most often represented by blank space on the paper, in a similar way to some types of cloud, or by using a dotting technique with white paint.

▲1

Draw the outlines of the mountains, setting up the main elements of the composition.

2▶

Using a large Sheep-hair brush and the *ran* technique, indicate the areas of sky and water with the lightest of washes. This is so that the snow on the mountains and the river banks, where the paper is left blank, stands out.

▲3

Add more details of trees and *cun* the banks of the river.

Compare the finished painting with the similar composition in the rain project, and note the different atmosphere. The rain picture shows the human struggle against the weather. In this picture, the man and woman are going on an outing to admire the hardy plum blossom, as explained in lesson seven.

 ▼ 5

▲ 4

Draw the people on the bridge. Make sure the black ink emphasis points are all in place. Finally, use this technique for the falling snow: Load one brush with opaque white pigment. Use another brush to hit the shaft of the first one, causing the paint to fly onto the paper in small dots. The size of dot depends on how hard you hit the brush. Practice on a spare piece of paper first.

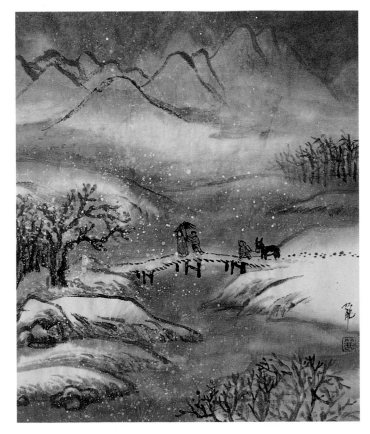

THE SHIMMER OF RAIN

(cao shu)

RAIN

Rain has even less form than cloud, so every other image in the painting must be used to explain its effect. We show one way of doing this in the following step-by-step on rain.

Using light ink, put in the main shapes of the picture. The space for the river is left wide deliberately, so that the man will appear even smaller by contrast, and therefore more pitiful.

▲2

Make the fine marks for the rain by splaying out the bristles of the brush in a fan-shape, and touching the paper with the lightest of strokes. Notice that the rain does not fall uniformly, but is heavier in some places.

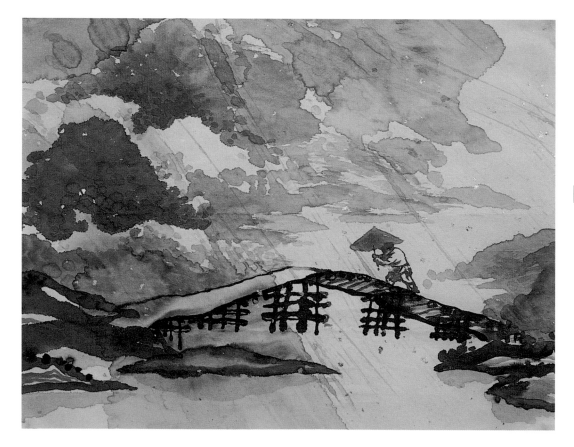

◄3

The picture has an asymmetrical bias to increase the sense of oppression by the rain and clouds, which seem to dominate not only the man, but also the bridge and the land behind him. Even the bridge appears to conspire against him, because of the low viewpoint that shows the underside of the part on which he resolutely presses forward; the other side is a perilous sheet of water.

"The spirit travels through space . . . like scurrying clouds kissing in the wind," wrote the poet **Sikong Tu** *in the Tang dynasty* (AD 618–906). *The close association between clouds and* qi *makes them an important element in a painting, along with their manifestations as rain and snow. Here are some more interpretations of these three forms of water to inform and inspire your own paintings.*

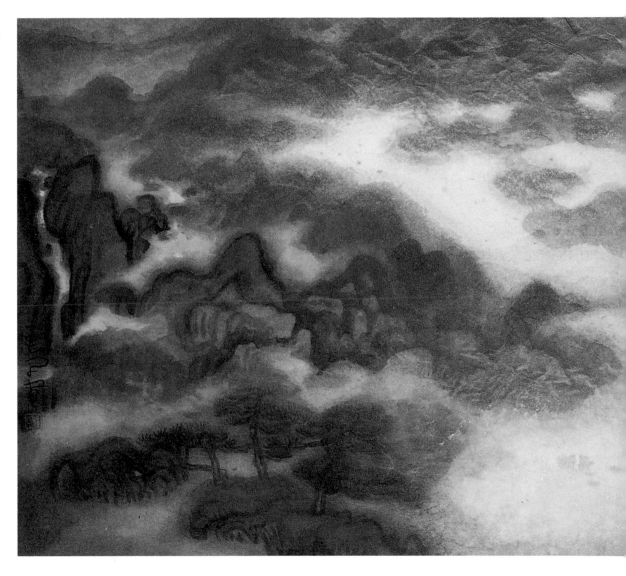

In **Mountain Clouds** by **Wang Jia Nan**, the method of leaving the paper blank was used to depict the clouds. The painting is interesting because the blue/green pigments are those used by masters from the 10th century onward, yet here employed in a totally modern way.

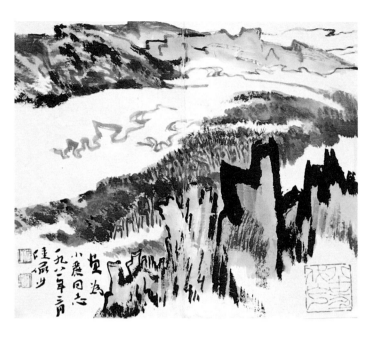

This *xiao pin* painting, **Clouds**, by **Lu Yan Shao**, shows the unique way of interpreting clouds for which this artist has become renowned.

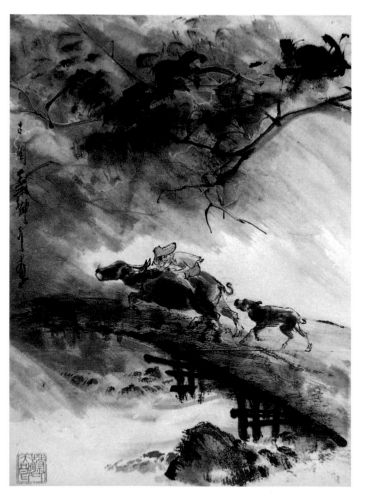

Boy with Buffalo by **Cai He Ding** shows another way of painting rain. Here the idea comes from the attitude of the creatures in the picture. You can empathize with the boy on the buffalo, with its baby bringing up the rear. The wind and rain almost blow them off the bridge, under which the swollen stream indicates how much rain has already fallen.

Snow on the Plateau by **Wang Jia Nan** uses the technique of crumpling paper before painting to give a textured effect very suitable for a rocky surface. Alternate highlights and shadows of opaque white and inkwork combine to give a forceful impression of snow with rocky crags.

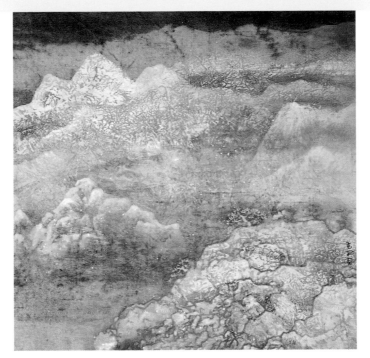

This contemporary painting, **Snowy Mountain** by **Yang Yan Ping**, does not have an underlying story. It simply enjoys the feeling of the majesty of the mountains blanketed in snow.

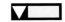

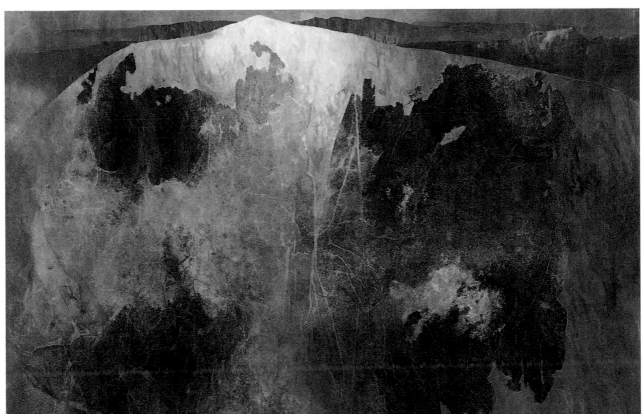

LIGHT

SPRING PAVILION

by *Wang Jia Nan*

Chinese colors and the way in which they are mixed with ink can enhance a painting with a magical light. Here, the pavilion is bathed in a shower of yellow light that imbues the scene with a warm glow. There is no particular highlight or shadow — the light pervades all the images in the painting.

● All the paintings in this lesson are by **Wang Jia Nan**.

Color, mood, and light are inextricably bound together in Chinese painting. Traditional Chinese painting is not concerned with realistic light sources in the Western sense. Nevertheless, there is an implicit awareness of how light can affect the mood and atmosphere of a picture. This can be seen in the popular subject of four companion pieces depicting the seasons. The Song dynasty artist **Guo Xi** said: *"The light in spring appears bright yellow, summer light appears deep green, fall (autumn) light is pale and subdued, winter light is gloomy and dark."* Even without the nuances of the original, we can see that the writer associates the light of spring and summer with the predominating colors of those seasons, but he refers to fall (autumn) and winter light much as a Westerner would.

We have already seen how color is linked to mood (pp.54–59). To understand the effect of the addition of light, imagine that you are looking at a stage set before the performance begins. The color and mood have been chosen to reinforce the story. Suddenly the stagelights are turned on and light floods the scene. This is similar to what happens in Chinese painting.

We can best achieve our purpose by concentrating on the relationship of light to mood. As you know, you must work quickly with ink and paper, and you must think about the whole atmosphere before you start. The particular nature of Chinese colors, and the varying amounts in which you mix them with ink, can give them an intense luminosity. This can be utilized to suffuse the painting with light rather than

THE AIMS OF THE LESSON

To explain the Chinese view of light and how you can introduce it into your painting

introducing particular highlights and shadows.

Western art uses light to describe form. In Chinese painting you learn to paint the three sides of a rock with different strokes. This is a basic way of defining shape, but that is not its main purpose. The intention is to show the light and dark sides, to bring out the *yin* and *yang* duality of the object. Light is often used in Western painting to concentrate the eye on parts the artist wishes to highlight. Chinese artists also have features on which they want to focus. But instead of using light from a recognizable source, they do it through areas of contrast in which the *yin* and *yang* aspects are once again brought into play. Light and dark tones are used in a "host" and "guest" relationship, just like the various elements in a painting.

STUDIES AND SKETCHES

Look carefully at Chinese paintings in which light is used to express ideas. Start by comparing the spring and fall subjects in this lesson. Ask yourself whether they give you a sense of the season. Do the colors reinforce the mood?.

Next, try some experiments of your own. Take a subject with which you are familiar, such as a tree, and think of it in different moods, changing the colors accordingly. Then introduce an impression of light by adding color washes in complementary or contrasting tones. Can you mix the colors and ink in the right proportions to give it that special glow?

● ● ● ●

The purpose of light in a Chinese painting is to give the viewer a heightened awareness of the scene, as the use of special wording does in poetry. Color and mood are enhanced by light in a painting; it is the *qi* of emotion.

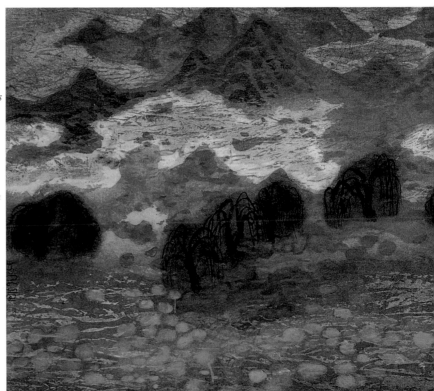

Complementary dark and light, *yin* and *yang* contrasts are used to focus attention on features that the artist wishes to emphasize, and light is conveyed through its intrinsic relationship with shadow. In **Lotus Lake**, the contrasting colors of blue and yellow are used to suggest a feeling of light.

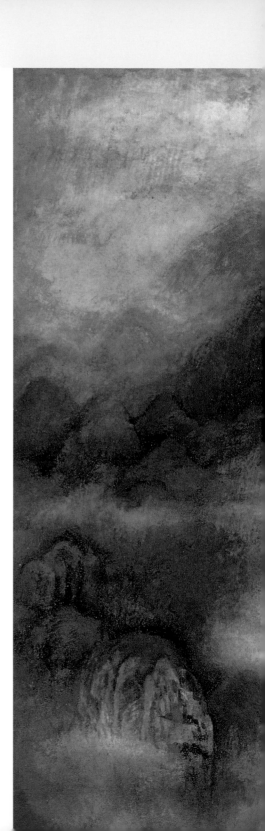

In the 20th century, Chinese artists have introduced some new ideas related to light into traditional landscape subjects. In **Mountain Cloud at Sunset**, the sunlight is reflected by the cloud. The contrast of the mountains in shadow emphasizes the brightness. Although this is not a description of light in the Western sense, you feel the emotion as the sun sends forth its dying rays before slipping behind the horizon.

This is a modern painting whose subject is **Autumn Light**. It is painted in an *impasto* technique, using thick Chinese stone colors. There is no pretense of realism in the strong contrast of red and yellow. The light does not come from one source. There are shadows and reflections from the mountains but they are not accurate. As in the painting above, some light is reflected from the cloud.

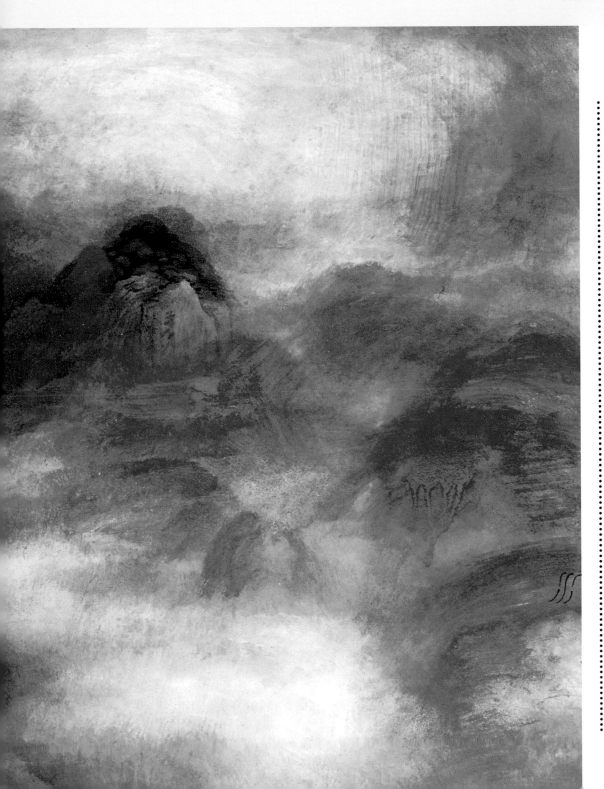

THE RAYS OF THE SUN

(slim golden)

FIGURES

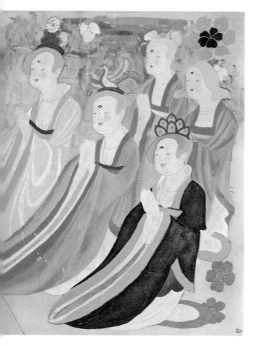

The grottoes at Dunhuang, in China's extreme northwest, were one of the most important sources of figure painting. These attendants on a king or nobleman are an exact copy of part of a large mural. The sweeping lines of these calm and dignified ladies influenced the subsequent portrayal of females in Chinese art.

MATERIALS FOR THE LESSON

BRUSHES

Large Sheep (7)
Medium Sheep (9)
White Cloud (12)
Orchid and Bamboo (19)
Plum Blossom (20)
Small Wolf-hair brushes
(21 & 22)

COLOR

Ink, Indigo, Earth Brown, Warm Red (hong), Cold Red (rouge), Rattan Yellow

Glue

PAPER
Xuan

The next two lessons deal with the representation of figures in Chinese painting. It may seem surprising to include them under the broad heading of landscape, but this is a useful way of understanding how the Chinese approach the subject. Landscape painting is representative of the spirit of human beings; it is concerned with showing people in empathy with the universe. The same criteria can be applied to figure painting. The next lesson shows how to introduce a figure into an environment. Here we concentrate on paintings where the figure is the subject.

There was a strong interest in portraying the human figure from the earliest times, mainly for didactic or exemplary purposes. On early bronzes men were shown hunting with spears, wrestling with animals, and performing daily activities. Religion was also a great source; images of the Buddha, of bodhisattvas (wise and holy Buddhists), and of gods and spirits from Daoist beliefs were much in demand. Confucian principles were displayed by characters from history and the classics, as well as by morally uplifting examples from everyday life. Portraits of emperors and family ancestors showed their virtues. None of these was done simply to record a likeness of the subject. The Chinese needed to identify with the person in the picture just as much as they did with the features of a landscape, living vicariously through both. Some such subjects remain popular. They can be a form of escapism from the problems of modern life; or, on the contrary, they can serve as a kind of meditation to help solve those problems.

THE AIM OF THE LESSON

To represent a person as the main subject of a painting

From a purely artistic point of view, they can be virtuoso exercises in the control of brush and ink.

The scholar-painters had a considerable influence on the development of figure painting. Since they spent much time in introspection, they sought to portray their own emotions through sympathetic images. Chinese artists have continued to use scholars, particularly in the persona of the monk, to express their innermost feelings. The scholar-monk followed the lifestyle of a hermit or traveler, and was free to do as he pleased. This idea appeals to modern artists, who can use the image without giving offense, and take the opportunity – rare in Chinese painting – to introduce a little lighthearted humor.

Another major and long-lasting category of figure painting is the portrayal of fine ladies. The original purpose was to provide examples of moral rectitude, but the paintings developed into a display of stylistic inkwork, using a decorative and sensuous line. The women are usually shown in elegant pursuits, such as embroidering, or watching flowers or birds.

Like all other Chinese painting, figure painting depends on line. Fine- and free-brush styles coexist. As with other subject areas, you must choose the one that is best suited to your intention.

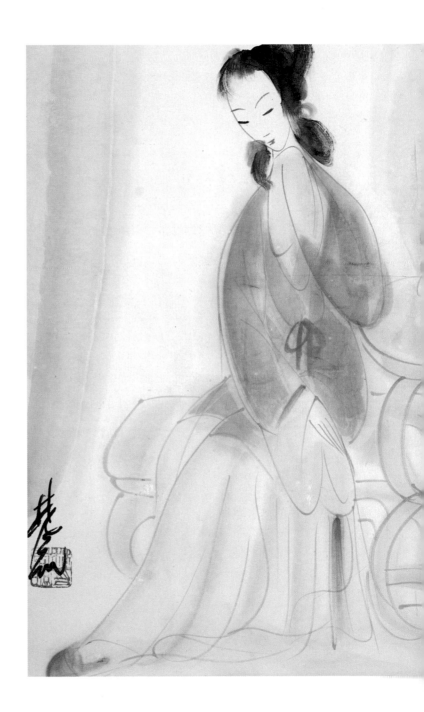

ELEGANT LADY

by ***Lin Feng Mian*** *(1900–1991).*
This modern painting is clearly derived
from the inspiration of the Dunhuang
grotto paintings (see copy opposite). Both
the ancient and the modern women were
painted in a decorative, stylized manner.

TECHNIQUES

Figure painting differs from the other types of Chinese painting in one important respect. You should not rely so much on copying examples from earlier ages. Even if you want to paint a subject based on tradition, the image should come from real life.

When you are painting the human face, the eyes are the key. This has been a precept since a famous master, **Gu Kaizhi** (345–406), said that he often delayed putting in the eyes of his figures for years, because they were the mirror of the soul, and he did not want to get it wrong. The moment you put the eyes in, he said, the painting becomes alive. Nowadays we consider that other facial features can also tell us much about a person's character.

A painter of people obviously needs to be acquainted with the anatomy of the human body, and a Western manual can supply any details you need. Our concern here is how to convey the image using Chinese painting techniques. A knowledge of the way the body moves is essential for painting full-length figures, because it will affect the hang of the clothes and the manner in which they drape themselves around the human frame. When painting figures using the minimal brushstroke techniques, every line will be crucial to bringing the image alive.

STUDIES AND SKETCHES

Start by careful observation of people in all sorts of situations. Whenever you see an interesting face, try to remember it. Study people when they are happy or sad, relaxed or nervous, and so on. You can do this even without your sketchbook. Develop a personal memory bank of images. This will help you to invest your figure with the utmost vitality.

In your preparatory sketching, focus on the aspect of the face that is most revealing — the nose, the mouth, even the teeth. This should be where the highlights of your painting are set. After the face, the hands and feet, and body posture are signals of character.

THE JOLLY MONK
The two projects show very different figure painting styles. In both, you need to concentrate on the face. We begin with a jolly monk, who is exuberantly declaiming the joy of living.

Start by indicating the position of the head and chest. Then paint the shape of the clothes with energy, using a large Sheep-hair brush, loaded with fresh ink mixed with a little glue. Make the strokes boldly.

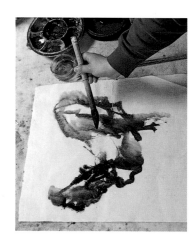

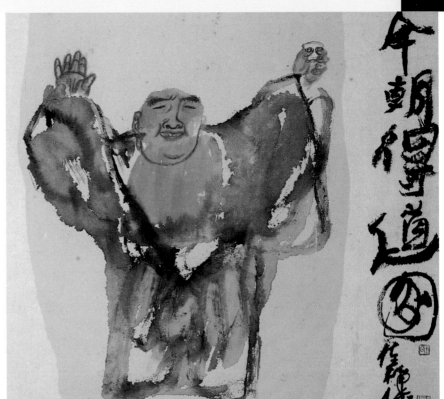

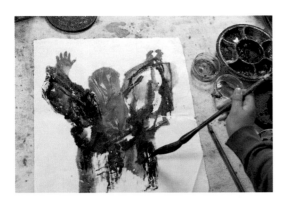

▲2

While the first ink is still wet, add more ink to give texture to the robe, allowing the pigment to spread. Use a brush loaded with dry ink to paint around the chest in the "flashing white" technique (see lesson one). Start putting color on the face and hands, mixing light brown with a little orange, warm red, and yellow.

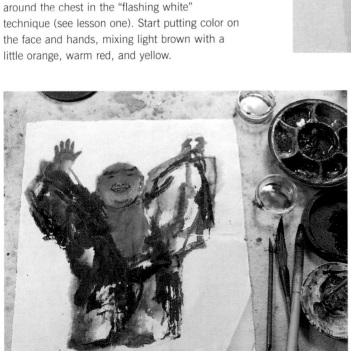

◀3

Add the details of face and hands, using a Wolf-hair brush and dark ink.

▲4

In the finished painting, the full expression of exhilaration is manifest. The brushstrokes are unique, with the calligraphy in the same strong, expansive style as the figure. In this example grass paper has been used, which adds to the heartiness of the subject.

A REALISTIC PORTRAIT
This project teaches you how to paint
a more realistic portrait, which owes
much to Western influences.

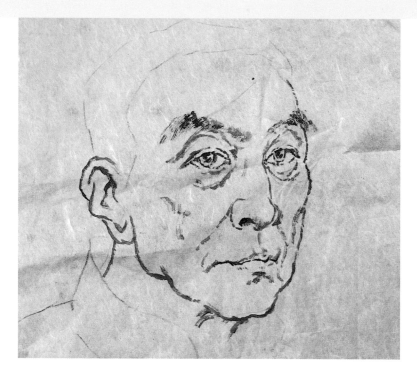

▲2

Continue with the details of the head, adding some indication of facial
muscles. Pay special attention to the individual characteristics of the
nose, ears, and mouth.

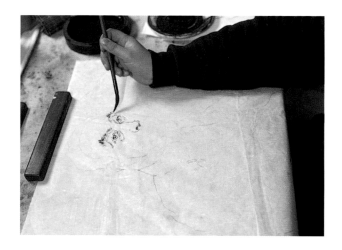

▲1

Lightly indicate the outlines of
the head and shoulders in
charcoal. Take care not to
overdo this, or you will lose the
sense of spontaneity when you
draw them in ink. Decide
where you want highlights,
because these are achieved by
leaving the paper blank. Put in
the eyes. Add details of the
nose and eyebrows.

◄3

Start drawing the clothes,
indicating the underlying form
by the wrinkles and folds.
Begin to color the face, using
light brown with the addition of
a little yellow and a little ink.
Work from the darker areas and
shadows to the lighter.

▲4

Add more color, taking care to
vary the brushstrokes. Notice
how the blank paper highlights
stand out – no white paint has
been used. Finally, reinforce the
dominant lines with dark ink,
where needed.

▲5

The finished portrait: an
effective use of the materials
and techniques of traditional
Chinese painting to produce a
Western style portrait.

FINDING THE TRUTH

(*xing shu*)

FURTHER EXAMPLES

*The examples on these pages,
which span the ages, show the
continuing dominance of line in
figure painting.*

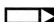

A traditional painting by **Liu Ling Cheng** of a **Wife
Serving Tea to her Scholar Husband** embodies the
principles of the scholars in its underlying philosophy and
its execution. The husband sits in his study with books
and writing materials; through the window, he can see his
beloved pine and bamboo. The dutiful devotion of his wife
is described in every line of her inclining body. You can
see her relationship to the ladies of Dunhuang at the
beginning of this lesson.

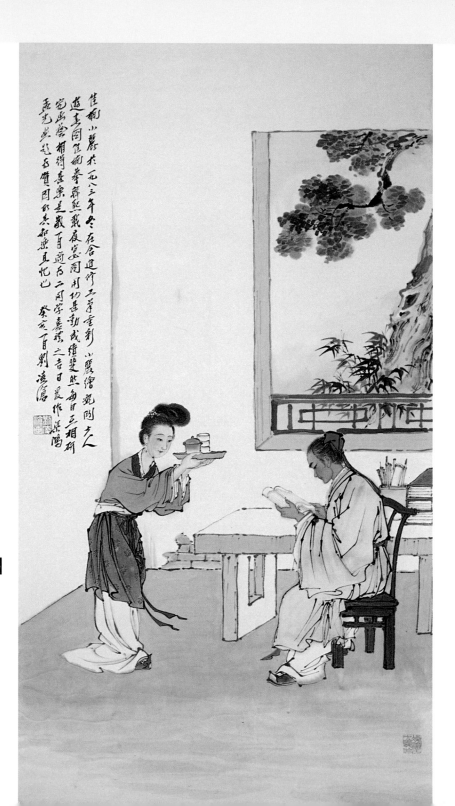

The **Students Absorbing the Wisdom of the Dao** by
Wang Jia Nan are also intent in their respectful
attention to the words of the Master. This is based on a
16th-century drawing.

In **Meditation** by **Wang Jia Nan**, you can see that Chinese
painting relies on line rather than form to indicate facial
characteristics. Observe how this can be just as descriptive.

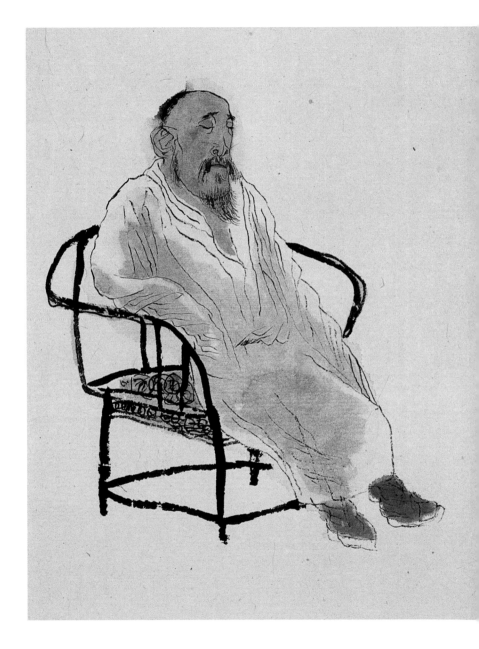

The Walker by **Wang Jia Nan**.
Compare the expression of the
wide-awake *Walker* with the
previous face in repose in
Meditation by the same artist.

The attitude of the scholar-
monk, **Enjoying Reading Alone**
by **Wang Jia Nan**, precisely
expresses his relaxed feeling.
The loose, enveloping clothes,
in particular, help this
impression.

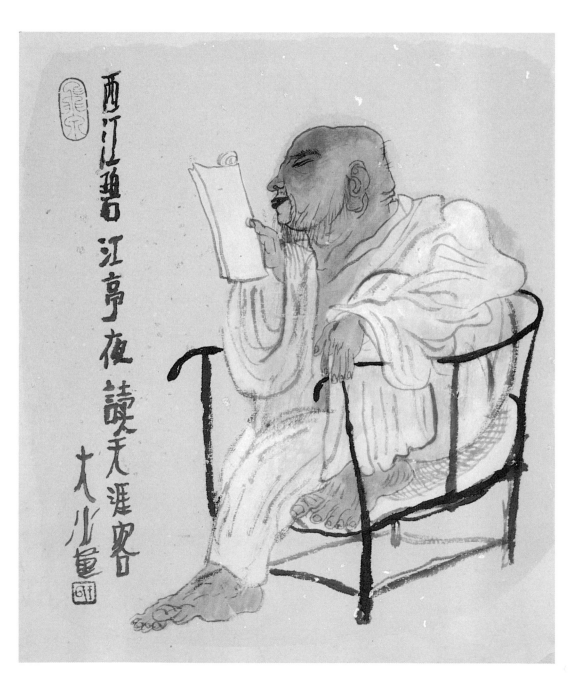

Similarly free-brush techniques have been used for the **Flute Player** by **Wang Jia Nan**. Notice that very little color was applied to any of these figure paintings. Here, there are two telling highlights in the red lips and necklace.

The glee on the face of this monk, **Delirious with Drink** by **Wang Jia Nan**, is obvious. The impact of the drawing of the physical features is heightened by the *pomo* splashing ink technique (see glossary) used for his clothes.

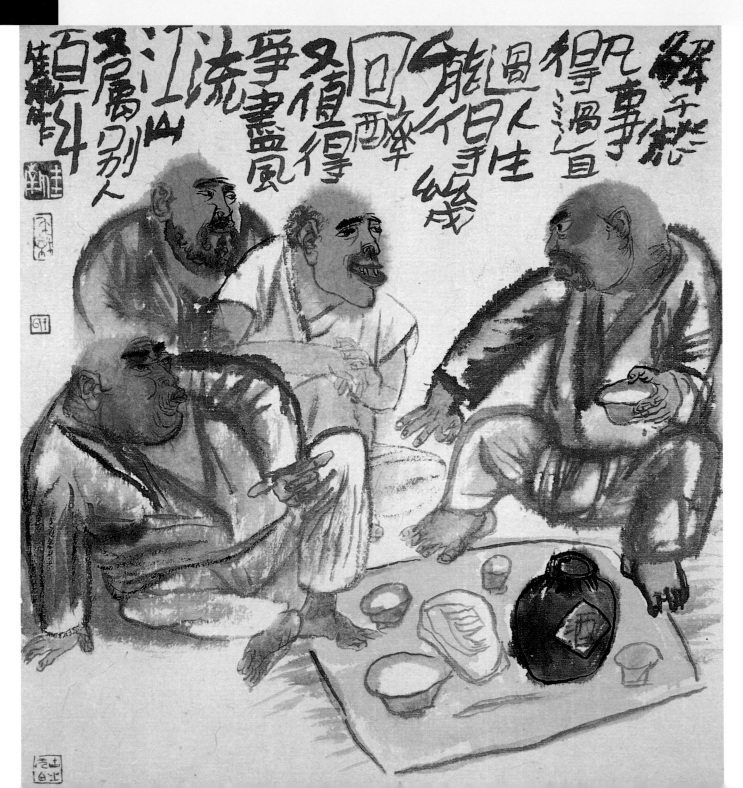

 The charming **Child Playing with a Chick** by **Liu Han** uses its free brushstrokes style to enhance the vivid coloring, and tender relationship between child and bird.

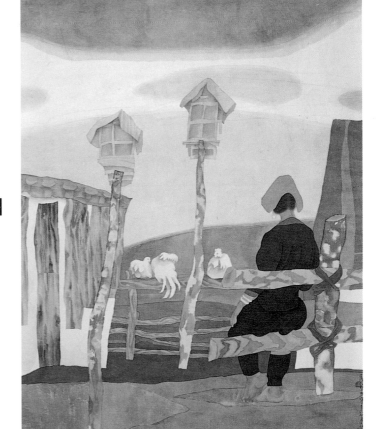

The **Bucolic Banquet** by **Wang Jia Nan,** shows how to group figures. Notice the way in which their eyes contact each other, so that they appear to be in animated conversation. The body postures, facial expressions, and gestures all contribute to the liveliness of the scene.

Waiting by **Wang Jia Nan** and **Cai Xiaoli** shows how the ideas about painting women first seen in the 10th-century Dunhuang caves continue today. Although this girl is in the dress of the Miao minority people, she is as elegant as the courtly ladies. The shapes are reduced to a minimum, without losing individual expression. The painting relies almost entirely on the skillful inkwork to suggest color.

POSITION OF MAN

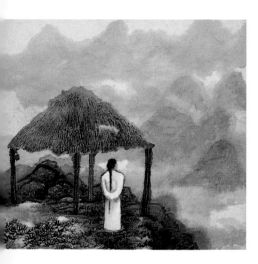

STANDING ON TOP OF THE MOUNTAIN

by Wang Jia Nan

The scholar is totally isolated from society. As you look at the distant mountains through his eyes, you begin to understand the process of inner purification which he is experiencing.

MATERIALS FOR THE LESSON

BRUSHES
Large Sheep (7)
Medium Sheep (9)
White Cloud (12)
Orchid and Bamboo (19)
Plum Blossom (20)
Small Wolf (21 &22)

COLOR
Ink
Indigo
Earth Brown
Cold Red (rouge)
Rattan Yellow
White

Glue

PAPER
Xuan

When the Chinese put a figure in a landscape, it is done for a reason: either to reinforce the mood of the painting, or to show human behavior in the setting. So if figures are present, we need to ask why? According to the Chinese conception, people go to the countryside for one of three purposes: to live and work; to visit and enjoy; or to escape and hide. Figures in a landscape should support these ideas and not overwhelm them by being painted too large or in too bright colors. People give extra life to a landscape. They also help to provide a sense of scale, especially as one of the main intentions is to instill a feeling of awe in the presence of features such as imposing mountains and powerful waterfalls. When we put figures into a landscape, we must consider exactly where to place them.

The people who live and work in the countryside must be painted using different techniques from those who are there for recreational or fugitive purposes. The latter, who include the scholar-painters, should be done with the freest of brushstrokes, emulating their libertarian way of life. The former should be done with a tighter line. The technique of painting the landscape associated with both should confirm their respective positions.

THE AIMS OF THE LESSON

To learn when and how to place a figure in a landscape

To explain how the Chinese relate to the universe

STUDIES AND SKETCHES

In Chinese painting, the whole of nature is regarded as the mirror of mankind; to some extent, therefore, the presence of a person can be seen as superfluous. That is why a figure must always be introduced with extreme care, to reinforce the ideas in the picture and not distract from them.

It is important to use the right environment and scale for your chosen figure. On these pages are a number of figures for you to copy, along with suggestions for settings and positioning. The principles of composition from lesson seventeen will also be useful.

WORKING AND LIVING

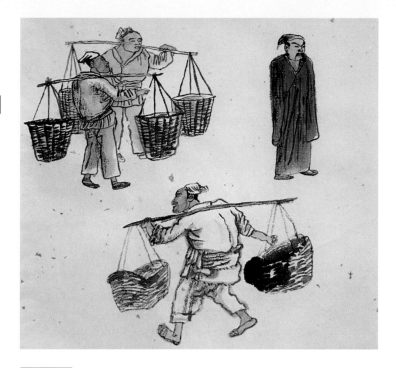

▲2

This example shows how you might group the figure below with others. Notice that the clothes of the working men are tighter and more restricted than those of the scholar. The wrinkles in them underscore the rigors of the men's work, while he appears completely relaxed in his flowing robes.

◄1

Use a small wolf-hair brush to copy this example of a working man, starting with the head. Notice how he leans slightly back and his head juts forward, because of the weight of the baskets.

When you have practiced drawing these figures with a brush, introduce them into a landscape. Here are some suggestions for placement and scale. The figure must go into an appropriate setting. The hard life of the laborer should be reflected in the terrain: he must carry water up a mountain, for example. The scholar, on the other hand, makes his unhurried progress through a landscape that seems to welcome him in the undulating shape of the mountains.

▼3

VISITING AND ENJOYING

This painting by **Zhao Wang Yuan** shows a landscape typical of the Shaanxi area of central China. In **The Ferry Crossing**, a group of people see friends off on a journey. They are ordinary villagers, so the brushstrokes are simpler than in a traditional scholar-style landscape. Notice how their eyes all follow the direction of the boat, thus contributing to the *qi*.

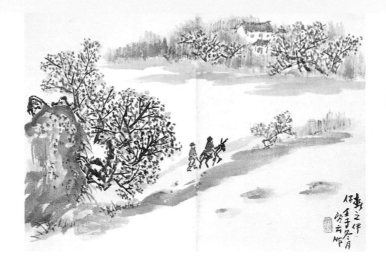

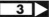

The subject of **Travelling in Spring** is two newly-weds returning home to visit their parents. No doubt the prospect of seeing plum blossom in the snow was an added attraction. Both these paintings by by **Zhao Wang Yuan** have a down-to-earth quality.

Facing the Wind by **Wang Jia Nan**. This scholar painting shows how strong brushstrokes back up the subject – the figure feels himself to be as strong as the trees withstanding the force of the wind.

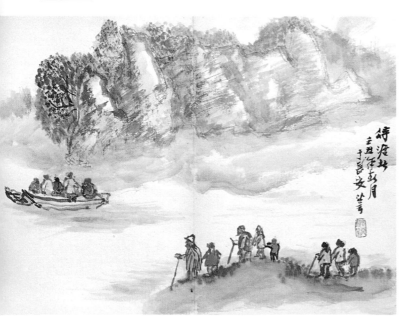

ESCAPING AND HIDING

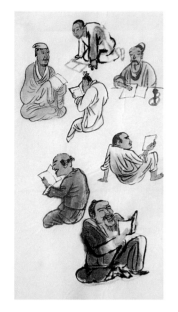

◀ **1**

These relaxed characters, engaged in the elegant activity of reading, are painted very differently from their working counterparts. Notice the way that the clothes drape around the underlying forms of their bodies. They are not drawn with much detail, but what there is must be accurate. These figures are models for scholars seeking isolation in remote locations.

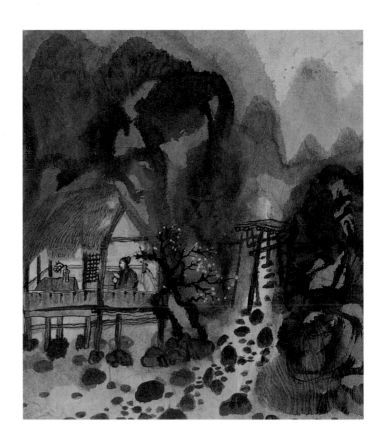

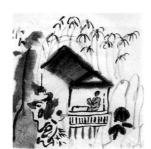

◀ **2**

Here are some suitable settings in which to place your scholar. Where you position him is also important, because he will become the focus of the painting. Generally speaking, the best place is slightly off-center; the corners are unsuitable, and the middle should be used with discretion.

▲ **3**

Reading in the Mountains by **Wang Jia Nan** shows how everything is brought together to describe the atmosphere. The scholar in his remote, straw-thatched hut is surrounded by the water and mountains that he loves. The only link with the outside world is via the fragile bridge.

FURTHER EXAMPLES

Each of these paintings contains a single human figure in a countryside setting, and each suggests a different mood. Notice how the atmosphere is conveyed through the way in which the figures are associated with their environment, and the painting techniques that confirm their relationship.

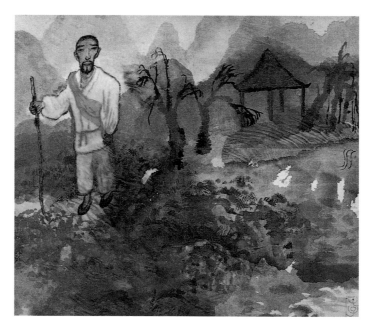

The Traveler by **Wang Jia Nan** shows that not all journeys are joyous. This is the disadvantage of leaving home and family to take up the life of a wandering scholar. The landscape echoes the sadness in his face.

Compare the **Peasant with Buffalo** (left) by **Cai He Ding** with **Standing on Top of the Mountain** (on p.190) and try to feel the contrasting atmospheres engendered.

In **Returning Home** by **Wang Jia Nan**, on the other hand, you can feel the welcome of the little village, with the double-tiered roof to the entrance gate and the friendly encircling trees. The donkey seems more reluctant to go home, but will certainly be persuaded by his gentle master.

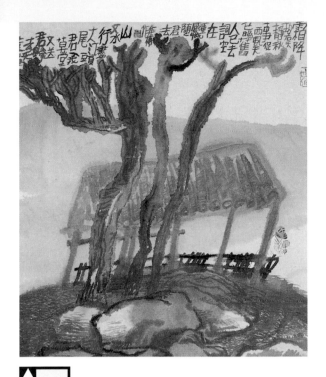

In **Autumn's the Time for Thinking**, by **Wang Jia Nan**, the scholar leans out of his pavilion in an effort to get even closer to nature. The building seems to incline in sympathy with him. The calligraphy flutters among the treetops like leaves. Subject, color, mood—all are in harmony.

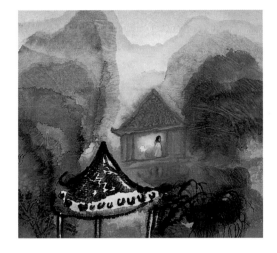

Standing Alone in the Pavilion by **Wang Jia Nan**, uses the blue/green colors of Tang dynasty landscapes, which are particularly fitting for this magical world, where only the scholar has time to stand and stare. Notice how his white robe makes him the "eye" of the painting. In this case, the artist chose to place him in the middle of the composition to increase the concentration on this lonely figure.

LISTEN TO THE GEESE

(*xing shu*)

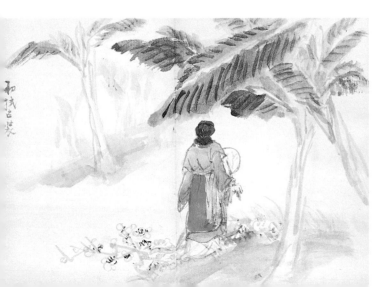

Under the Banana Tree by **Zhao Wang Yuan**, is drawn in a much more delicate style, suitable for the young woman waiting anxiously for her lover.

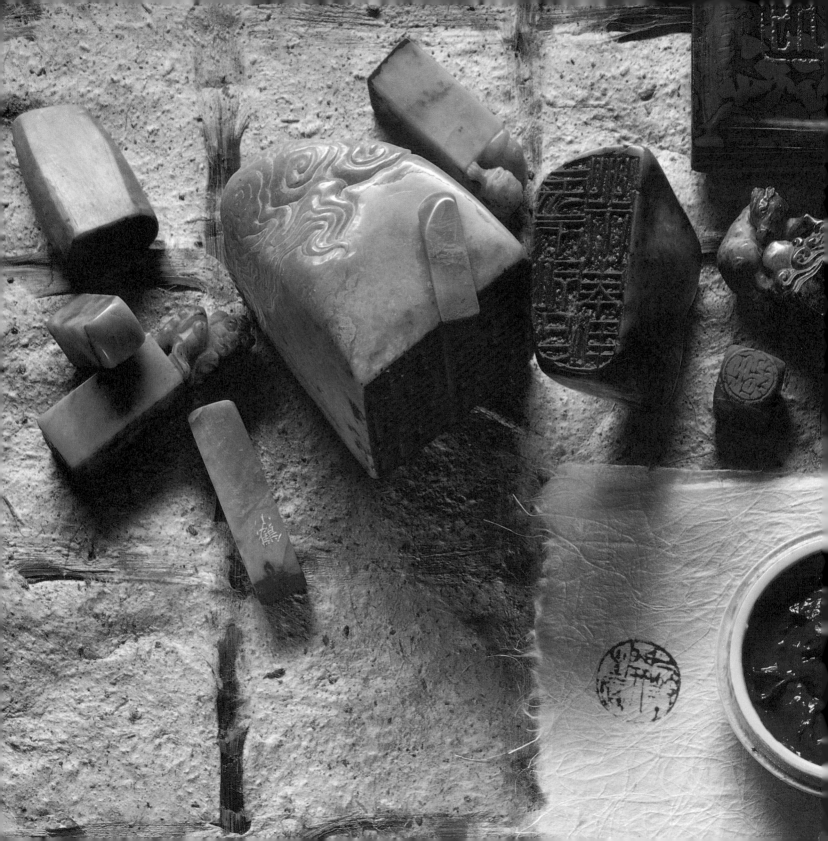

SECTION 4

RELATED TOPICS

Chinese folk arts are an

increasingly important

source of inspiration.

We give examples of the

two-way traffic of ideas

between artists from China

and abroad. We whet your

appetite for future painting,

and suggest how to display

your finished work.

FOLK ART

Alongside the specialized style of the scholar-painters, there developed a tradition of native folk art created by ordinary people without formal training. It was strongly rooted in the concerns of their everyday lives. They used their art to safeguard their family, houses, and animals by propitiating the gods who looked after such matters. They also used it to decorate buildings and disseminate knowledge among the mass of people who could not read. Until the 1970s, folk art was little known outside the communities that produced it, but nowadays most academies have departments of folk art, and modern Chinese painting has been influenced by it.

Folk art in China is highly varied, with numerous regional differences. Before the development of transportation communications, many areas of this vast country were isolated. People had to rely on their own resources, and little changed from century to century, so that the same techniques and designs were largely repeated down the generations. In this feature we concentrate on three of the most important: paper-cutting, woodblock prints, and peasant painting.

Paper-cutting is one of the oldest and most enduring art activities in China. The earliest examples come from the Han dynasty, when gold and silver foil were used instead of paper. Paper-cutting is concerned with the balance of positive and negative space. The basic materials are a piece of paper and a pair of scissors. From such modest requisites this essentially simple craft developed into a highly skilled and popular art form. Papercuts are not only

THE FAMILY

This typical papercut from the Shaanxi province of central China shows the effective use of one color and was intended to be put on a wall. Its subject is what used to be considered the ideal family: two sons and one daughter. The design shows an interesting organic development. However, for the cutter, the connection with the progressive forces of nature would have been more important. The girl is in the middle, maybe still in the mother's womb. On either side, the boys grow like apples from the parental tree. The mother's hair transmutes into two birds.

used to decorate walls, windows, and lanterns; they also depict images of what the family hope for in life and death.

Paper-cutting is found throughout China, but other folk arts are closely related to the region in which their materials are found. Trees are prolific in the south of China, and much folk art there derives from woodcarving and printing with woodblocks. Some woodblock pictures were taken from papercuts, but because the material is more difficult to incise, a less fluid line was possible. The carvers turned for inspiration to the stone carvings found in caves and on tombs all over China that depict the lives of emperors and gods, and have calligraphic inscriptions.

In north China, where there is little wood, peasant paintings often served the same function as woodblock prints. They frequently featured repetitive geometric patterns and strong, bright colors, using gouache – very different from the traditional painting of China but often now an inspiration to professional artists.

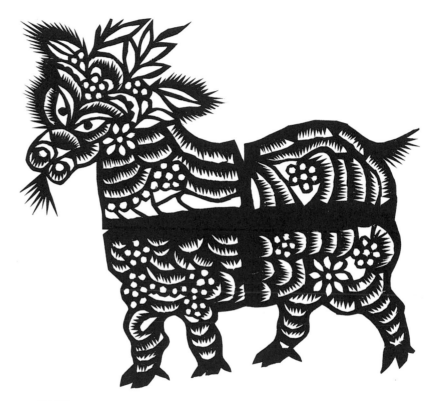

SHEEP

Another single-color example from Shaanxi was for pasting on a window, so the cutaway space is relatively large to let more light through. Again the subject is closely connected to everyday life: farmers need strong sheep. The strength comes out in the forceful paper-cutting, but the creator's imagination devised a fantastical animal with stylized hair, ears that are leaves, and two eyes seen on the same side of the face.

In southern China, when the daughter of a family was about to marry, the parents commissioned special woodcarvers to decorate a room. Every surface was covered, from floor to ceiling, from bedstead to closet (wardrobe), and from tables to chairs. This practice led to a great tradition in woodcarving.

PAPERCUTS

These two delicate papercuts for window decoration are from Hebei province in northeast China. Totally different from the Shaanxi examples, they involve the use of vivid colors.

GOLDFISH WITH LOTUS

This papercut (below) has a wish-fulfillment symbol, hoping for fertility.

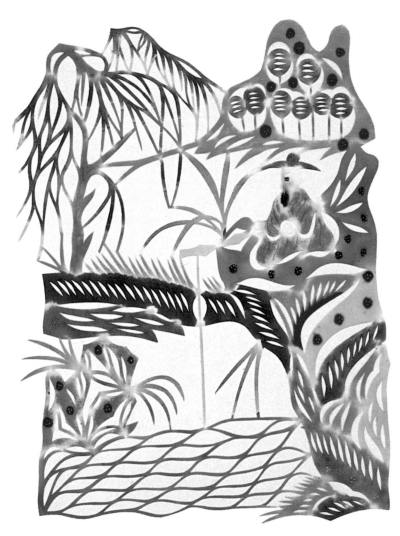

FISHERMAN

This papercut shows how stories were passed on before people could read. In the story, when passers-by saw the old man fishing from a rock, they wondered why he held his rod three feet (one meter) above the water. He said it was to attract the attention of the emperor, when he came to visit. His ploy was successful, and he was made prime minister. Notice, in particular, how the water has been rendered.

刻版　杨修义　潍坊年画社制

TIGER

This tiger is a typical woodblock print from the eastern province of Shandong. The brief, strongly incised outlines are reminiscent of Han dynasty stone carving. The almost human face is full of character. The pine needles behind are more delicately carved. The image relies for its effect on the control of the black ink, just like traditional Chinese painting. The tiger is depicted in the bright red and yellow often associated with China, added by hand after printing.

WOODBLOCKS
The images on this page are Ming dynasty woodblock prints, colored by hand.

BLESSINGS ON THE HOME

This print was designed to protect the family home. It was put up behind the stove in the living room. There is a story that the Emperor of Heaven sent a man and a woman to keep an eye on how the family behaved. These are depicted with the farmer and his wife. Every New Year the picture was burned, so that the two could report to the Emperor on what they had seen.

THE GOOD GENERAL

The prints above are another example of storytelling, which is also in the repertoire of the Peking Opera. Set in the Three Dynasties period, it recounts how General Zhao Yuan rescued the three wives and children of the emperor and took them on the long journey home. It was a lesson in good generalship.

PROTECTING THE LIVESTOCK

The following three images are Ming dynasty woodblock prints, colored by hand. This woodblock print portrays the gods who look after the house, the horse, and the buffalo. The animals, who were crucial to the livelihood of the family, lived in a building attached to the family home, and this print would have been hung behind the manger there.

FORTUNATE DESTINY

The most important event in the Chinese calendar is New Year. People want to placate the gods and ensure their good offices. Papercuts and woodblock prints are pasted up in every location where help might be needed.

THE ROOM

This painting from the Golden Hills district near Shanghai tells the story of a snake that turned into a young girl and fell in love with a scholar. The entire room is represented in geometric patterning and vivid color, including the decorations that are painted on the furniture. It is a detailed record of the articles that a peasant family used.

PAINTINGS USING CHINESE CALLIGRAPHY

SINGING BY THE RIVER

by Shao Daohong

This modern Chinese painting includes a poem, originally composed in the Tang dynasty, which was written in exile and refers to the poet's longing to return home. This example shows that even when the main image of the piece is pictorial, the calligraphy is an integral element of the painting.

There has never been a language with so close an affinity to art as Chinese, and the love affair continues to the present day. Calligraphy is an important part of the artist's skills, as we saw in lesson one. From very early times, artists have enjoyed putting Chinese characters on bronze, stone, and other artifacts. Modern painters use them as a main image in their paintings, both for their underlying meaning and for their beautiful and sensuous shapes. Characters were originally in the shape of the object they represented. As time went on, meaning and sound symbols were added to these pictographs, so that it is now difficult to see how they relate to the objects they stand for. Artists mostly use the elegant later scripts, such as the *kai* and *cao shu*, but they sometimes return to earlier forms in their paintings.

MATERIALS FOR THE LESSON

BRUSHES

Medium Sheep (9)

White Cloud (12)

Orchid and Bamboo (19)

Small Wolf (21 & 22)

COLOR

Ink, Indigo, Earth Brown, Rattan Yellow, White Glue

THE AIM OF THE LESSON

How to compose a painting using calligraphy and seals

STUDIES AND SKETCHES

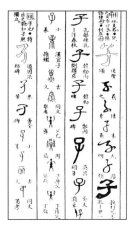

This page from an old dictionary shows diverse ways in which the character for "son" used to be written. The relationship of many of them to a human form is clearly visible. The project in this lesson shows you how to go about making your own picture, using ideographs like those in the dictionary. Try to think how you might group them to bring out the meaning, as well as creating a well-arranged composition. In our example, the characters look like a lot of little people playing Practice the project and then develop variations of your own.

1

Choose some characters and paint them on rice paper, using a medium sheep-hair brush, loaded with white pigment to which a little yellow, or other pale color, has been added.

YELLOW

WHITE

2

Put a wash on the back of the paper, using a large sheep-hair brush, loaded with brown pigment and mixed with red and a little ink. The color will not go through the paper, where the figures are painted, but will make them stand out.

3

When the wash is dry, mount the painting, as described in lesson twenty-four. This will bring out your strokes very clearly on the front. Finish by painting details, or use collage to add extra figures and effects.

Calligraphy can be used for fun, or to create a serious work of art, as these additional examples show.

This collage by **Wang Cai** entitled **Spring Song** is made up of different calligraphy styles. It uses the characters for "enjoy the spring flowers" against a background of appropriate colors and shapes to write a joyous exaltation to the most important festival in the Chinese calendar – just as artists have done for centuries.

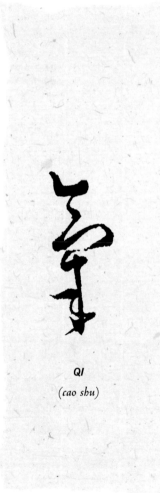

QI
(cao shu)

Dragon, also by **Wang Cai**, is a serious work of art. The character for one of the main Chinese symbols is surrounded by others associated with ideas of the power of the emperor, the supernatural, and integrity.

BACKING AND MOUNTING

Applying your own backing is an important way of learning exactly what proportions of ink, pigment, and water are satisfactory for your painting. In China we say that 30 percent of the finished picture is in the painting, 70 percent is in the mounting!

• • • •

FRAMES FOR CHINESE PAINTING

The following points will help you choose a frame in keeping with the principles of Chinese art:

● Use a natural wood frame for ink painting, because it will be in greater sympathy with the natural materials.

● Do not skimp on the dimensions of the mat (mount) surrounding the painting: allow 4 in (10 cm) on each side for a painting up to 16 in (40 cm).

● The color of the mat (mounting) board and the frame must be in harmony with the painting.

When you have completed a painting, you will be anxious to display it to its best advantage. Here we show you how to back your work so that it can be mounted in either the Chinese or a Western way. Backing is an important procedure that greatly enhances the appearance of the painting.

The popular way of finishing a Chinese painting has generally been in the form of a scroll. This is basically a long piece of paper or silk with a roller at either end. Its main advantage is portability. The idea came from Buddhism and was particularly adaptable to the Chinese attitude to painting and to life in general. A hand scroll can be unrolled gradually as the viewer goes on a journey with the artist through the scenes depicted. A hanging scroll (see left) can be rolled up and changed regularly according to the season or the mood of the owner. The scroll is especially suitable for the architecture of traditional Chinese houses. Mounting a painting as a scroll is a skilled operation. The mount is considered to be part of the picture and there are conventional dimensions and rules to be followed. Professional help would be needed for this. However, it is equally possible to frame your picture in a conventional Western way once it has been suitably backed.

To back your painting, use a similar type and weight of paper to that used for the painting, so that the two papers will react in the same way whatever the atmospheric conditions. The backing sheet is known as the "life paper," because after it is applied, every nuance and tone of the painting comes to the surface and is seen to its best advantage. The disadvantage is that imperfections will also be clearly visible.

MAKING PASTE

1 Put equal proportions of flour and water in a small saucepan.

2 Heat gently, stirring all the time, until the mixture becomes transparent.
3 When it begins to thicken, remove from the heat and sieve into a large bowl. When cool, add water to the right consistency.
4 Test for stickiness on some spare *xuan*. Add a little water if the paste is too thick.

TIPS FOR SUCCESSFUL BACKING
● If your ink runs when you apply the paste, it may be poorly made or old. Using properly rubbed, good-quality ink will help.
● Apply colors sparingly, so that they are thoroughly absorbed into the fabric of the paper.

BACKING AND MOUNTING
Work on a clean, flat table with a non-porous surface. Hard plastic or sealed wood is suitable. The Chinese always use a red table for backing and mounting because all the possible imperfections can be easily seen.

◀ 1

Cut the backing paper to size, using the actual painting as a template and adding 1½–2 in (4–5 cm) to each side. Set the backing aside.

▲ 2

Turn your painting over and paste the back, moving the brush to each compass point as in the Chinese character *mi* (rice), which is written in the *li shu* style at the end of this lesson. Be careful not to use too much paste. Make sure that you get rid of all the air beneath the paper.

◀3

Check that the painting is flat and that there are no hairs or specks of dust on it. Then smooth the rolled backing paper carefully over the pasted painting with the special Chinese smoothing brush, unrolling it as you go.

• • • •

Take care not to paste the rice paper on the painted side! Mounting a painting back to front is a common mistake made even by professionals.

• • • •

STORING YOUR PAINTING

Before mounting, *xuan* paper can be folded without coming to any harm. After mounting, keep it rolled in a tube, preferably a cardboard one, or flat between boards. Any mark made on it at this stage will be permanent.

 4

Cover your work with newspaper and use another smoothing brush to mop up the excess water. This will also help the backing to stick. Make sure that there are no wrinkles.

5 ▶

Paste the backing paper around the edges, where it projects beyond the painting. Lift up the backed painting carefully with two hands and place it face down on the board, starting with the top middle. Brush around the pasted edge area leaving one small gap. Insert a drinking straw into this and blow. This is to ensure that the painting comes away from the board. As it dries, it will become flat. Leave the painting on the board for four or five days. Then cut it off with extreme care.

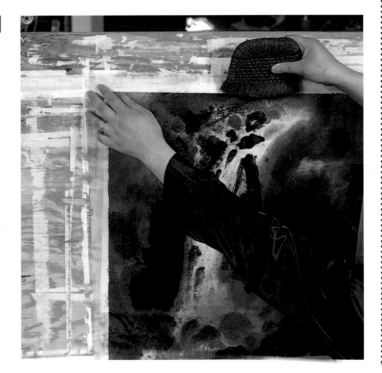

RICE

(li shu)

SILK PAINTING

BIRDS AND FLOWERS

by Emperor *Zhao Zhe*

A painting on silk by the outstanding connoisseur, innovator, and practitioner of art, the Emperor **Zhao Zhe**, who founded the renowned Song Academy.

Silk has been used as a painting surface since at least the 3rd century BC, long before paper was invented. Silk is durable and accepts color well, but the weave can be a problem, except when needed for special effects. In the beginning, silk was used for figure and portrait painting; the technique was to draw first in ink with a brush, then fill in with color. Originally the paintings were hung like a banner, with the picture visible from both sides. Later, artists tried painting on the back of the silk to protect it. When they found that this affected the front color, and improved the texture, they started to exploit the new possibilities, and to add a backing material. From there, it was only a short step to the scroll format. The techniques used for silk painting today remain largely unchanged. The medium reached its zenith during the Song dynasty, when the process of priming the silk with glues and alum was introduced. This gave a smooth surface, highly suitable for the finest brush painting. Both fine brush (*gongbi*) and free brush (*xieyi*) styles were applied to silk, but fine-brush techniques

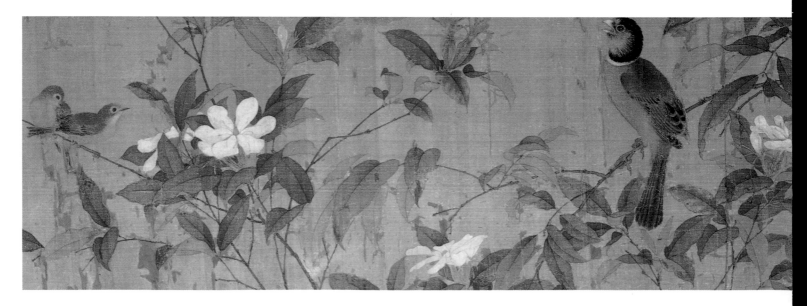

gradually came to predominate after the Song dynasty as the properties of paper were found to be better suited to the freedom of *xieyi*.

One of the most influential figures in the history of Chinese painting was the Emperor **Zhao Zhe**, who disregarded affairs of state to concentrate on artistic pursuits. He collected an Imperial Gallery of paintings, which numbered several thousand items. He inaugurated and directed an academy, comprising a hierarchy of painters, drawn by competition from all over China. There, he instituted new methods of study, including detailed sketches, research into and observation of plants and animals, and good working conditions. He invented his own form of calligraphy the "slim golden" style, and was one of the greatest painters on silk of his day. Eventually his neglect of state duties allowed the Mongols to invade, and he was captured. However, the Song court

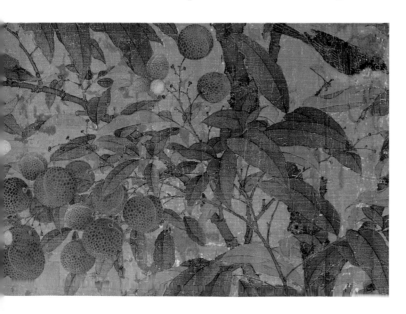

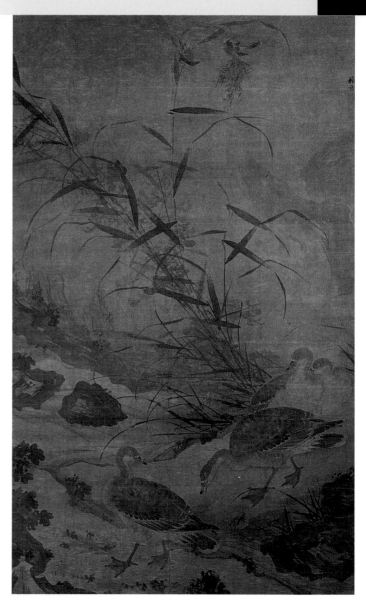

WILD GEESE BY A MOUNTAIN STREAM

by *Lin Liang* (active 1488–1505)

Lin Liang belonged to a Ming dynasty imperial academy modeled on the Song school but with a different painting style. They developed Flower and Bird painting by treating the genre more freely, and merged it with landscape painting details.

moved south to Hangzhou, and a new academy followed his example.

The outstanding qualities of the Northern Song Academy were the brilliant, enamel-like colors, and the precise observation of each flower petal and every bird feather. Even so, this was a formalized, decorative art form, using calligraphic stroke shapes, rather than a realistic one. Just as with the other types of Chinese painting that we have described in this book, the artists made a careful selection of items for inclusion, according to the mood and atmosphere they wanted to create. In the Song dynasty, paintings on silk were often very large. Nowadays we are restricted by the standard one-yard (one-meter) width silk available.

Copy of Emperor *Zhao Zhe*'s

LADIES AND GIRLS PREPARING SILK

by *Cai Xiaoli*

In the section to the right the scene shows two females pounding the silk with pestles, while another pair watch. As the silk painting is unrolled it reveals one lady is sewing; another is fanning a charcoal fire. Yet another group stretch the silk out for inspection, while one lady irons it, and a little girl looks at the underside. The figures are treated in a most lively way, even though there is no background setting.

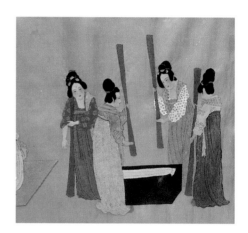

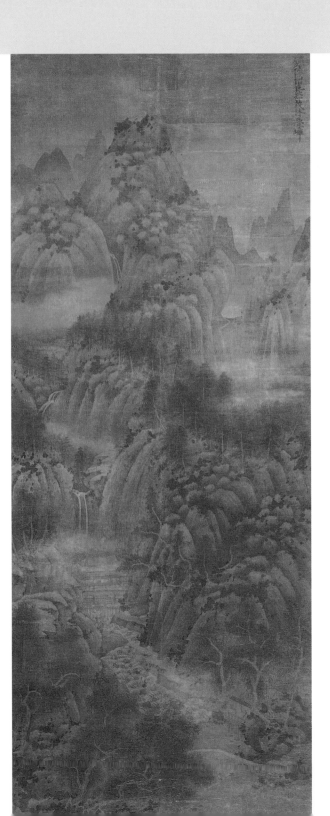

LANDSCAPE

by *Ju Ran* (active 960–80)

This artist monk who specialized in landscapes, painted with great spirit. He was especially famous for his pointed mountains, and the way he painted rocks among trees. His work became a model for later artists. This example embodies all the principles of landscape painting taught in Part Three of this book.

**THE TREASURES
OF THE EMPEROR
TIAN LI**

LOOKING FORWARD, LOOKING BACK

WISHING BUDDHA

by *Kong Bai Ji* *(living in the United States)*

This painting continues a tradition that began in the murals of the Dunhuang caves of northwest China during the 4th century AD, when Buddhism was being introduced from India. The linear image emerges with intense fervor from a rock-like background.

The examples and techniques in this book concentrate on traditional Chinese painting, which has been developing for well over 2000 years. We hope that we have succeeded in showing you that it is not the arid art form, only concerned with imitative copying, that some people in the West believe. For many Chinese artists, it continues to be a repository of ideas and inspiration. During the 20th century, China has experienced increasing contact with the West, and many artists have chosen to work entirely in Western styles. In this information feature, we take a look at some Chinese artists now living and working in North America and Europe, where they obviously have maximum exposure to Western art. It is interesting to see how they reacted to this new cultural environment. The artists all went back to their roots to some extent, and integrated new ideas with the old. In many respects, you can appreciate the positive aspects of your native land when you view it from a distance. In China we say that you cannot recognize the face of the Luo Mountains when you are close to them. The pictures in this feature are very different from one another, but all are recognizably Chinese, even though the artists now paint in a way so seemingly dissimilar from the one they would normally have adopted at home. We hope that you will be able to identify where they have drawn on their native art sources.

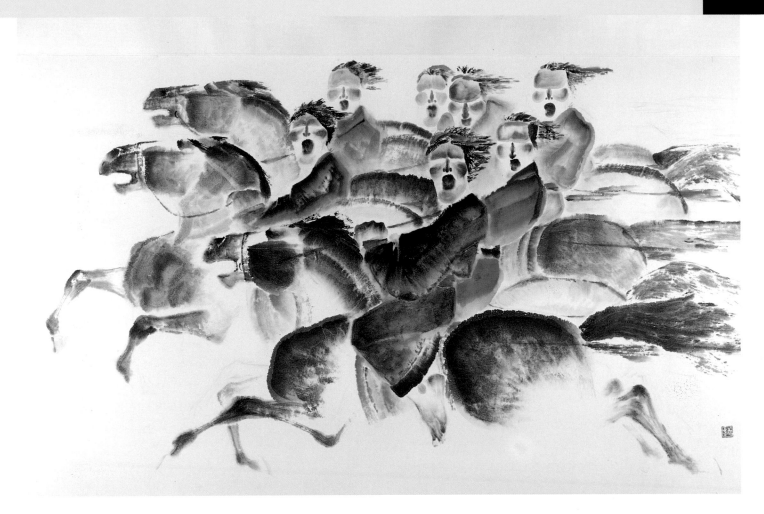

RUNNING HORSES

by *Zeng Shan Qing* (*living in the United States*)

This example is reminiscent of Han dynasty stone-rubbings, but the presentation is modern. You can hear the thunder of the hooves and the cries of the riders, as they gallop past.It is the splendid brushwork technique using traditional materials that promotes the image.

HERE AND NOW

by *Qu Lei Lei* (*living in Great Britain*)

The alliance between painting and calligraphy is continued as the artist repeats the maxim: "I used to pace between the collections of the past and a yearning for the future. There were two gates, one closed, one open. Then I realized that human life is always changing, so I must not let it slip away."

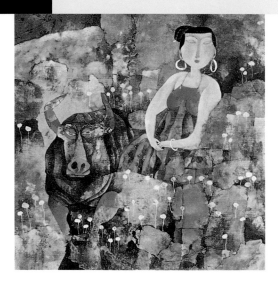

ROCK FLOWERS

by *Hu Yong Kai* (living in Hong Kong, now reclaimed as a province of China)

Echoes of folk art are apparent in the patchwork of color used to portray this scene of the buffalo, enjoying the luxuriant meadow alongside his human companion. This is no longer a working relationship, but the two share a peaceful afternoon, whiling away the time in pleasant dreams.

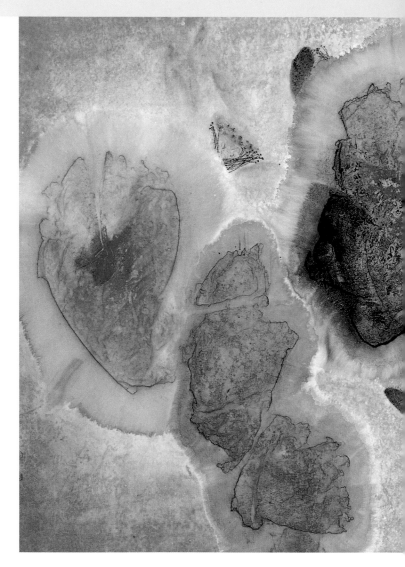

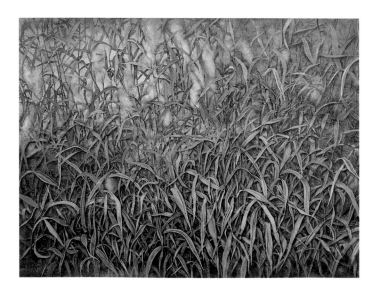

AUTUMN

by *Cai Xiaoli* (living in Great Britain)

The fine brush style of this painting recalls the Song academy of the 12th-century Emperor **Zhao Zhe** (see information feature ten). Every blade of grass appears to be described in detail, yet as the eye follows their interlacing movement up through the picture, they mysteriously dissolve in a puff of mist. Once again, ancient techniques and materials are married to a new concept.

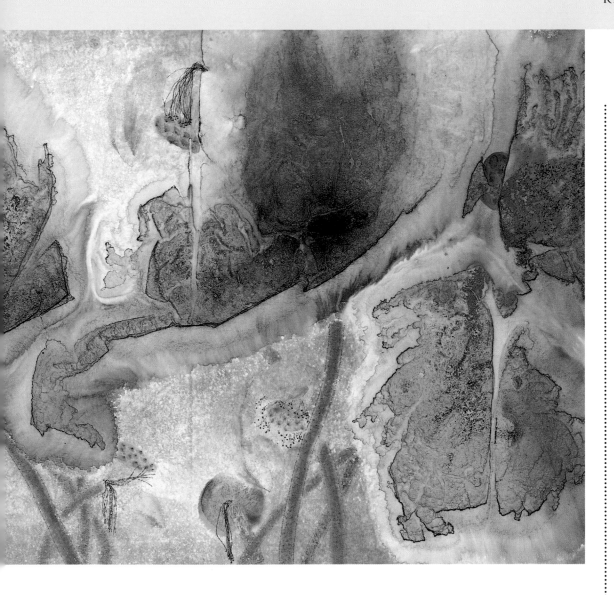

**CAPTURE THE IDEAS
OF THE GODS**

LOTUS

by Yang Yan Ping *(living in the United States)*

This painting exploits the liquid possibilities of ink techniques
to the full. The rhythmic movement through the painting, the
balance of form and void, the presence and evanescence,
which exemplify traditional painting, are all there.

GLOSSARY

Terms used in Chinese painting

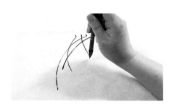

bai miao

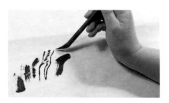

cefeng

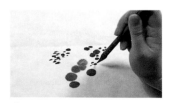

dian

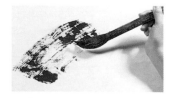

fei bai

bai miao	traditional ink and brush line drawing
bifa	brush techniques
bimo	ink and brush techniques
cefeng	side brush
cun	textured rough stroke
dao	the way
dian	dots
fei bai	flashing white
fupi	ax cuts
gongbi	fine brush painting
gou	outline drawing with a brush
jie	bamboo joint
jie hua	drawing with a ruler
mi	character for rice
mo	ink stick
mofa	ink techniques

• • • •

Each lesson contains a piece of calligraphy for you to use in your painting if you wish, but please note that these examples (and their transcriptions) were chosen purely to fit with their respective lesson, since Chinese uses the same symbol or *pinyin* word (transliteration into the Latin alphabet) for different meanings, depending on pronunciation.

Each information feature has a seal example for the same purpose.

• • • •

Dates of dynasties mentioned in the text

Shang	16th–11th centuryBC
Han	206BC–AD220
Tang	618–907
Song	960–1279
Ming	1368–1644
Qing	1644–1911

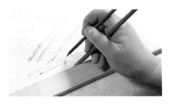

jie hua

pobi

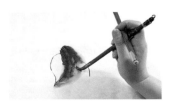

ran

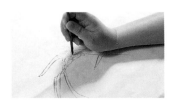

zhongfeng

mogu	without bone
pima	stranded hemp
pobi	split brush
pomo	splashed ink
qi	spirit
ran	faint coloring and shading
shuang gou	drawing on both sides
tuobi	dragged brush
xiao pin	simple style (artistic creation)
xieyi	free brush painting
xuanzhi	rice paper
yan	inkstone
yun	charm; good taste
zhi	paper
zhongfeng	center brush
zhuanbi	turning brush

INDEX

CREDITS

Quarto would like to thank the following individuals and galleries for supplying photographs, and for permission to reproduce copyright material. While every effort has been made to trace and acknowledge copyright holders we would like to apologize should there have been any omissions.

KEY T=top, R=right, L=left,
B=bottom

Art Beatus 142; British Museum 7, 212, 213, 215; City Gallery 93 (T), 141 (T & B); Roto vision 4, 5, 8 (B); Wang Fung Art Gallery 92, 151 (T), 204; Leom Woodal 8 (T).

All other photographs have been supplied via the authors from private collections throughout the Far East and Europe. The authors would like to express their sincere thanks to all those who have contributed work to this book.

The publishers and copyright holder would like to thank the following for their assistance in the making of this book: Pauline Cherrett and Professor Roderick Whitfield.

Typeset by: Central Southern Typesetters, Eastbourne, England.
Manufactured by: Universal Graphics (Pte) Ltd., Singapore.
Printed by: Star Standard Industries (Pte) Ltd., Singapore.